CONTENTS

Foreword

'Two of the most frustrated trades are dentists and photographers,' Picasso once said. 'Dentists because they want to be doctors, and photographers because they want to be painters.'

Like all good aphorisms, this is completely bogus. The painter himself didn't believe it. The inspiration for Cubism arguably came from some distorted images taken on his friend Severini's broken camera and, in any case, Picasso also announced: 'I have discovered photography. Now I can kill myself. I have nothing else to learn.'

Discoverers of Neil Crighton's work in the generously illustrated pages of this important new volume will not be rushing to follow Picasso's lead. For one thing, we have plenty to learn and this is just the book to teach and inspire us.

This is much more than a how-to manual. In his engaging introduction, Neil traces the line of descent of landscape art to its early fifteenth-century origins, and the early croszcfertilization of art and photography with camera obscura and lucida – a glass prism on an adjustable metal arm fastened to the artist's drawing board, which refracted a traceable image on paper.

There was the usual grumbling about photography killing art, of course (just as video would kill the radio star, and Kindle the printed book). Charles Baudelaire, reviewing an 1859 photographic exhibition said:

'If photography is allowed to supplement art, it will soon have supplanted or corrupted it altogether.... If it is allowed to encroach upon the domain of the... imaginary, upon anything whose value depends solely upon the addition of something of a man's soul, then it will be so much the worse for us.'

A flick through some of the extraordinarily atmospheric photographs in this book shows how misplaced these fears were.

Far from being a frustrated painter, Neil's photographic calling came early. His own personal development grew from school science lessons – 'for me, the whole magical process of photography then was a continuation of the study of chemistry and chemical reactions applied to a creative purpose' – to experiments with his father's 35mm Kodak Coloursnap, a secondhand Zenit, and a prized Asahi Pentax SV.

Usefully for any photographer hoping to make a living from the business, his own career route, from positions with the National Physical Laboratory and Portsmouth Polytechnic, to a globetrotting role with ICI/Zeneca took him to fifty-six countries, and ultimately to his own business. He now lives with his wife Julia in northern Sweden, where he has converted an old church into a photographic gallery and school of photography.

Throughout, Neil's infectious enthusiasm and passion for his subject, and his subjects, shines through. Enjoy.

Richard Lomax,
Journalist and Director:
Redhouse Lane Communications Ltd.
(London and Glasgow)

◀ Winter moon.

Introduction

Painters began to include nature in their work during the fourteenth century, introducing elements of the landscape as the background setting for the figures in their paintings, which were invariably 'religious commissions' depicting important religious figures or biblical characters in an allegorical setting.

Landscape painting was established as a genre in Europe early in the fifteenth century, portrayed as a setting for human activity, yet still often expressed within a religious context. Landscapes were idealized, mostly reflecting a pastoral ideal drawn from classical poetry which was first fully expressed by Giorgione and the young Titian, and remained associated above all with a hilly wooded Italian landscape, depicted by artists from Northern Europe, many of whom had never visited Italy. Joachim Patinir developed a style of panoramic landscapes with a high viewpoint that remained influential for a century, and was further used by Pieter Brueghel the Elder. The Italian development of graphical perspective allowed large and complex views to be painted very effectively.

The term landscape was not used until the sixteenth century. It was borrowed from the Dutch painters' term *landschap*, meaning region, or tract of land, but when brought into the English language it had acquired a newer artistic sense as 'a picture depicting scenery on land'. The seventeenth century saw the dramatic growth of landscape painting, particularly in the Netherlands, in which extremely realistic techniques were developed for depicting light and weather.

In England landscape painting was considered a minor branch of art until the late eighteenth century, when the Romantic spirit encouraged artists to raise the profile of landscape painting. William Turner, known as 'the painter of light', employed watercolour landscape painting techniques to his use of oil paints to create a unique style of light and atmosphere for his land- and seascapes. Initially he toured England and Scotland, and later in his career travelled widely in Europe to Germany, Holland, Belgium, France, Italy and Switzerland.

Turner's Romantic style gradually gave way to a style that was to become even more widely recognized, developed by the French. From the 1830s Jean-Baptiste-Camille Corot and other painters in the Barbizon school established a landscape tradition that would become the most influential in Europe for a century, with the impressionists and post-impressionists making landscape painting for the first time the main source of general stylistic innovation across all types of painting.

◀ View of Stockholm through a window.

DEVELOPMENT OF THE CAMERA

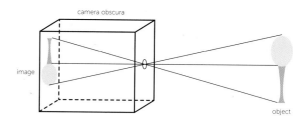

▲ A simple diagram showing how a camera obscura works.

The artist David Hockney and physicist Charles M. Falco have suggested that advances in realism and accuracy in painting and drawings in western art were primarily the result of optical aids such as the camera obscura, camera lucida, and curved mirrors, rather than solely due the development of artistic technique and skill.

The camera obscura was a small wooden box with a lens at one end that projected the scene before it onto a piece of frosted glass at the back, where the artist could trace the outlines on thin paper. In the seventeenth and eighteenth centuries many artists were aided by the use of the camera obscura. Jan Vermeer, Canaletto, Guardi, and Paul Sandby are but a few.

The camera lucida was an adjustable metal arm fastened at one end to the artist's sketchbook or drawing board and used a glass prism at the other end, the refracted image of the subject or landscape would be superimposed on the paper – it was then a simple task to trace the features with a pencil. By the beginning of the nineteenth century the camera obscura was adapted, with little modifications, to accept a sheet of light-sensitive material, to become the photographic camera.

In France Louis Daguerre had been searching since the mid-1820s for a means to capture the fleeting images he saw in his camera obscura. He formed a business partnership with Joseph Nicéphore Niépce, who had been working on the same problem – how to make a permanent image using light and chemistry – and as early as 1826 had achieved primitive but real results. In 1839 Daguerre revealed his daguerreotype process, in which a one-of-a-kind photographic image was produced on a highly polished, silver-plated sheet of copper, sensitized with iodine and exposed in a large box camera. The image was then developed in mercury fumes and fixed with 'hypo' sodium thiosulphate, which is still used to fix black and white films and paper. Daguerre used the process to record static subjects and Parisian views.

In 1840 William Henry Fox Talbot, British inventor and a pioneer of early photography, produced a negative image that could be used to make positive paper prints. He discovered that an exposure of seconds, leaving no visible trace on a chemically treated paper, left a latent image that could be brought out with the application of a solution of gallic acid. This process, called calotype, opened up a whole new world of possible subjects for photography.

Fox Talbot wrote and illustrated *The Pencil of Nature*, the first commercially published book illustrated with photographs. It was published in six instalments between 1844 and 1846, containing twenty-four salted paper prints from paper negatives that were carefully selected to demonstrate the wide variety of uses for photography, including landscapes. He also made major contributions to the development of photography as an artistic medium.

Not only did this new process allow people to document their family and loved ones, but also to provide images of distant lands. The custom of the Grand Tour, which was undertaken by mainly upper-class European young men and women of means, served as an educational rite of passage and was documented at first by diaries, sketches and drawings and then later by photography. Francis Frith, a successful studio photographer and founding member of the Liverpool Photographic Society, travelled to the Middle East on three occasions in the mid-1850s, with very large cameras (16" × 20").

▲ Urban cityscape (central Stockholm).

According to Frith, 'the difficulty of getting a view satisfactorily in the camera: foregrounds are especially perverse; distance too near or too far; the falling away of the ground; the intervention of some brick wall or other common object... Oh what pictures we would make if we could command our point of views.' He set himself a huge photographic project, to document every town and village in the United Kingdom, in particular the notable historical or interesting sights. Initially he took the photographs himself, but as success came, he hired people to help him and set about establishing a postcard company.

LANDSCAPE PHOTOGRAPHERS

Landscapes, their character and quality, help define a region or area, to differentiate it from other regions. Landscape comprises the visible features of an area of land, including the physical elements of landforms such as mountains, hills, rivers, lakes and the sea; the living elements including vegetation; human elements including land use, buildings and structures; and transitory elements such as lighting and weather conditions. Photographers have always been inspired by land formations and natural wonders, such as vast forests, canyons, mountains, deserts, lakes and waterfalls.

English photographer Roger Fenton remained in the tradition of a stereotypical picturesque tourist Victorian postcard style, creating idealistic views of the landscape which closely copied the previous

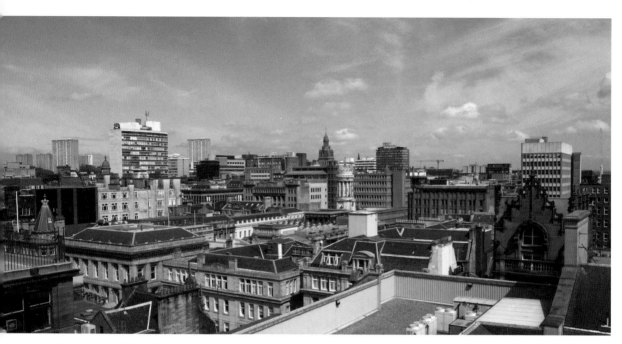

▲ Urban cityscape (Glasgow).

work of painters. Peter Henry Emerson pioneered a movement based around 'naturalistic' photography, which was the opposite of the contrived and sentimental style of painting. The pictorialist movement of the late nineteenth and early twentieth century established photography as a fine art in its own right, taking on board different processes and techniques, such as blurred details in landscapes and cropping. Even impressionist painters looked towards photographic cropping to produce unusual images. Japanese art also had its influences in a strong and sometimes simplistic graphic style of photography.

In the American West the Union Pacific Railroad used photographer Andrew Joseph Russell to document the railway's progress from 1868 to 1869. William Henry Jackson's photographs helped to create the American National Park system, beginning with the creation of Yellowstone National Park in 1872. Edward Muybridge, who took up photography in the 1860s, learned the wet-collodion process and used it to focus principally on landscape and architectural subjects, quickly building his reputation with photos of Yosemite and San Francisco. Carleton

Watkins started photography in 1861 and became interested in landscapes, making photographs of California mining scenes and the Yosemite Valley. He favoured his mammoth camera, using large glass plate negatives, and a stereographic camera. He became famous for his series of photographs and historic stereoviews of Yosemite Valley, and his images helped influence the decision to establish the valley as a National Park in 1864.

Ansel Adams is known for his extensive photographs of nature, especially in the American West. His work continues to inspires potential and practising photographers throughout the world. Adams developed the Zone System as a way to determine proper exposure and adjust the tonal range of his final prints. The clarity and depth characterized his iconic black and white images of the American West. He used large-format cameras despite their size, weight, set-up time, and film cost, as their high resolution helped ensure sharpness in his images. HDR photography, shooting Raw or combining different exposures in layers may be considered to have similarities with Adams' Zone System.

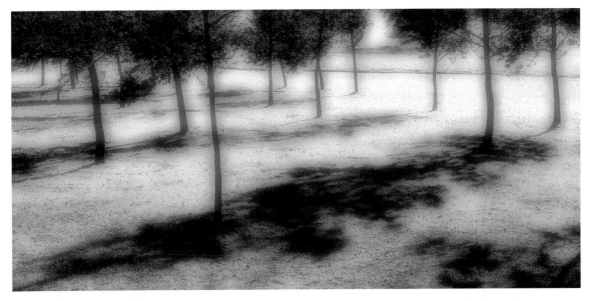

▲ Landscape, impressionistic style.

Adams founded the Group ƒ64 (ƒ64 being a very small aperture setting that gives great depth of field on a large-format camera) along with fellow photographers Edward Weston and Imogen Cunningham, to practise pure or straight photography over pictorialism. The group's manifesto stated: 'Pure photography is defined as possessing no qualities of technique, composition or idea, derivative of any other art form.' Adams also advocated the idea of visualization, where the final image is 'seen' in the mind's eye before the photo is taken, to achieve the aesthetic, intellectual, spiritual, and mechanical effects desired. According to Adams, the natural landscape is not a fixed and solid sculpture but an image that is as transient as the light that defines it.

Weston was born in Chicago in 1886 and moved to California in 1907 when he was twenty-one, where he produced some of the most famous photographs taken of the trees and rocks at Point Lobos, near where he lived.

Photographers have always developed methods of improving and enhancing their images. In the early twentieth century Autochrome, an additive colour system, became available to produce colour transparencies. Ernst Hass achieved an

impressionistic photograph of a landscape in the 1960s by double exposure: making the first exposure underexposed and out of focus and the second correctly exposed and in focus. Fay Godwin's black and white images give us insight into the rugged and desolate nature of the landscape, featuring archaeological sites and ruins of stone structures while suggesting past inhabitance. Don McCullin's moody black and white landscapes are littered with hints of human intervention: paths, fences, tracks and the English cultivated structural countryside. Martin Parr's landscapes are characterized by the inclusion of people and enhanced colour, to suggest the social reality of an urban craving to escape to the less inhabited rural areas.

Today the countryside is reduced to a short tourist visit for a picnic or a holiday in England's throw-away culture. The tendency of the photographer to ape the painter has passed. However it is still interesting and important to study the artists' techniques, and a photographer can learn a lot from them. Interestingly, the top-selling paintings are still the traditional, local, modern and semi-abstract landscapes.

PHOTOJOURNALISM V ART

As with all forms of mass communication, from the development of the first telephones to the mobile telephones of today, from typewriters to word processing, even from the postal services to e-mail, the underlying motivation has been speed of communication. Within the photographic world, the developments in cameras and image processing were largely fuelled by the demands of the news industry, and the ability of that industry to recognize the need for fast information gathering and dissemination. Indeed, the success of a newspaper was, and still is, determined by the ability to publish a story (along with accompanying photographic images) quicker than its rivals, and our use of digital cameras and the digital darkroom today is directly linked to the developments within those industries. However, there is no doubt that the most important development in photojournalism was the commercial 35mm Leica camera in 1925, followed closely by the invention of flash bulbs. A golden age of photojournalism was born.

While content remains the most important element of photojournalism, the ability to extend deadlines with rapid gathering and editing of images brought significant changes. As recently as the 1990s, nearly thirty minutes were needed to scan and transmit a single colour photograph from a remote location to a news office for printing. Now, equipped with a digital camera, a mobile phone and a laptop computer, a photojournalist can send a high-quality image in minutes, even seconds after an event occurs. Camera phones and portable satellite links increasingly allow for the mobile transmission of images from almost any point on the earth. Along with this is the increasing use of bystander images to illustrate stories (inevitably this has not been welcomed by professional photojournalists or newspaper photographers).

▲ Leitz logo.

▲ Digital camera, mobile phone and laptop computer.

When photojournalism exploded onto the scene in the 1920s, Edward Weston was already an established photographer, and landscape photographer Ansel Adams was beginning his career. Both were enticed into photojournalism at different stages of their careers. Weston knew he wanted to be a photographer from an early age, and initially his work was typical of the soft-focus pictorialism that was popular at the time. Within a few years, however, he abandoned that style and went on to be one of the foremost champions of highly detailed photographic images.

Ansel Adams' only known foray into photojournalism was the publication of a little known work, *Born Free and Equal: The Story of Loyal Japanese-Americans at Manzanar Relocation Center, Inyo County, California* in 1944. The book received mixed reviews. Some critics saw it as an important piece of photojournalism, while most condemned it as disloyal propaganda, to the extent that in some parts of the USA the book was publicly burned.

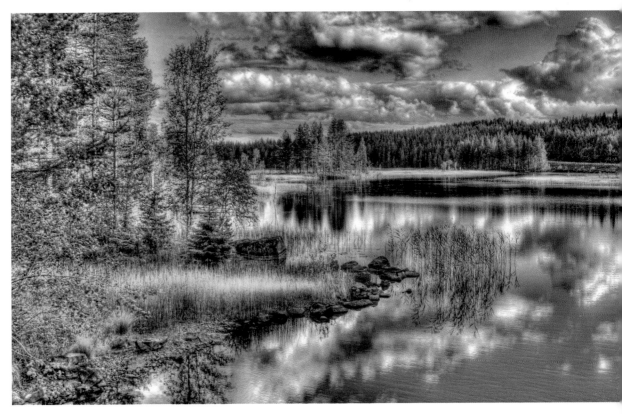

▲ Image of lake and trees, using high dynamic range (HDR).

Adams and Weston's decision to practise pure or straight photography over pictorialism was undoubtedly a reaction to the sensationalism that newspaper editors craved from their photographers. By the 1960s and 1970s, the newspaper readership also began to object to images that became more and more sensational and moralistic, reaching a pinnacle during the Vietnamese War. Many readers and politicians began to criticize editors who they felt were using editorials and photographs to dictate their own political views.

Ironically, therefore, while early photojournalism and pictorialism certainly seemed to attract more public interest between the 1930s and the late 1970s, the increasing sensationalism and politicization of the images saw the re-emergence of landscape photography as an art form.

DIGITAL V FILM

These days we can go out with one camera and shoot high quality stills and HD video. We can geo-tag our pictures so we know their exact location. No need to use your memory or a notebook. We can electronically copyright them in metadata and even shoot 3D. We, as photographers, are always looking for 'the edge', to produce new and exciting images. We can produce our own books and upload our photographs to the web, design the pages and add copy to them. Even if we have little or no design skills we can use pre-designed templates to help us and effectively self-publish them.

We can make albums on line, so a wider audience can view them, or we can limit who views them. Social networks are very powerful and they can be used to gain comment on our work from a worldwide audience. Photographic images can communicate far more than they ever could. Mobile phones have integrated cameras with higher resolution than the first professional DSLR. We now even have a huge range of applications (apps) that we can download to our phones to create artistic effects or tools that were once essential in our camera kit, such as exposure meters and remote control.

Where does photography go from here? There are certain groups of people who, in any social setting, would like to turn the clock back to those considered times when we had the time to think about what we would like to do and how best to do it. Traditional cameras and lenses that once plummeted in value have now found a new lease of life, older lenses being used on digital camera bodies or camera bodies being used as pinhole cameras, and thus taking photographers back to exposing film.

Ironically we are now looking for a different way to portray the world and give it a different look. Put a cheap basic plastic lens on DSLR to give us that arty 'less than perfect' result. What about Polaroid? People loved those small instant prints, and Polaroid

▲ An older-style manual lens on a digital camera.

▲ A selection of older manual lenses.

▲ Wider aperture setting on an older lens.

cameras are now selling for more than when they were new. Polaroid-type film is being made again to fit those cameras. Black and white photography has also found a new lease of life. It shows us something

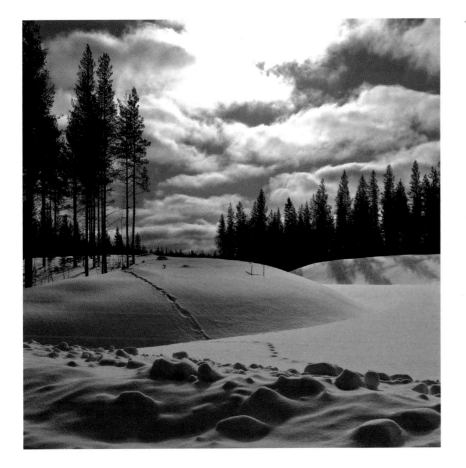

◀ Trees and snow in black and white, backlit.

that we do not see in colour, as it can focus our minds on a particular subject or draw our attention to something that we may not have seen in colour. For the purist, the tonal range of film cannot be reproduced digitally.

For the landscape photographer our main asset is time. The digital revolution and the speed with which images could be shot and transmitted, whilst considered important for the media industries, is of less importance to the landscape photographer. We have time on our side. If a landscape photographer chooses to use a large-format plate camera, or a twin-lens reflex camera with film and wet processing, they can do so.

The potential to express ourselves using the medium of photography is now greater than we have ever had. Photography can be planned around quality of light, and the subject is chosen before the photography takes place. Photographers have the use of programs like Lightroom and Photomatix for HDR photography to produce the qualities in the landscapes that they are looking for.

The ideas and tools are ours – however, let us not forget that the viewer is the best judge of the success of the photograph.

"A photograph is not only an image, an interpretation of the real; it is also a trace, something directly stencilled off the real."

Susan Sontag, *The Image World,* 1982

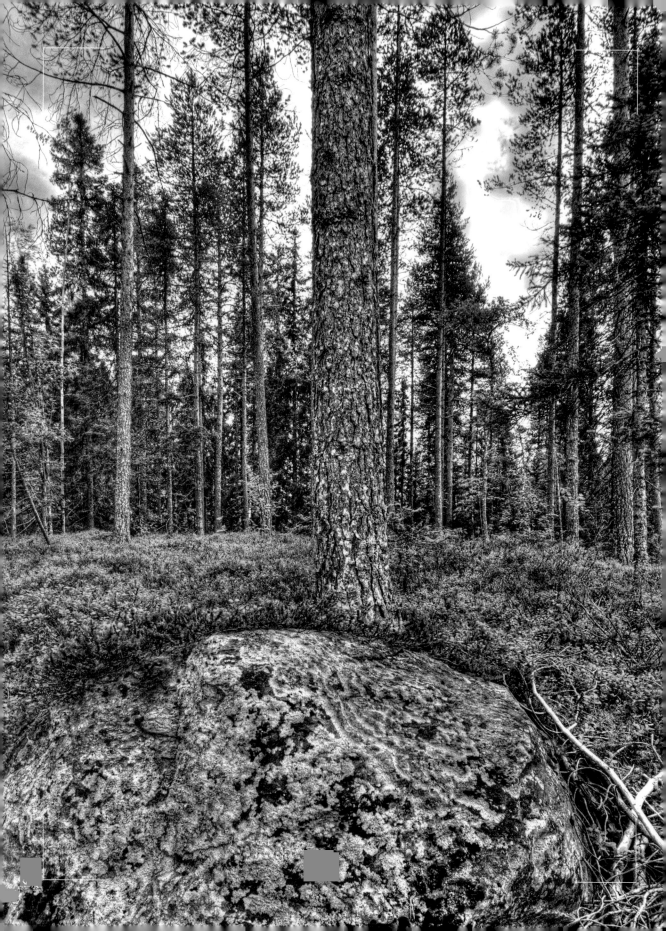

Chapter 1

Your Camera

If you have a desire to shoot and create interesting photographs then you are a good part of the way there. When you set out to take a photograph you should go by instinct and react to a scene; you should not need to worry about the right settings or lenses or whatever. Once you have the passion along with a camera you really enjoy using, and you know its menu system and have set it up to your liking, then it is all about using it as much as possible.

Knowing how to change your camera setting should be second nature to you. Modern digital cameras have different menus, and access to different camera functions through menus. When did you last read your instruction manual? Have you ever read it? Do you know your camera's chip characteristics, what settings give you the best results for different situations? Do you know which of your lenses will give you the best result for a given situation? Do you know how well your lenses perform at a given aperture, how sharp they are at full aperture and when they are fully stopped down? Do you know your camera's ISO performance limits and the way to get the best images you can from it?

You should strive for 100 per cent creative control, and free your mind to concentrate on creating the most imaginative photography you can achieve. You should be able to shoot without stress, without worry, without hassle.

WHICH CAMERA?

With so many brands and models to choose from, with so much information, how do you know what camera to buy?

To begin with, do you have a good idea of what you want to accomplish with your photography – personal satisfaction, relaxation, hobby or professional aspirations?

What style of photography do you want to concentrate on – landscape, macro, natural history, ecological, wild animals or birds, artistic or general nature?

What do you want the final product to be – a digital file that you show on a large screen, a digital file for publishing, a print or your own book of photographs?

If you have a camera in mind go and see if you can try it out first before you buy it. The camera may have the specifications you want, but are the economics right for you? Find out what cameras are available that will most closely match your budget and have the features and specifications you need. Narrow your search down, then arrange to try them out. Does the camera feel right?

◀ Forest and rock – tonemapped – Vasterbotten, Sweden.

▲ Using a long lens and an aerial perspective draws the distant
mountains closer.

▶ Night mist on a lake.

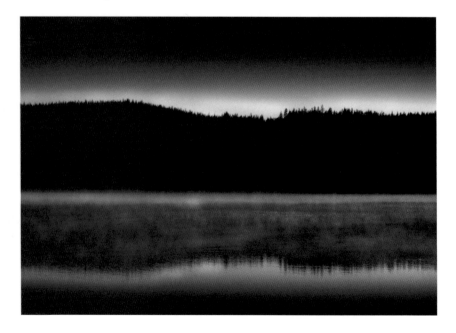

DSLR v Compact

Why would you want a DSLR (digital single-lens reflex) when compact digital cameras are so much smaller, lighter and more affordable? The answer is versatility and image quality. Versatility, in that you can change lenses and add a wide range of accessories, from flashguns and remote controls, to the more specialized equipment that allows DSLRs to capture anything. It also about the creative versatility offered by the more advanced controls and higher-quality components. The quality difference between a good compact and a DSLR is minimal; both will produce sharp, colourful results with little effort. But when you start shooting in low light, capture fast-moving action or wildlife, or when you want to experiment, the advantage of a DSLR's larger sensor and higher sensitivity starts to make a big difference. A DSLR cannot beat a compact camera for convenience, but for serious photography the DSLR wins hands down.

Types of DSLR

At the end of the day most cameras today will produce pictures that will be perfectly acceptable, but each brand has its own characteristics, and it is the one that you prefer using which is always the best.

Some are more suitable than others for particular photography. Generally the larger the chip size the higher the final quality. DSLR sensors fit into one of three sizes: Full Frame, APS-C and Four Thirds Sensor. The crop factor, as the sensor gets smaller, captures a smaller area of the scene. The result is a photograph that looks like it was taken at a longer focal length (1.5x or 1.6x longer for APS-C, 2x longer for Four Thirds).

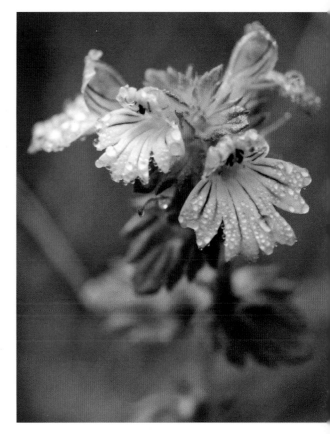

▲ Macro shot of flowers in a woodland setting.

If you are buying a DSLR to replace a film camera and you have got a kit bag full of lenses you need to be aware that unless you buy a Full Frame model all your lenses will produce very different results. For telephoto users the result is quite a bonus, as all your lenses will effectively get longer. But the wide-angle lenses will not produce a 'wide' field of view. So you may be forced to change some of your lenses to digital versions. APS-C is the most common format, used in Canon, Nikon, Pentax and Sony DLSR models. With a crop factor of 1.5x or 1.6x you need digital lenses to get true wide-angle results.

Four Thirds is a digital format developed by Olympus and used in Olympus and Panasonic DSLR models. Four Thirds is not based on any film SLR system and uses unique lens mounts, with the lenses in the system designed only for digital. Four Thirds offers compact camera bodies and lenses. But the smaller sensor means that they produce slightly noisier results in low light and at higher ISO sensitivities.

Full Frame DSLRs have the biggest, brightest viewfinders and because there is no crop factor they are often chosen by photographers who are upgrading from a film SLR and already own expensive wide-angle lenses. Also the larger sensor will produce the best results in very low light and at higher sensitivities. Full Frame cameras are usually larger and more expensive, but you will also lose the increased focal length offered by smaller sensor cameras when shooting with telephotos.

If you want longer lenses for more wildlife maybe you are better buying a smaller chip to give you longer lens capability or a camera that has a higher than average shooting rate to capture fast-moving subjects. You may want to work on macro subjects. If so you will need a camera that has the best range of macro lenses.

Special Considerations

If you intend to take photographs in low light or with long telephoto lenses, camera movement may be an issue. Image stabilization systems are designed to counteract the motion of camera shake. Each camera manufacturer has a different anti shake solution (such as SteadyShot, Vibration Reduction or OIS), but all are based on one of two different techniques: either by using a small element inside the lens or by the camera moving the sensor itself.

Even entry-level DSLR models focus and shoot faster than any compact. With the more expensive models the focus speed increases, and continuous shooting frame rate increases – important for sports and wildlife photographers. Entry level DSLRs offer

a continuous shooting rate of about 2.5 or 3 frames per second but limit the number of shots you can take in a single burst.

If you need faster shooting you will need to move into the semi-professional range where you can expect at least 5 frames per second, although 10 and more frames per second are possible in some models. Together with a larger buffer memory this means that you can shoot more frames in a single burst.

If you are going to do a lot of photography in damp, humid or dusty conditions you will need a DSLR with some kind of weatherproof sealing and with a built-in dust removal system to keep the sensor clean.

If you like to travel light then perhaps one of the new generation of ultra compact lightweight DSLRs may be the answer.

Some DSLRs even have a rear screen that can be angled to offer a better view when getting behind the camera is difficult or when working at a low viewpoint.

Live View is a useful feature when working in a studio. The ability to magnify a portion of the display to check focus is really handy, and the fact you do not need to put your eye to the viewfinder can make shooting from very awkward positions considerably easier – especially useful if working in a tethered situation with the camera attached to a laptop.

With the introduction of Live View to DSLRs, HD movie shooting has appeared. Video-capable DSLRs have already been made popular with both amateur videographers and serious movie makers. The main reason is the big sensor, allowing narrow focus effects, excellent image quality, even in low light, and the versatility to use a huge range of lenses, thus opening up a new world of creative possibilities. Video-enabled DSLRs only have basic manual controls, but all are capable of surprisingly good results.

Camera Bags

A camera bag can go a long way towards protecting a camera and its accessories from dings, scratches, and other damage. There are different types of camera bags, ranging in size from a small case that simply covers the camera to a large bag with many pockets and compartments for camera bodies and accessories. Some are designed to be damage-resilient, waterproof or weather-resistant.

The size of the camera bag purchased depends entirely on the amount of equipment that needs to be carried in it. It is important that the camera and any accessories fit snugly into the bag, without having much room to slide around and bump each other in case the bag is dropped. This has to be balanced with being able to open the camera bag quickly and be ready for any occasion. Most photographers end up with a range of bags for different occasions.

Most camera bags are designed to be carried like a backpack, shoulder bag or case. Some are designed to carry just the camera. Having a holster design that will be carried while walking or hiking, one with straps that will allow it to be slung over the shoulders, is generally a good bet. Smaller, lighter compacts can be slipped into a smaller case and carried in a pocket or belt.

Leather, canvas and plastics are all popular choices for camera bags. Some offer rubber type handles to make them easier to grip. Some camera bags are waterproof, which is a good choice for those who shoot outdoors. Some are reinforced, making them more resistant in case the bag is dropped or stepped on. Probably the most important consideration is weight. Many cameras are heavy enough on their own, so it is important not to add weight, making the bag uncomfortable to carry.

Supports, Tripods, Monopods

A camera on a tripod or a monopod will always give you a better, sharper photograph than one taken handheld, particularly during longer exposure times at dawn or dusk. The disadvantages are weight, size and speed of working. However, the newer carbon fibre tripods are probably the most rigid and the lightest available, other than traditional wooden ones. The only disadvantage is the light weight in windy conditions where a heaver sturdier one is a better option.

Of course if you only have one tripod you can always attach a weight or ballast to prevent any movement. Some tripods are equipped with a centre column, which has a hook at the bottom where weights can be attached – you can use sandbags, camera bag, carrier bag full of rocks or stones or a rucksack weighted down.

A beanbag is great for setting up the camera for a low viewpoint shot.

Extra Memory Cards

Faster and reliable memory cards are important, as is the ability to withstand accidental damage shock which can lead to data corruption. Some cards are packaged with file recovery software that can be very handy. Storage cards are getting cheaper than ever, so you might consider simply buying a number of them. Be aware that the cheaper cards may not be fast enough for your camera's video mode, so check what speed you need if you want to shoot a lot of video material. It could be that for storage alone it pays to have a good number, especially if you are bracketing images or shooting HDR images.

Be careful not to buy big memory cards. It pays to split your images up to several cards rather than having all your labours on just one big one. What if you have a problem with writing or reading the card? You could lose a lot of material that you may not be able to replace.

Before shooting you will need to decide whether you want to work with JPEGs or raw files, and to set the camera to save images to the memory card in that format.

Shooting raw files allows you to control the quality of the image, which is not possible with JPEG. A raw file is comparable to an exposed but undeveloped piece of film. It holds exactly what the imaging chip can record and we need to process it to reveal the finished image. This means that we are able to extract the maximum possible image quality.

Raw files do not have a preset white balance; they are tagged with whatever the camera's setting was, but the raw data has not been changed. This allows us to set any colour temperature and white balance after the event with no image degradation.

File conversion is done on a computer, with a fast and powerful microprocessor allowing far more sophisticated algorithms to be used than those done in a camera. The raw file is tagged with contrast and saturation information as set in the camera, but the actual image data is unchanged. We can still set these after the images have been taken.

One of the biggest advantages of shooting raw is that we have a 16-bit image to work with. This is important when editing an image, particularly if one is trying to increase shadow detail or alter brightness in any significant way.

If you shoot JPEGs you will have smaller files, and more of them will fit on a card, and for many applications the image quality is more than sufficient, such as family snapshots or news images that have to be transmitted wirelessly and online. Some photographers do not have the time or inclination to post-process their files, so raw is not an issue for them.

Some cameras cannot shoot quickly when working in raw mode, and compacts generally can only shoot JPEGs, so for certain work I use two different compacts that will shoot raw as well as JPEGs, because small is sometimes the best.

Some cameras allow you to shoot raw and JPEG files at the same time. On a camera that has a two-card slot you can nominate one card for raw and the other for JPEG files. It is a great solution, as it lets you gain the most from both file types.

Power

Before setting out to shoot always check and recharge batteries. Ensuring you have enough power on hand is always a problem with electronic equipment and cameras. You can never have too much, and you will always need a way to power up all the equipment you have.

DIGITAL FEATURES

White Balance and Colour Balance

Prior to digital photography when shooting colour film we would include an 18 per cent grey card in the first frame of the film and any subsequent frames where the colour temperature of the light may have changed. Either that or we would include a flesh tone to act as our reference colour. This would be used when colour printing or when a colour separation was being made for commercial publication.

The digital replacement for white balance is a calibration process of recording realistic colour in a scene, so that objects that appear white are rendered white in the photograph. White balance takes into account the colour temperature of the illumination, or the relative warmth or coolness of light.

Digital cameras often have difficulty with auto white balance (AWB) and can create colour casts. Certain subjects can create problems for AWB even under normal daylight conditions. If an image has an overabundance of warm or cool colours the AWB will overcompensate for it and averages the colour of the scene to neutral, but in doing so it creates its own colour cast. Mixed illumination with different colour temperatures can further complicate performing a white balance and you will need to decide where the colour accuracy is most important in the scene.

**GUIDE TO RELATIVE COLOUR TEMPERATURE
OF LIGHT SOURCES**

1000–2000 K	Candlelight
2500–3500 K	Tungsten bulb (household variety)
3000–4000 K	Sunrise/sunset (clear sky)
4000–5000 K	Fluorescent lamps
5000–5500 K	Electronic flash
5000–6500 K	Daylight with clear sky (sun overhead)
6500–8000 K	Moderately overcast sky
9000–10000 K	Shade or heavily overcast sky

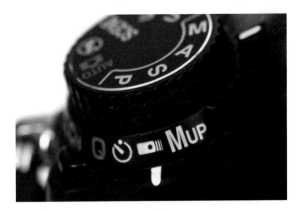

▲ Mirror lock-up setting on a camera.

By far the best white balance solution is to photograph in raw; then you can decide what is the most appropriate colour balance after the photograph has been taken. But if you are photographing in JPEG you will need to determine the colour balance before you start shooting, because correcting later in the software will be more difficult and cause possible loss of quality in some conditions.

A neutral reference is often used for situations where you can anticipate that auto white balance will encounter problems. Neutral references could be part of your scene or a grey card that reflects all colours in the spectrum equally under a broad range of colour temperatures. Just like a smooth colourless 18 per cent grey card used for film photography.

Mirror Lock-Up and Self-timer

DSLRs have a mirror that must be moved out of the optical path before a photograph can be taken. When this mirror moves, it causes vibrations to be set up. These vibrations move the camera and lens and can lead to a loss of image sharpness. This can be particularly apparent when using long telephoto lenses or when doing macro photography, and can be seen in images at higher magnifications.

Loss of image sharpness is worse at shutter speeds between 1/60 and 1/2 sec. At fast shutter speeds the shutter is only open for a short time, whilst at long shutter speeds the vibrations are reduced over time, and only part of the total exposure is taken while the camera is vibrating. In addition a flimsy tripod can make vibrations worse by travelling through the system as a whole.

One of the possible solutions to this vibration is mirror lock-up (MLU), where the DSLR can be fired using two operations. Firstly the mirror can be locked in the up position and the vibrations can be allowed to die out; then secondly the shutter can be fired at a suitable time interval using a remote control, so as not to touch the camera.

An electronic self-timer is usually built into the shutter release of a camera, which can be used to trigger the shutter after a set period of time, allowing the photographer to be in the picture, or to avoid vibrations in the camera. Most digital timers offer the ability to select a delay length of time and have a count-down system giving beeps or flashing as warnings, and then tripping the shutter.

▲ Ice on the branches of a tree using a zoom lens.

LENSES

The older-style fixed lenses offer higher quality and better optical images, and usually wider apertures are available than zoom lenses. Modern zoom lenses are good at giving you a reasonable quality throughout the range but may not have the same optical quality throughout all the range. A lot of the telephoto zooms offer switchable optical image stabilization. The best zoom lenses are very expensive, such as the Canon L range and the equivalents in Nikon. Using a telephoto and longer zoom lens when shooting landscapes can bring out the unique characteristics of the general scene by isolating them in the composition. Extreme wide angles and fisheye lenses not only provide a dramatic and sweeping view but also when used close to a detail

in the landscape can provide the reference to the detail by putting it clearly in its natural environment.

Lens Techniques
Depth of Field
Hyperfocal distance is the determination of appropriate depth of field for a given lens using the appropriate aperture to gain the depth of field that you require for a photograph. A lot of cameras have a depth of field preview button that allows you to check your depth of field before you take the picture. This is determined by the aperture's chosen point of focus and focal length of a lens. If you are using a tripod there is no problem, but when using a handheld camera you may be limited by the amount of available light. This is usually fine if it is bright, but if it is dark you may have limited options.

▲ ultra wide

▲ wide

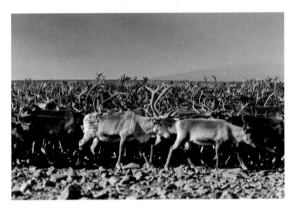

▲ long

▲ medium

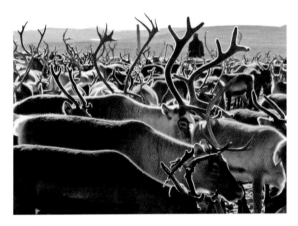

▲ close-up

▲ A reindeer sequence showing different lens effects:
ultra wide, wide, longer, medium, close-up.

CHECKING FOR DUST

Regardless of the format of the camera you choose to use, prior to leaving for the photoshoot you should inspect its image sensor to determine if cleaning is required. To do so, set a lens aperture to the highest setting (typically ƒ22), point the camera to a white image displayed in full screen on a clean computer monitor, defocus the lens, and take a picture.

Review the picture on the computer monitor at 100 per cent zoom. What you see is what you will get in every image captured (dust specks will appear softer with wider aperture settings).

When deciding to clean or not to clean, be aware that opening the camera body always carries a risk of introducing additional dust specks.

If you decide that cleaning is not necessary even though some dust specks are present, still save the dust reference image, as it can be used either for faster manual locating of dust spots in the subsequent images or for feeding into dust removal software (some cameras have this feature built in). If cleaning is required, follow the manufacturer's guidelines.

▶ Tilt and shift used to give a softening effect to the foreground and background, to create a narrow plane of focus.

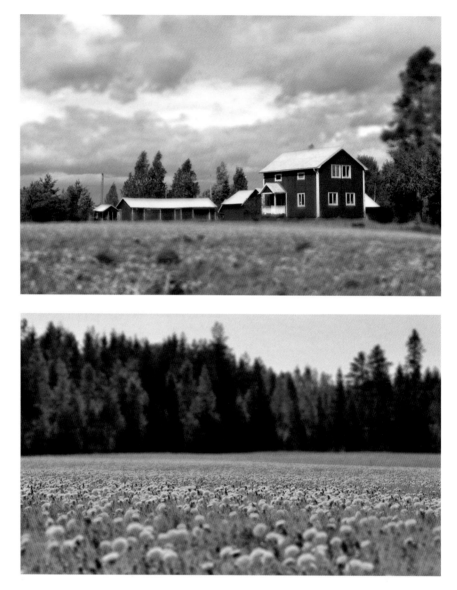

How can we increase our hyperfocal distance? A tilt and shift lens can be one solution. Another is by using a similar technique if you have a technical camera where you can adjust using camera movements. Another possible solution is to take two shots focused at different points in the picture, then combine them later in software such as Photoshop.

Tilt and shift are usually combined into one lens and are used to correct two different optical effects. However, there are limits and ranges of corrections that can be applied simultaneously. Tilt is the lens

movement used to control the depth of focus. If using a large aperture you will get a small depth of field. If you stop down the lens to gain increased depth of field you end up with diffraction effects softening the image. If you use the tilt movements on the tilt and shift lens you can arrange the plane of focus between both elements that you would like to be in focus. You may need to stop down the lens to achieve the full effect but this minimizes the softening of the image detail.

Telephoto lenses can be used to create false perspective in a picture. They can flatten and add immediacy to a subject by drawing it closer to you. In hot conditions this tends to give a mirage-like or watery heat effect. Mirror lenses are another possibility, although not as popular today as they have been, due to the ability of lens manufacturers to produce better extreme telephoto lenses and the popularity of 2/3 chip cameras that increase a given focal length (so a 300mm lens becomes effectively 450mm lens with no loss of aperture). However, mirror lenses have a unique feature, in that they have a narrow depth of field at a fixed aperture, are usually lighter weight due to the use of mirrors in their construction and have a unique doughnut-shaped bokeh. Tamron was one manufactured to produce a close focus 250mm ƒ5.6 version of a mirror lens.

Panorama

Panoramic stitch photography should be carried out using low distortion prime lenses to minimize optical distortions present in zoom, wide-angle and telephoto lenses. Panoramic stitch can be a good way to introduce to the view a sense of how big a landscape is, especially if it is printed to a large size – bigger is usually better. A good tripod is almost essential, as is getting the tripod level. If you do not have a spirit level built into it you can buy a small spirit level that fits into the hotshoe on the camera. Some of the newer cameras have an electronic levelling system.

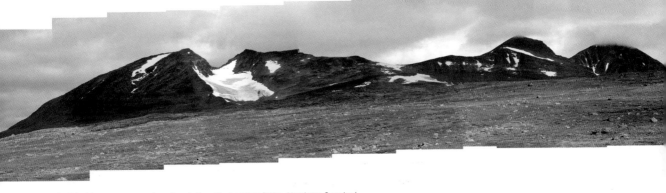

▲ Stitching a panorama together before final editing (Akka, Northern Sweden).

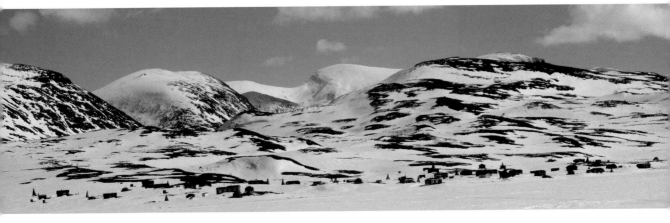

▲ A finished panorama (Alesjaure Sameby, Northern Sweden).

To produce a really good panorama, first decide on your prime lens, fix your aperture, focus and exposure on manual, being aware of lighting during the sequence, and keep the exposure at a constant. You should allow a 30 per cent overlap in shots to minimize optical distortion within the lens. Once you have got all your photographs these can be imported into software programs like Photoshop; one of the automated functions, such as Photomerge, automatically places the images in the necessary order and merges them for you.

You do of course have the option to assemble the image yourself if you so wish. Be aware that once you have the panoramic assembled it will be a very large file, which you will need if you intend to make a high-quality large print.

Some compacts and indeed camera phones have an automatic panoramic maker software included which will either automatically stitch together the shots or semi-automatically guide you and indicate the position of the next photograph in the sequence.

FILTERS

Polarizing Filters

One of the most useful filters for the landscape photographer is the polarizer. There are two types of polarizing filters: a linear polarizing filter and a circular polarizing filter. Both do exactly the same thing, but the circular is more commonly used with DSLR auto focus cameras as it does not affect the auto focus systems. A circular polarizing filter has an added layer which scrambles the filtered light coming from the polarizer so that the camera is able to auto focus.

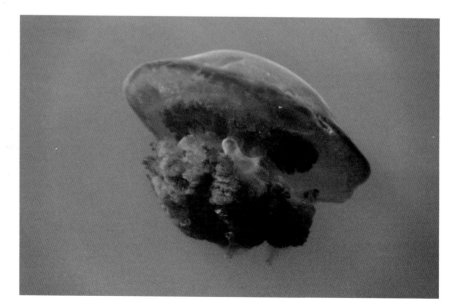

▶ A jellyfish under water, photographed using a polarizing filter.

With a circular polarizing filter attached to your lens you will see the more saturated colours, bluer skies and a reduction or elimination of any reflections, particularly useful in seeing through water. You will get the maximum effect if you are at 90 degrees to the sun. A polarizing filter on an overcast day can also saturate the colours, such as of wet leaves. However a polarizer will cut the amount of light reaching your sensor by 1 or 2 stops, but has a bonus of acting as a neutral density filter (ND) when you need one. Add the two together and you can get a variable ND from 4× to very strong.

Bear in mind that cheap circular polarizing filters may suffer with a colour cast, green or yellowish – make sure your filter has a neutral grey cast for correct colour rendering. Another thing to look out for is the larger rim on your filter, which rotates to control the amount of polarization; when used with wide-angle lenses, it causes darkening at the edges of the image. It is usually available as glass, but also available in filter systems.

▼ A polarizing filter was used to saturate the colour in a blue cloudless sky.

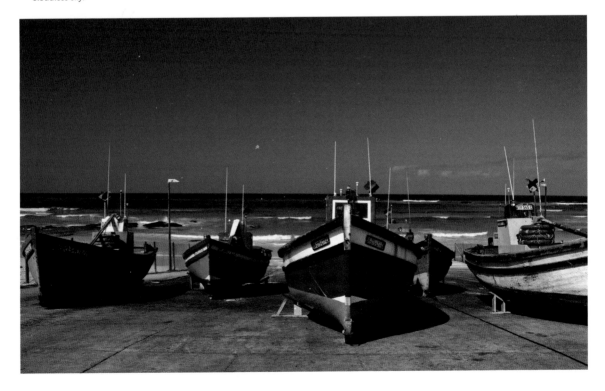

▶ The use of a neutral density filter allows the exposure time to be increased, to create a misty effect with the water.

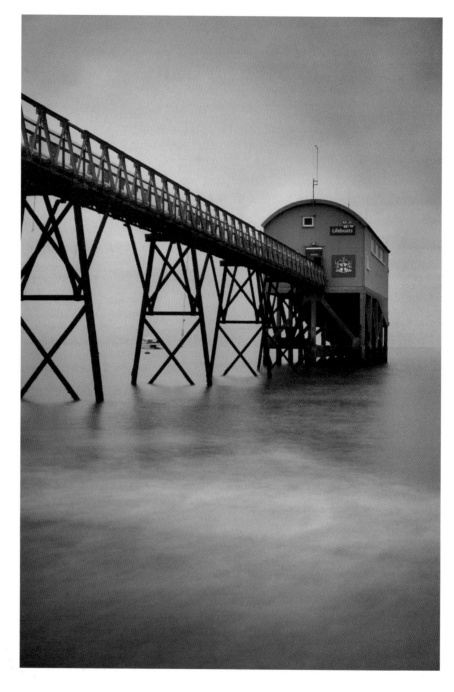

Neutral Density Filters

Neutral density filters can reduce light levels. They are available in different densities of grey and are often expressed in terms of exposure factor or stops, and they are optically neutral. Variable ND filters are now available to reduce costs and take up less space in your bag. Again, they are available in glass and in filter systems. Originally used in the film industry to reduce light levels, and still used in video cameras, they are used to reduce the effective aperture for filmic focus. They are used in DSLRs, also, to reduce the lens aperture for selective focus effects.

ND filters can be used to reduce the shutter speed but retain correct exposure so that blur occurs in the subject, for example where water is moving to create a soft misty effect. They provide an effective technique when photographing a busy street or landmarks if you have problems with people getting in the way. If the shutter speed is slow enough they will not be seen on the resulting image. When using flash you can often reduce the exposure of the flash using auto settings, but for macro photography that is not always enough, so try using an ND filter to reduce the flash effect.

▲ A variable neutral density filter.

▲ A neutral density filter.

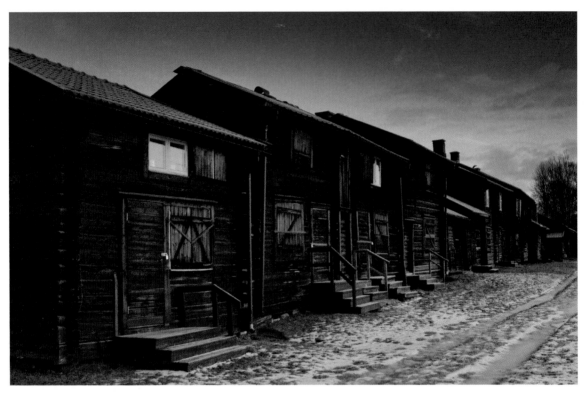

▲ A graduated neutral density filter used to increase colour highlights (Old Church Town, Skellefteå, Sweden).

Graduated Neutral Density Filters

Most landscape images will have a density difference between the sky and foreground. A set of neutral density graduated filters can help to produce a landscape image that would be spoilt by either a washed-out sky or a dark foreground. They are graduated 50/50 starting from dark grey at one end to clear at the other and are usually available in different densities, 1 through to 5 stops, depending on manufacturer. Some of the more expensive filters are available in hard edge and soft edge, usually made in optical-quality plastic but the higher quality in glass versions. They could form part of your system filters (such as Cokin or Lee) comprising a filter mount and holder for the filters that can often take more than one filter at a time.

Filters need to be carefully used to prevent damage to them. Technically they are used to prevent unwanted flare getting into the lens, thus degrading the image. The same result can be obtained in processing with graduation effects in software programs such as Adobe Lightroom.

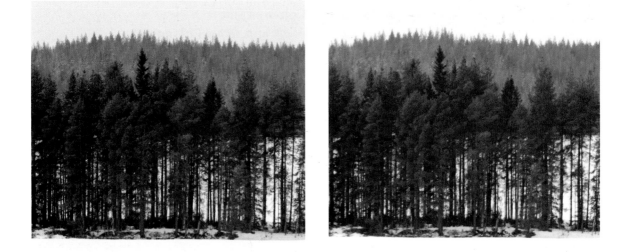

The effects of a UV filter on a distant landscape. The picture taken without a filter (left) shows increased haze and a bluish tint in the distant trees, while the one taken with a filter (right), from the same viewpoint and using the same exposure, shows less haze and less blue with increased sharpness and contrast.

UV Filter

An ultraviolet filter, sometimes referred to as a skylight filter, provides protection to the front element of your lens from dust, water, and minor damage and has the ability to absorb UV light, which can make distant landscapes hazy and indistinct. Some film photographers used a very light red (1.5Kr) on longer lenses. If photographing on water or in snow conditions you can use a UV filter to help the rendering of the subject.

UV filters can be used most of the time as they have very little other effect, but remember that all filters are a potential source of flare, so if you are going to use them buy the best you can. One of the few negative effects I have seen was during photography of the Northern Lights, which can produce unusual optical effects but these were lost due to the filter. Ultraviolet filters do seem to reduce a fringing effect known as chromatic aberration in some cameras and lenses.

Coloured Filters and Colour-Graduated Filters

I use any sort of filter and technique that will help me create the look I want; I am expressing my imagination, not trying to duplicate reality. However some of the best images come with natural lighting and need no enhancement. In general I only use filters when the light is not perfect.

Colour conversion filters are not really used when shooting digital, as you can adjust the colour balance in the menu or after you have shot the picture, using the white balance adjustment. An infrared filter like the Hoya R72 (it looks black) creates effects like a black sky and white foliage, producing dramatic results; it blocks most of the visible light while allowing IR to pass though it. Some artistic effects can be achieved through using coloured filters, but software like Photoshop and Lightroom can emulate these settings. Some cameras have software built into them that also simulates filters.

Half colour, half clear filters with a graduated density transition for smooth blending into the scene, offer image-makers the potential to create an illusion or enhance reality. Some of the most popular applications of these filters are to add colour to a drab sky, changing a specific colour in a scene to create a desired special effect and enhancing an existing colour or creating subtle colour drama in the image.

Colour-graduated filters are usually offered with a 'hard' edge or 'soft' edge. Hard edge graduated filters are generally used for long lenses because a soft edge would get lost in the image. Soft edge graduated filters are primarily for short focal lengths, because a hard edge gradient would look like a hard straight line. Soft edges are for subtle blending with irregular-shaped subjects or unusual lighting. Cokin produces a large variety of different effects in a filter system. However, once these effects are used it is difficult to get rid of them, so be sure that it is really what you want to do.

Remember that all these effects are obtainable with raw files using non-destructive software processing which is far more sensitive.

Coloured Filters in Black and White Photography

In black and white photography certain colours look very similar when converted into a greyscale, so in order to separate them you can use coloured filters over the lens. There are five basic colours that are commonly used in black and white photography – red, orange, yellow, green, and blue. Each filter lets through its own colour of light and blocks other colours to varying degrees. Therefore colours that match the filter appear brighter in the image, while other colours appear darker.

In landscape photography, a red or orange filter will turn a blue sky almost black and make clouds really stand out, giving the scene a dramatic feel, as if it has been shot in infra red. Filters are excellent for increasing visibility in haze and fog. An orange filter also gives materials in buildings contrast, depth and texture. A yellow filter slightly darkens the sky, bringing out the clouds, and helps to balance exposure against darker ground. A green filter is mainly used for photographing plants, separating the green foliage and increasing the detailed appearance of grass and trees, but also lightening the sky. A blue filter can increase the appearance of haze and mist, enhancing the mood of a misty scene. Some DSLR cameras have filter effects built into a menu, but these are post-processing effects.

▼ Cokin filter system.

WORKFLOW AND
IMAGE MANAGEMENT

Before you start shooting digital images you should consider how you are going to organize them and store them. Look at the process carefully and decide how you want to use your images, because that will determine your workflow and storage requirements. Consistency in how you handle your images after they are shot is as important as the techniques you use to compose and shoot your images.

Image Storage

If you are shooting a lot of images, you will need a place to store all of that data. I use a portable 500gb hard drive together with a high spec small laptop, but if you are not going to do any file processing you could consider a netbook with a portable hard drive. Apple's iPad offers a way to dump pictures even for raw files but you will want to consider how much space you have available, especially if you are shooting large volumes of raw files. You might need to go with an option that packs more storage. There are a number of battery-powered, hard-drive-based media storage devices that let you simply insert your card and hit a button to transfer your images. A multimedia viewer offers not only storage space but also a colour screen for reviewing images.

GPS Device

I have a portable GPS system that I use in the car and can use on foot. I consider this an essential piece of equipment, especially when travelling around areas that you are not familiar with and even areas that you think you know. They can be useful, but not to be used on their own – a map is always a good idea. GPS can put you in positions that you would not wish to be in. There are specially designed GPS systems for hiking and systems for plugging into your DSLR camera as well as compact cameras that have GPS systems built in to them.

I find geo-tagging a very useful tool for doing travel photography, as I have difficulty in remembering exactly where I shot a particular picture. This is the process of embedding latitude and longitude coordinates in the metadata of your images, so you always know where they were shot. If you have an iPhone it has geo-tagging capabilities with an app like PlaceTagger.

CHECKLIST

▷ Camera suited to your needs.
▷ Camera bag.
▷ Lightweight but sturdy tripod or camera support.
▷ Memory cards.
▷ Power supply and extra batteries.
▷ Filters.
▷ Adopt a consistent approach when editing/storing your images
▷ Image Storage.
▷ GPS.

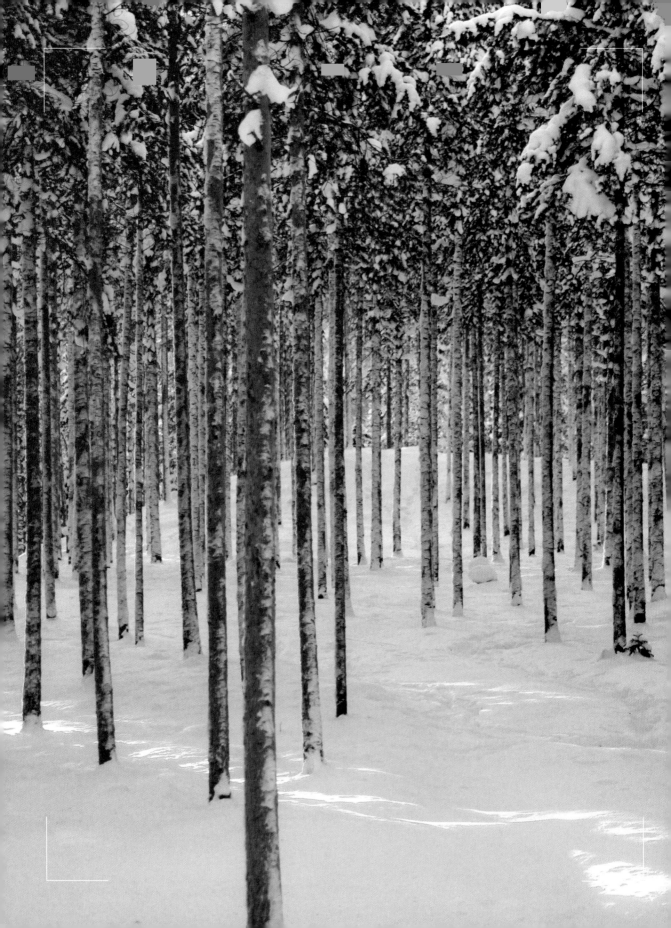

Chapter 2

Choosing Your Subject

Landscape is not only the geological structures of rivers, lakes, hills, mountains, plains, sand dunes, swamps or rocky outcrops; it is largely composed of natural vegetation, and maybe human intervention, and it is human intervention that can determine the characteristics of the landscape photograph – the weather, light intensity and position – and control its depth and interpretation.

We are drawn to lines and layers, minimalism, colour, a focal point and context. When we look at a landscape, we selectively focus on the elements that we find most appealing. Our field of vision is large, but our eyes and brains have the ability to scan and ignore all except the most interesting details. A camera needs you to interpret the view by selecting the camera position, viewpoint and lenses, combined with good interesting lighting.

We have a human tendency to want to photograph the spectacular, and we are less likely to want to photograph the stubble field just down the road. It is often better to concentrate on an area near where you live – which you know and understand – rather than feeling you need to venture to unknown places. Try walking around near your home. You will probably be surprised by the images you can take in very ordinary locations, and if you can spot the potential of a shot in an environment that you may not have considered, you are far more likely to spot the

▼ Long lens shot over strongly lit field.

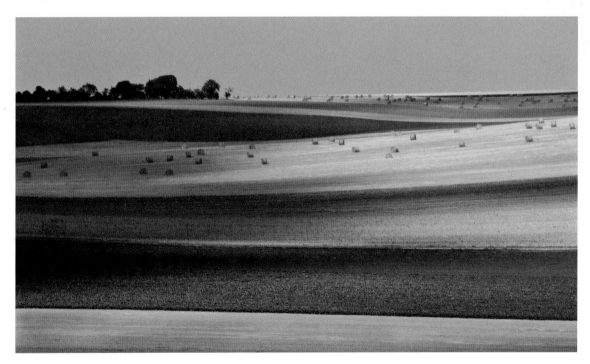

◄ Late afternoon light through trees.

▶ Walking allows for diversions, to obtain a different view of the landscape.

▶ A walking stick with a tripod attachment can minimize the amount of equipment that needs to be carried.

▼ Housing in a landscape (Western Cape, South Africa).

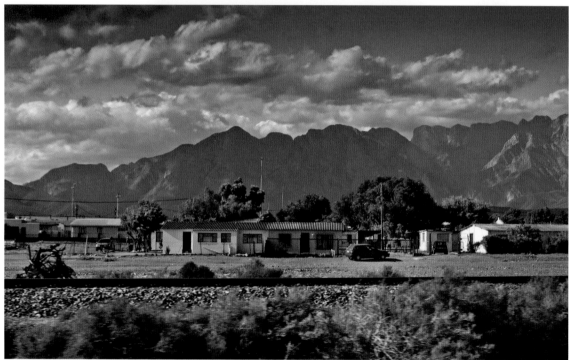

shot in a more beautiful location no matter what the weather or light are doing. Look for walks where you will find wildflowers, autumn leaves, picturesque lakes, waterfalls, ridgelines with great long views, or paths with scenic backdrops like a line of mountains on the other side of a lake.

Many photographers seem to recognize only one season and forget that there are a variety of seasons, each of which give new photographic opportunities, as does the time of day and weather conditions. There is no season that cannot produce interesting subjects. Colour or black and white is not an issue; digital imaging allows us to adjust the final result in our software. We do not need to carry different speeds of film stock.

THINK BEFORE YOU SHOOT

Being in the right place at the right time is not just luck, though certainly sometimes being lucky helps, but usually it has taken a lot of work to get it and may have taken some time to organize. Good planning can help your odds of getting good images. Source a prime location that shows what you want to photograph in its best environment, that maybe shows general views and details in which you can use the foregrounds to the best effect.

When you arrive in a place you have never visited before, spend time scouting different locations, looking for different vantage points. Good strong lines and S-shapes can guide the viewer around the landscape. Wide open expanses and immediate detail can work together. Recognize the potential to create an abstract image using the detail of the landscape.

Take time to work out where the sun will rise and set, and imagine how the place would look in different kinds of light. A compass can be a useful device for this. Sometimes you will find that what you are interested in photographing is not lit at all, and if you feel you would like to record it you will then need to photograph it on an overcast day or maybe after sunset.

Flat lighting can produce dramatic images. Shadows are almost non-existent. Flat lighting is often hard to cope with, particularly in the tropics, and it is usually better using strong shapes, tones and colours. Know what to do once you get there, particularly if the light is changing quickly, and react quickly to it.

Knowing what your camera is capable of and how it works can greatly increase your odds of getting the good shot. You should know your camera and how to adjust it 'inside out'. Likewise a correctly exposed image is what you are after. It is easy to forget something in the excitement of the moment.

However, sometimes all of your planning has to give way to flexibility and adaptability. What if the flowers aren't blooming when you get there? Do you pack up and go home, or do you look for other subjects to shoot? The truth is, there are great images to be made just about anywhere and getting them requires many things, but particularly, an open mind.

In my experience though, the biggest factor in increasing the number of good images you get is seeing them in the first place.

You may already be in the right place at the right time, but do not realize it. If you want to make good landscape shots you must choose the best locations and make the most of the natural lighting; and while you may get some good photographs wherever you happen to be, the best photos are taken when you find the perfect location with the perfect weather conditions.

"To be able to take pictures of a landscape I have to become obsessed with a particular scene. When I have found a landscape which I want to photograph, I wait for the right season, the right weather, and right time of day or night, to get the picture which I know to be there."

Photographer Bill Brandt,
Camera in London, 1948

BE PREPARED

Part of getting the right shot is being in a position to do so, both mentally and physically. It is good practice – and can be essential – to clean, check and repack your equipment after use, ready for the next shoot. Then you can be ready for whatever you find.

▶ An old barn photographed
on a stormy, overcast day
helps to put the life of a
pioneer farmer in context
(Västerbotten, Sweden).

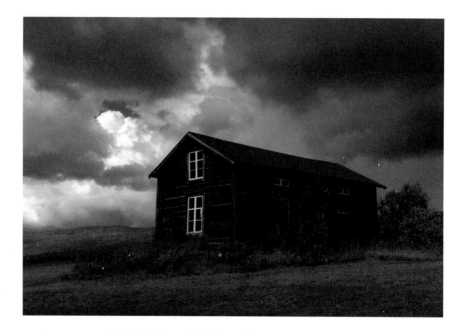

▶ The detail of the fence in
this monochromatic beach
shot shows the impact of the
S-shape.

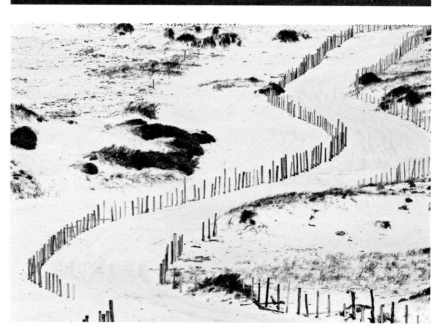

▶ Fallen autumn leaves provide
an opportunity for an
abstract composition.

SPOTTING THE POTENTIAL OF A SCENE

Learning to spot a potential photograph is one of the most difficult parts of becoming a better photographer. It is complicated by the process that the photograph may not be the finished product, but only the raw material that you will use to construct a final image. Often, you will be presented with scenes that are good potential photographs, but not perfectly finished images. Learning to recognize the potential of an image is a function of experience, and an understanding of what is possible with your camera and image software. An experienced photographer can generally spot a potential photograph and even when not working, that is, when on holiday, it is rare to actually disengage from seeing good potential images.

Some of the best photographs have been made unexpectedly, and unforeseen opportunities that present themselves just require your experience to recognize them when they occur. Get closer when you see a grand vista, or vast landscape. If you use wide-angle lenses, your distance will get stretched and details in your image will get smaller, and the result can be an image with no discernible subject.

Remember that sometimes less is more. Shoot both horizontal and vertical shots. Pay special attention to the background and keep the foreground strong. Try getting in close with a longer lens, and capturing part of the vista, or find a detail in the scene and shoot that. Some landscapes are simply too big to fit in a photograph so concentrate on the details.

▼ Identify the potential for a good image (St Fargeau, France).

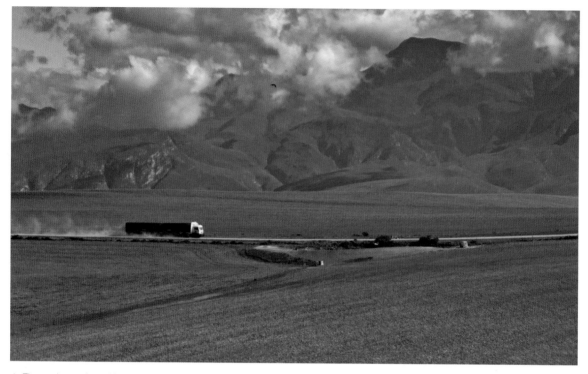

▲ The moving truck provides the focal point in this vast South African landscape.

When you are looking for inspiration for a detailed abstract photograph, you need to change the way you look at the world around you. You need to stop seeing the big picture and look for details, look at the shapes and patterns that occur, rather than focusing on the actual objects. Look and think about what you are seeing. What elements are there, what textures, what colours, and what shapes?

Seeing detail is the first step in spotting the potential for an abstract photograph in nature. Once you have seen something that strikes you as interesting, you need to focus in on that, and explore the possibilities. Look at what caught your attention from different angles, from the sides, from higher up, and low at ground level. Abstracted photography is not just about finding the details in the bigger picture but can also be about changing or modifying (maybe in software) some of the original photography to a personal interpretation of the image.

DIFFERENT ANGLES

Whatever the subject, we need to explore it from all possible vantage points. We usually start with the most predictable – which is quickly dismissed – and then start the challenge to find a different spot to shoot from, searching for new angles that could mean getting down to the ground to shoot low or finding a higher vantage point to shoot from.

▲ Shooting from a low angle using a medium zoom lens allows different foreground plants to be emphasized (Lighthouse, Southern Cape, SA).

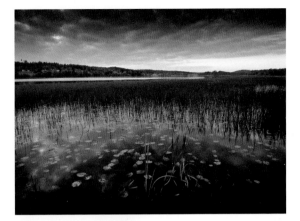

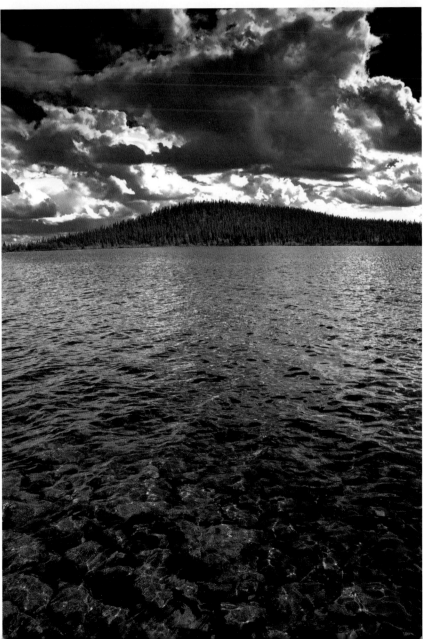

◄▲ An opportunity for a variety of shots in one location – close detail, an overall view and a low angle shot – using a polarizing filter to capture the stones in the water (Strömfors, Sweden).

Choosing Your Subject [45]

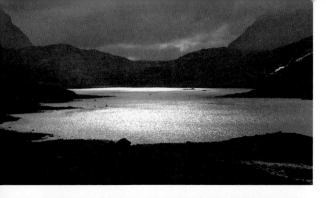

WEATHER CONDITIONS

The weather has the ability to change unpredictably in precisely the same 'right place, right time' as you are trying to photograph. Interesting weather can make for interesting photos of course, but only if you can adapt to the changing circumstances when it happens.

For the light, the best time of day to shoot photographs is either early in the morning or late in the day when the sun is not harsh and directly overhead. You should, with experience, be able to anticipate the appearance of a scene at different times.

Bright Sunlight

What can you do if you have to shoot on a very bright, sunny day? Set a low ISO, to the lowest your camera allows, giving you more exposure latitude. A lens hood will help reduce flare by shading the end of the lens. In addition a French Flag (a camera tool to shade the lens) can block the direction of direct light into the lens. A circular polarizing filter can and will increase contrast in your subject. Some days it will be so bright that the normal protection from the circular polarizer may not be enough. Neutral density filters come in different grades. Some will really block out a lot of light, allowing for slower shutter speeds and better colours. However ND filters will not help as well with flare, unlike the CP filter gradient neutral density filters which can be used to help darken a washed-out sky, leaving the detail of the landscape. In bright sunlight, a camera's light meter may be thrown off by light-coloured or shiny surfaces within the subject area.

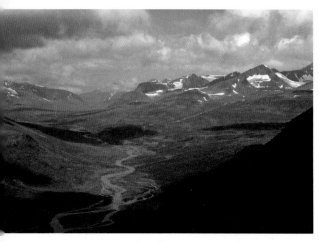

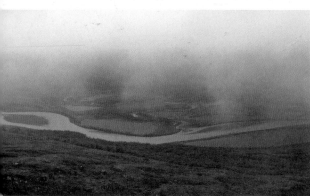

◀ The weather can change in a short space of time during the same outing.

Rain, Fog and Mist

In bad weather conditions, such as rain, fog, mist and poor light you can capture some of the most interesting photographs. When it rains it tends to create shiny surfaces on most materials. In the cities the rain causes the streets to shine and the buildings to look gloomy. In the countryside the plants, grasses and leaves can shine and droplets of water can hang from branches and leaves. The clouds that accompany the rain often provide a diffuse light that provides fill-in light and softening shadows.

When it rains you will probably have to use either a longer shutter speed or a wider aperture because the darker conditions block out direct sunlight. A tripod can ensure that you can get sharper results as well as giving you the opportunity for longer exposures and for using longer lenses. Capturing bolts of lightning requires a good stable tripod and a long shutter speed or keeping the shutter open on B option of the shutter speed until the lightning has passed and has been recorded. It will take some practice to predict the event of lightning striking, but if you can catch it, it certainly can make the landscape something special. But be aware of ending up as a lightning conductor!

▼ Trees reflected in a lake on a foggy day.

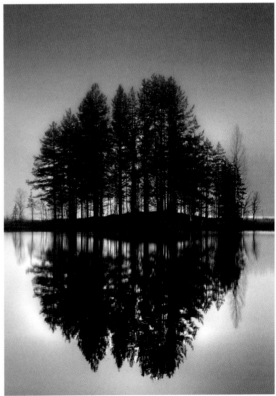

▼ Trees and hills showing aerial haze.

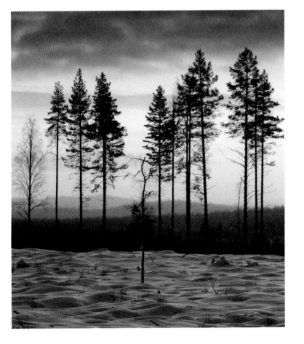

▶ A rainbow created by the moisture evaporating from the waterfall.

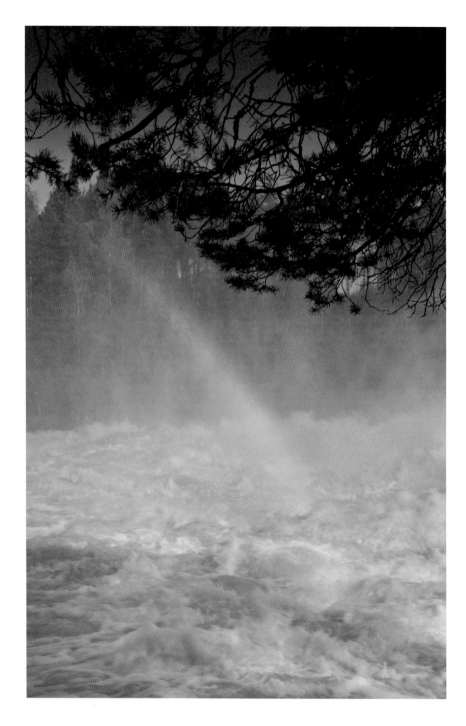

Rainbows and Storms

A rainbow's appearance will depend upon the conditions, yet it will occur usually when you have two elements present: falling or spraying water and bright sunlight. They are common when a storm is approaching or receding and around waterfalls/sprinklers/fountains. As rainbows are optical effects, the best way to photograph them is in front of a darker uncluttered background that allows them to stand out.

Storm chasing is best left to serious and adventurous photographers who have devoted their careers to getting the best photos of hurricanes and tornadoes. Storm photography requires some durable equipment and different techniques than other more normal types of photography. Some photographers stay relatively far away from the storm and just have to deal with rain and high winds. Other photographers commonly leave cameras set up on tripods in the paths of a storm so that they can operate by remote control from a safe location.

Snow

Snow changes a landscape photo into a winter wonderland. The whiteness of the snow tends to add a good contrast to the normal colours.

Bright and white snow can be trickier to capture effectively. The light metering on cameras tends to see snow as very bright so it sets the exposure for the brightness of the snow, leaving the background and other objects almost as dark as a silhouette. Most experienced photographers overexpose the snow, as with beach or water scenes. Snow can also disrupt the camera's automatic white balance sensor, so you should also make sure that you adjust the white balance to suit the snow conditions. Shadows also tend to become blue. You can set your white balance to a warmer setting to remove the excess of blue or shoot with a very light red colour correction (1.5R) filter to warm the scene.

▼ A graphic composition of snow in a landscape, taking advantage of the late afternoon light to provide a warm colour cast.

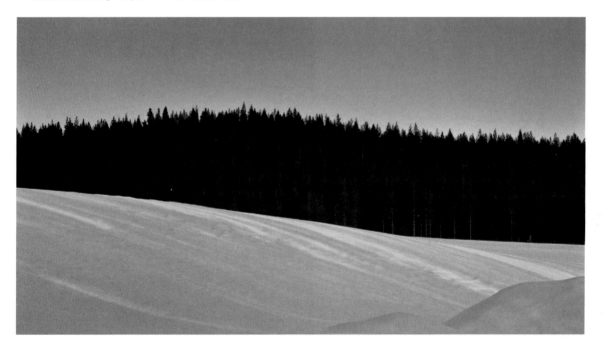

LIGHTING AT
DIFFERENT TIMES OF DAY

Angle of the Sun

The sun is fairly high in the sky anywhere in the UK from 10am to 2pm. The entire landscape will be flooded with the same amount of light and have few shadows, which are short in length. The result is that the photograph looks flat. When the sun is rising and setting, the angle of the sun is steeper and produces longer shadows and highlights textures within the landscape.

Colour of Light

The colour of light also changes at different times of day. Morning light tends to have a 'cool' or blue cast to it, while afternoon and evening light has a 'warm' or orange cast to it. In the middle of the day, the light shining on your landscape does not have much colour. The same landscape photographed in late afternoon light will have texture and dimension and come alive. The best way to see how the colour of light changes over the course of the day is to take several different photographs of the same view at different times of day.

Being able to shoot the same scene in different seasons over the course of a year or years can help you understand the changing effect of light.

THE HAND OF MAN

Some nature photographers believe that 'the hand of man' must not be visible in a nature photograph. A nature photograph that depicts nature alone, without any trace of human intervention, can be difficult to photograph because it is hard to go anywhere in this world without seeing some sign of Homo sapiens, whether it is a power pole or the vapour trails of an aircraft.

Other photographers are convinced their photography plays a role in promoting such ideals as saving the planet, raising awareness to social and ecological issues, or the preservation of endangered species. But can our images really make a difference? William Henry Jackson, the photographer whose early images of Yellowstone were instrumental in establishing the world's first national park, did make a difference. Are such achievements still possible today? The oil spill in the Gulf of Mexico

▶ The setting sun provides a contrast between the land and the water.

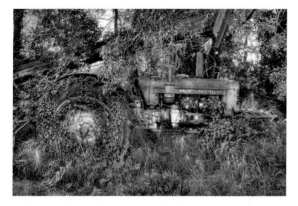
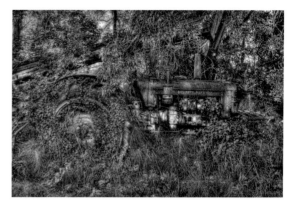

▲ Nature reclaiming its own in these HDR images of an abandoned tractor being engulfed by foliage.

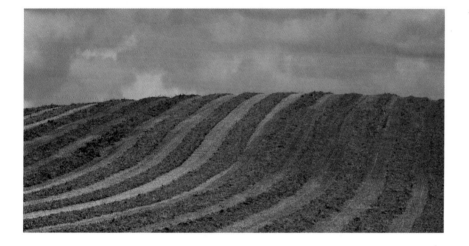

◀ While the 'hand of man' is evident, the viewpoint of the cultivation lines gives them a curved appearance against the cloud-filled sky, creating a strong visual impact.

was considered by many to be the largest environmental disaster in the US. We all saw images of dead and dying wildlife, devastated habitats. However the Gulf and other oil rich areas are no better protected today than they were before the spill.

Images of aspects of the environment and man's impact and relationship with nature are considered by many as 'reportage' images that convey a message or tell a story about energy pollution, conservation, regeneration, land use. Agriculture, crofting, forestry and biodiversity are all part of today's landscapes as well as the unique natural beauty. We tend to forget that nature can take back its own environment, such as when an industrial area becomes swallowed by nature. It is interesting that only post-apocalyptic films tend to feature this landscape.

CHECKLIST

▷ Plan ahead.
▷ Learn to spot the potential of a scene.
▷ Know what to do in different weather conditions.
▷ Understand the effects of light.
▷ Be aware of how you want to deal with the Hand of Man.
▷ Try every angle.
▷ Always be prepared to be flexible, and know what you are gaining and what you are giving up by making compromises.

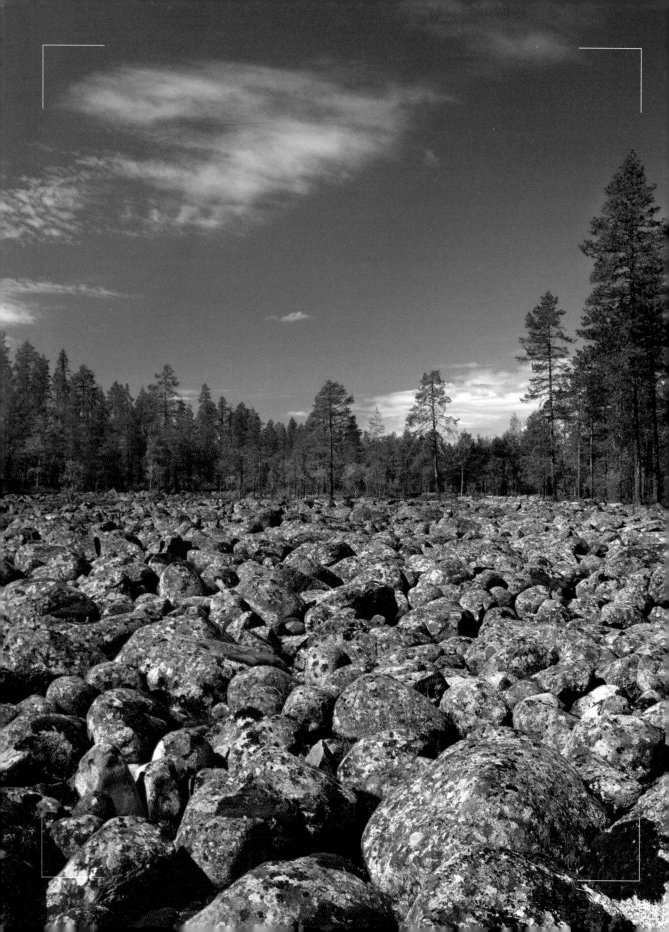

Chapter 3

Using Light and Depth

If you take photos of a place near you, you can choose the perfect light for a certain subject. Generally, the light of early morning and late afternoon when the shadows are long is usually best for landscapes, and it is often better to have the sun in your back. Be aware of your own shadow, as it may appear in the foreground; you may need to disguise it by either shooting from a low viewpoint or hiding yourself, say behind a tree. If it is foggy or rainy, a filter maybe useful, but the lack of contrast may be perfect for certain subjects to give them a feeling of drama.

Early morning and late evening are the perfect time for photographing reflections, especially on water when the sun is low so it has a far more reflective and usually calming effect. The first hour of light in the morning and the hour before sunset is known by photographers as the 'golden hour' – a time of day when the light is warm and diffuse, contrast is less, the shadows are not as dark, and the highlights are not as bright. The scene can change quickly, and the lighting can make the difference between a dull picture and an interesting one.

▼ The midnight sun in the northern polar regions is renowned for its intensity of colour.

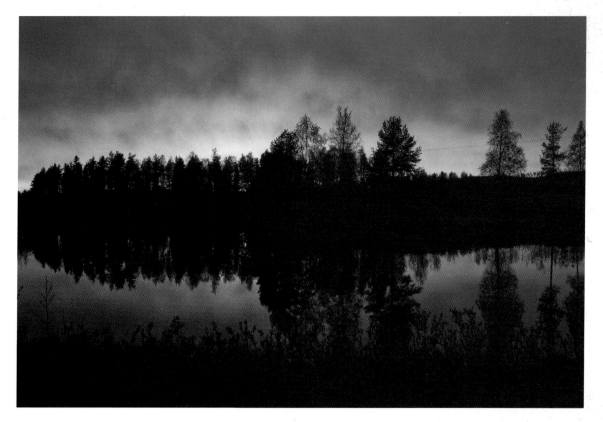

◀ Glacial deposit.

▶ An aerial perspective shows
the rolling Sussex landscape.

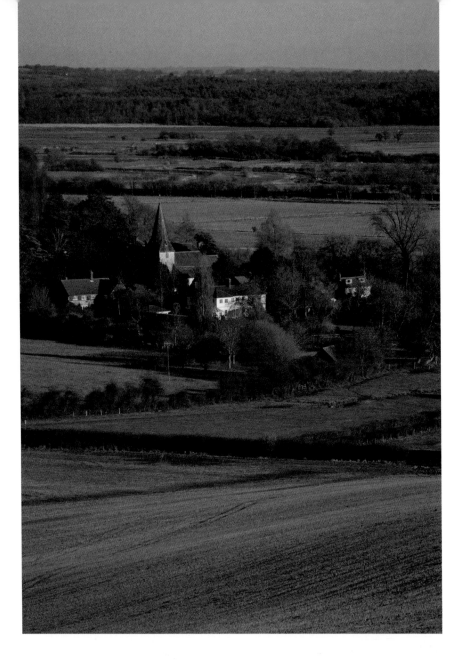

Sometimes you may be forced to shoot in the middle of the day and have no control over that. You may be lucky when it is midday with broken clouds. If there are clouds in the sky, wait a few minutes until a cloud covers the sun. If it is a thick cloud, you may have very nice lighting for foliage. If it is a thin cloud, the light will be diffused to an extent. If you have some clouds in the sky, you will at least have some interest – clouds make interesting photographs. If there are enough clouds, some interesting shadows will occur. Clouds are often used as key elements to pictures. A storm can produce dramatic clouds. High-contrast lighting is not ideal for colour photography but may make good black-and-white photographs. HDR photography may be an answer by taking bracketed shots of the same scene with your camera and then converting the images into one HDR image. Make the best use of the time you have.

METERING SYSTEMS

Most DSLR cameras use sophisticated matrix metering systems, but even these are not perfect, and getting accurately exposed photographs under difficult lighting conditions can still be problem. The 'Sunny 16' rule says that on the brightest day the exposure is roughly the reciprocal of the film speed at *f*16. If you are shooting using ISO 200 then the exposure will be 1/250 sec at *f*16. Extremes of a sunny day outdoors down to typical indoor room lighting covers a range of about nine stops.

So assuming an *f* stop of *f*8 and an ISO 400, here is an idea of the nine light levels and the shutter speed that would be needed for correct exposure. The nine brightness levels represent 95 per cent of the conditions under which photography is undertaken.

Camera metering systems go to great lengths to design multi-zone patterns and sophisticated software algorithms to enable their metering systems to provide pleasing and accurate exposures based on 13 per cent grey. A classic example of how meters can be wrong is a black cat in a coal cellar or a white cat in a snowstorm. In both cases using the most sophisticated multi-zone matrix metering system you would end up with underexposed and overexposed images. The meter sees the black cat and coal, or the white cat and snow as being 13 per cent grey. The experienced photographer will use some sort of exposure compensation to allow for the problem either by setting the exposure manually or adding it automatically using exposure compensation on the camera. A bit of underexposure is always to be preferred to overexposure. A spot-meter reading covers a very small area of the scene being viewed.

WEATHER/LIGHTING CONDITIONS	SHUTTER SPEED (IN SEC)
A sunny day outdoors	1/2000
A hazy bright day	1/1000
A bright cloudy day without shadows	1/500
An overcast day, or open shade on a sunny day	1/250
A heavily overcast day	1/125
Deep shade or woods on a bright sunny day	1/60
Just before a thunderstorm or late on a heavily overcast day	1/30
A brightly lit store interior	1/15
A well-lit stage or sports arena	1/8

◀ The variation of light levels and the presence of shadows in woodland settings invariably require the use of spot-metering.

▲ An urban landscape using multiple exposures.

BRACKETING
THE EXPOSURE

Exposure bracketing is taking at least three shots (but could be more) of the same subject: one correctly exposed, one slightly underexposed and the third one slightly overexposed, all exposures being made according to your camera's meter. By taking at least three shots, you make sure that you have

compensated for any differences in the perceived quality of light in a scene. Most DSLR cameras have auto exposure bracketing (AEB) the amount of under- and overexposure can also be specified as the number of exposures for the bracketing. HDR photography uses this technique to stretch the tonal range of a scene, then recombining the images into one final image. The final image once processed will exhibit an extended tonal range much like Ansel Adams' Zone System.

Use exposure bracketing when you think there is a possibility of extreme highlights or lack of shadow detail. In extreme lighting situations, which contain different intensity of light and shadows, you may be exposing for the different areas, where you want details to be visible. You would of course need to take these photographs on a good tripod for layering at a later date or for recombining them in specialist HDR software.

CONTROLLING
DEPTH OF FIELD

Depth of field can add to the look and feel of a photograph. Depth of field is the distance from a point of focus in a scene that remains sharp while the rest of the scene remains unsharp. The change from sharp to unsharp is a gradual transition. There is no critical point of transition. However the term 'circle of confusion' is used to define how much a point needs to be blurred in order to be perceived as unsharp. When the circle of confusion becomes perceptible to our eyes, this region is said to be outside the depth of field and not acceptably sharp (also called 'bokeh' from the Japanese). Two images with identical depth of field may have different bokeh, as this depends on the shape of the lens diaphragm.

A large depth of field will result in much more being in focus. A narrow depth of field will result in more of the scene out of focus. The determination

of the depth of field is up to you but is controlled by exposure. However, there may be different reasons for a certain depth of field: artistic effects, attention to a subject in a general scene, or sharp representation of the whole scene.

The control of depth of field is by selection of lens aperture, lens focal length, subject distance and sensor size. Focal length and distance to the subject are usually determined by your composition. So the lens aperture is the primary control over depth of field.

Selective focus is achieved by using larger apertures. If you want an entire scene sharp you will use a small aperture. Known as deep focus, it is typically characterized by sharp landscapes with no visible blurring. However lens sharpness will start to deteriorate at the smallest apertures due to defraction effects. You will have to find out how your lenses work at different apertures, with your camera finding the optimum for a particular lens.

▲ Using the red flower as a foreground, but ensuring that the whole scene is sharp, requires a small aperture.

◀ A close-up of the flower, using selective focus, requires a wider aperture.

▲ Pulling distant trees closer requires a long lens (in this case a 600mm 2.8) and a wide aperture.

Depth of field extends behind and in front of the point of focus, so when choosing your focus point you will want to focus about halfway into the scene. However some lenses, depending on their optical construction, may focus more behind than in front. Test them first so you know how they work. Some cameras have a depth of field preview so you can check before you shoot for DOF. With a DSLR you can see your resulting composition and point of focus, but not the depth of field. DOF preview that allows you to stop the lens down to the chosen aperture enables you to see the true depth of field. What you see gets darker because you are stopping the lens down, but it will give a good idea of what you will get.

The longer the focal length lens you use, the less depth of field. So you may for a particular shot have to change not only the aperture but also the focal length of the lens.

Telephoto lenses appear to create a much shallower depth of field, mainly because they are used to magnify the subject. With a wide-angle lens it is difficult to get the background unsharp unless you are very close to the subject. If you are shooting close-ups or macro with a macro lens you will find that they have a greater range of apertures towards the smallest aperture, and the depth of field is extremely small because you are very close to the subject. Final print size and viewing distance can also influence our perception of depth of field.

◄ A wide-angle shot from a low viewpoint gives maximum emphasis to the foreground, as in this black and white shot of pebbles on a beach.

NOISE

Reciprocity was more apparent with film than current digital sensors, which do not suffer the same effects. It was mainly apparent in low levels of illumination and at ultra high shutter speeds causing shifts in colour and increased exposure times. Reciprocity failure was one of the biggest reasons for astronomers to switch to digital photography. Electronic sensors have their own limitations during long exposure times – namely noise – but this effect can be controlled.

Digital cameras do have to deal with the problem of noise, which manifests itself as stray pixels during longer exposures. Rather than shooting a sixteen-second exposure, shoot a four-second exposure by adjusting the aperture and allowing some of the background to become blurry. Use as low an ISO setting as possible, and if your camera supports noise-reduction technology try enabling it and comparing the results with and without.

Shooting during dusk and night can produce problems in seeing through the viewfinder when there is little available light. A lens with a large maximum aperture can greatly increase viewfinder brightness during composition. Night scenes rarely have enough light or contrast for autofocus to work correctly, or enough viewfinder brightness to focus manually. You can focus using distance markings on the lens. However, autofocus lenses often focus past infinity, while older manual-style lenses have stops at infinity. You can try focusing on a light source at a similar distance to the subject or focus on a silhouette against the sky.

Larger-format DSLR sensors have a brighter viewfinder than crop sensors. Exposure in most cameras becomes inaccurate at about thirty seconds. You can try metering using a larger aperture, then stop down and multiply the exposure time accordingly. For exposure times longer than thirty seconds, use B setting with self timer or an

▲ Northern lights with silhouetted trees (vertical shot).

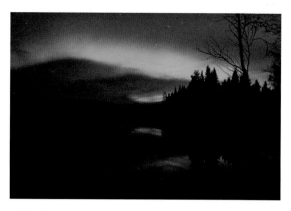

▲ Northern lights using a wider angle (horizontal shot).

electronic release. Remember the batteries will drain quicker when used on long exposures and in colder night temperatures.

A longer exposure at night can begin to reveal the rotation of stars in the sky. Use a longer focal length lens and the North Star as the centre of focus; the longer focal length will increase the distance that the stars travel across the image, leaving star trails.

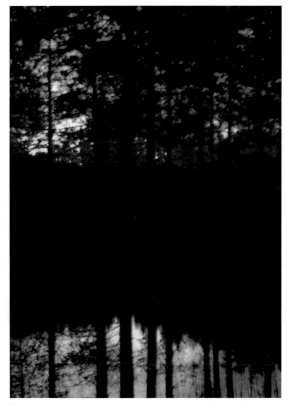

Photographing through the trees to silhouette them against the midnight sun reduces the appearance of noise.

Night scenes that contain artificial light sources can cause flare in what would otherwise be a dark area. Long exposures on digital cameras can produce visible noise, which looks a bit like the grain. This noise or grain is usually most noticeable in plain areas of the picture, such as sky areas.

Some noise will occur using long exposures, but how it is treated will depend on the camera sensor. Noise can be seen as random dead pixels in a neutral area. When using high ISO values use the noise-reduction system within your camera's menu, typically on/off and high/normal/low reduction from 800 ISO upwards. Give yourself time for your eyes to adjust to the decrease in light, especially after standing in stronger light or using a torch. You can use post-image processing to minimize noise, to varying degrees of success.

FLARING

Shooting into the sun can be a tricky business but can yield dramatic results. Silhouettes are all about interesting shapes and edges. Backlighting will tend to make your subject darker than what is behind it, and if what is behind it is the sun you have a real exposure problem.

In the past it was necessary to use graduated neutral density filters to block some of the light from part of the frame. I frequently used multiple stacked ND filters, each positioned differently to blend light across a scene. I do still use grad ND filters sometimes but often dispense with them completely in the interest of cutting down on potential flare.

Simply holding a hand over the offending spot can accomplish the same thing without the added expense or bother. You can also sometimes get rid of a stubborn flare problem by moving your position slightly or by angling the lens off axis slightly. Very small changes can have a huge impact on your flare situation.

You can solve a lot of lens flare problems simply by keeping the front of your lens spotlessly clean. Invest in some good lens cleaner and a microfibre cloth. Carry them with you and use them. If you put a filter on the front of your lens you actually triple your fingerprint problem, since now you have the lens front element itself plus both sides of your filter to contend with. I would urge you to dispense with the use of so-called 'protective' filters, at least when shooting into the sun. Save them for the beach

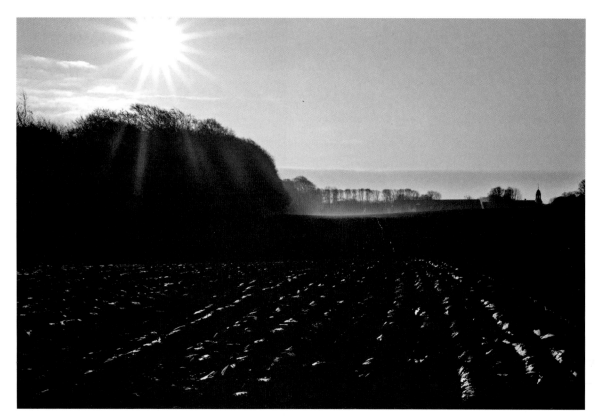

▲ Shooting into the sun darkens the image, in this case allowing highlights to be picked up on the raised ground of a ploughed field.

where they actually serve a purpose by keeping salt spray and sand away from your lens glass.

Another great thing about digital shooting is that you can easily retake a shot in an attempt to get rid of flare. Digital also makes it easy to combine multiple versions of a shot together to take advantage of the best parts of each. I have been known to shoot an image with the top part of the frame intentionally blocked with my hand to cut down on flare and stray light across the bottom part of the frame. Later at home in Photoshop I replace the top of my hand shot with the top of a straight shot without my hand in order to create a version with a better foreground and the same sun-filled sky above it.

Lens flare can be a huge problem. Modern zoom lenses have a lot of glass elements, and every glass/air interface can induce flare as the harsh light passes through. Good lenses have exotic coatings to minimize flare, but there is no way to eliminate

the problem completely. A good lens hood is a must. There is no sense in letting any stray light into your lens when you are already contending with potential flare caused by the light rays you do want.

KNOWING YOUR LENSES

Start by checking the number of blades inside your lens, easily found in the user manual. Lenses with an even number of aperture blades will produce sun stars with the same number of points. An odd number of blades will produce stars with double the number of points. Odd numbers create nicer-looking stars because they generally create far more points.

There are some great lenses out there, from third-party manufacturers, that have an odd number of blades and create really nice stars, but they also have very prominent lens flare. Lens flare could be used as a creative effect and in some occasions creates a pleasing effect, but most of the time it is something you do not want in your images. Some of the budget models like the Sigma 10–20mm have six aperture blades that will result in a sun star of six points.

Even if you can overcome lens flare, the same extreme backlighting can rob a scene of contrast. Everything can end up appearing washed out with no true blacks to be found. Shooting in direct sunlight can lead to images that have high contrast, blown-out highlights, lens flare and colours that might even look overly saturated. Shooting into the sun may lead to lens flare or a dark subject – but at times it can improve it drastically – particularly if you use a flash to fill in the shadows. Fill in the shadows caused by direct sunlight by using a reflector. Flare is technically something that is incorrect. The people who make our lenses do everything they can to prevent us from getting flare! What do you think lens hoods are for? Different lenses produce different types of flare.

DEBRIS AND DISTRACTING ELEMENTS

Before you start shooting always check that the area is clear of litter and debris often found hiding in the shadow areas of a scene. Before the digital camera, a Polaroid was used to check that everything was correct and to make sure that no one had left something in the shot or something had been overlooked. These days it is not so easy, although it is possible to shoot a digital shot and magnify the image, which allows you to remove anything not wanted before shooting.

However some things are not so easy. You may have a power line going through your image or vapour trail across the sky. Photoshop's Patch Tool if used carefully will eliminate power lines. Part of what makes an average photograph into a great one is retouching. I would estimate that the typical 'real' photograph that I take is only about 80 per cent complete before retouching. I believe that the images from the camera are only raw material and are not a finished product until proper retouching has been done, in the same way as a finished print was adjusted when using film.

Retouching is not the same as deliberate 'false' manipulation. Sometimes the retouching is only making minor adjustments of brightness and contrast or replacing grey, leafless trees outside a window with green foliage. On occasion I will clone out distracting elements such as vapour trails in the sky from a passing plane, but sometimes I leave them in if it helps the composition.

Remember to tread with care. Watch your own footprints in sand, soil and crops. They can ruin a good photograph or at best require a good deal of retouching.

CHECKLIST

▷ Early morning and late afternoon light is best.
▷ Know how to control the light.
▷ Bracket exposures to increase the chances of success.
▷ Experiment with depth of field.
▷ Understand what noise looks like on an image.
▷ Know your lenses.
▷ Check the scene for debris and distracting elements.
▷ Include retouching in your repertoire of skills.

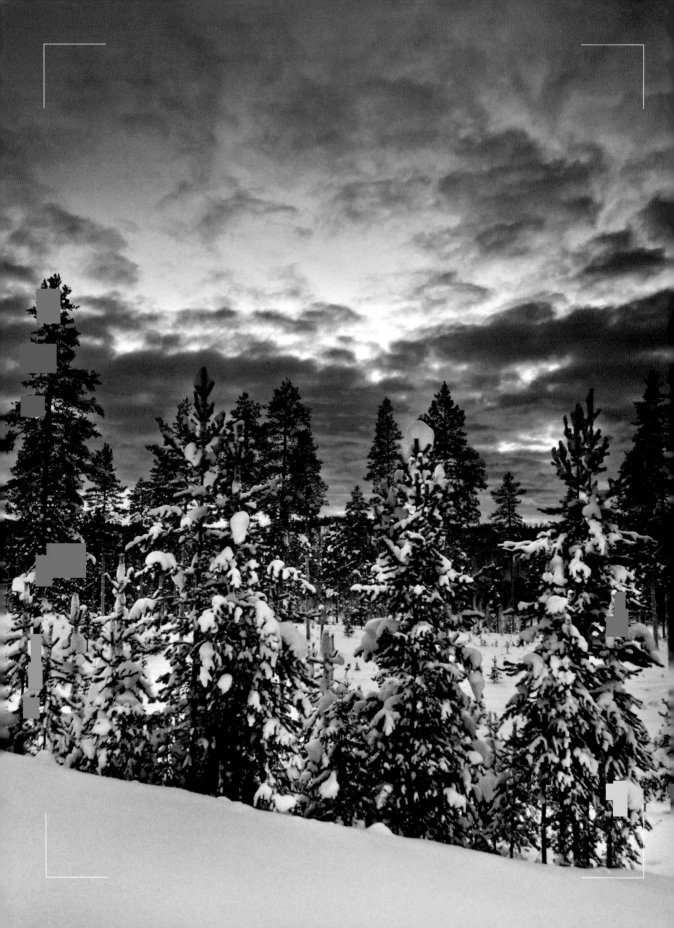

Chapter 4

Viewpoint and Atmosphere

Viewpoint, the position from which you take your photograph, is one of your greatest tools in creating a landscape photograph. The most obvious difference between one viewpoint and another is the background. The subject itself can look quite different viewed from different angles. Altering the position of the camera can change the image so that the subject has fewer or more distractions with which to compete. This may be achieved by getting closer, moving laterally, tilting, panning, or moving the camera vertically. Photographs take on a whole new dynamic by selecting an extreme angle of view. Perspective can change quite drastically, especially with wide-angled or telephoto lenses.

Choice of camera distance, direction, and height will influence the pictorial effect. Camera distance determines the scale, and emphasis of the subject, as does the angle of view of the lens, but also in relation to nearest and farthest points. An object, say, a tree close to the camera, will dominate the foreground and tend to dwarf anything behind. The tree farther away will merge into the middle distance or background. The viewing direction largely depends on what you want to show of the subject. Different sides of a static subject will show different lighting effects, especially early or late in the day.

Movement of the camera position will change the relationship between the subject and the background. This can be used to shift prominent features of the skyline to one or other side of the pictorial interest; foreground objects can also be used to cover up features in the middle distance. The camera height will determine how much the camera sees of near and distant parts of the scene.

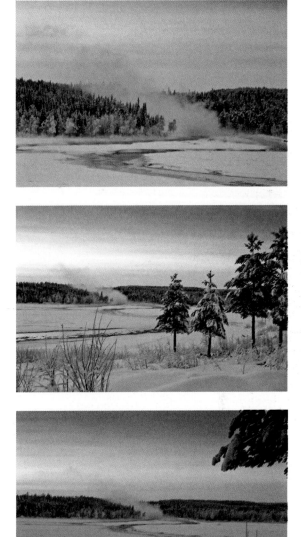

▲ When arriving at a location, viewing and shooting the scene from different angles allows for greater selection of the preferred viewpoint.

◀ Sunset and snow.

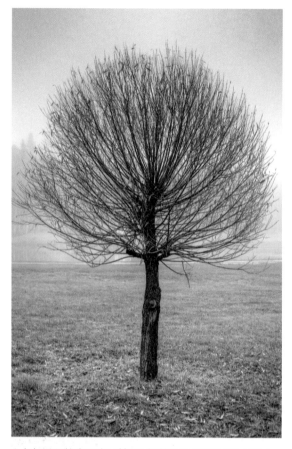

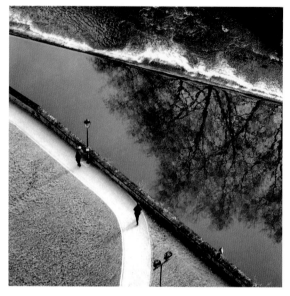

▲ A high viewpoint gives a different perspective to this urban landscape in Luxembourg.

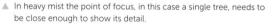

▲ In heavy mist the point of focus, in this case a single tree, needs to be close enough to show its detail.

▶ A low viewpoint of the lifeboat station in Selsey emphasizes the length of the walkway and the pebbles on the beach.

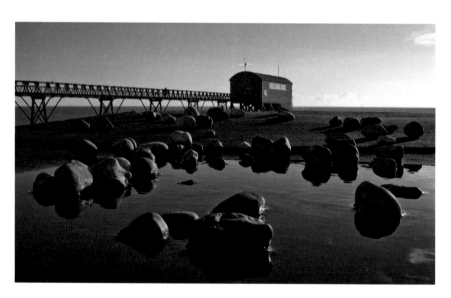

A high viewpoint will show the landscape against the ground, with middle distance and background being separated. In a low viewpoint the foreground dominates or may obscure much of what is behind. It also places the nearer features against the sky and isolates them.

LINES, POINTS OF INTEREST AND FRAMING

Diagonal lines can be an effective way of drawing the eye into the picture and to the subject. They could be the shape of a path, a line of trees, a fence, river or any other feature. Converging lines can also be very effective – pathways, ploughed fields, converging fence lines, power lines or any other lines that run parallel into the distance or that actually converge at some point giving a sense of scale.

Intersecting points of imaginary lines a third of the way into an image are key locations for positioning points of interest. Positioning a landscape on points of interest within a geometric shape can create an interesting composition. One of the most common ways to do this is to use a triangle shape between points of interest in a frame, positioned with one to each side and one centralized.

The rule of thirds, one of the first rules of composition taught to most art and photographic students, is an effective technique in landscape photography. Key points of interest in a landscape are placed on an intersecting point between an imaginary third of an image, which helps give your image balance and a focal point for attention. In a similar way you can also position a horizon along one of the horizontal

▼ The converging lines of the road draw the eye to the distance.

▶ The low viewpoint places the found arrangement of pebbles in a rock in context with the sea beyond, using the rule of thirds as a compositional element.

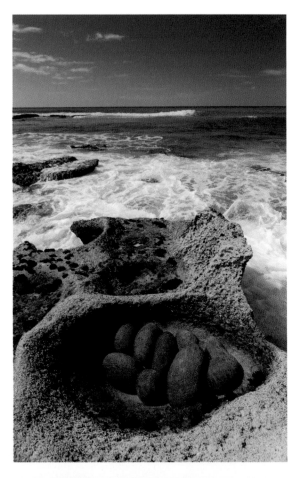

lines. The rule of thirds tends to come naturally with practice. The horizon line should not divide the photograph in two equal parts but should be positioned to emphasize either the sky or ground, showing more sky if the photograph has interesting clouds, sunrise/set, and more ground if it has an interesting foreground area.

As you learn how to use the rule of thirds, with practice you will learn to break it, which can result in some interesting pictures. Small, high-contrast elements have as much impact as larger, duller elements. Framing an object of interest in a scene with an even number of surrounding objects becomes more comforting to the eye. Try adding a frame to the foreground; that is, an overhanging branch will provide interest and lead your eye through to the landscape, and give images a sense of depth. Include some foreground interest such as rocks or water to balance out the scene and draw the viewer into the shot.

Providing a frame can not only draw the eye into a picture but also keep it there longer. Sometimes what you cannot see draws you to it as much as what you can see. The best-composed photographs are often the simplest. Images that contain clutter distract from the main elements within the picture and will make it difficult to identify the exact subject. If there

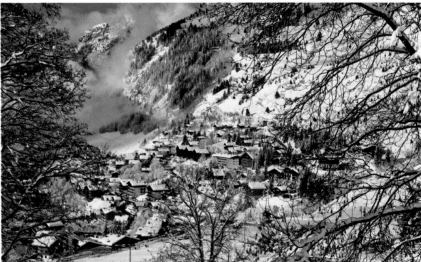

▲ The distant alpine view is framed by the trees, forcing the viewer to look into the shot.

are unwanted items in the way, such as power poles, cars, roads or buildings, try a different angle to hide them from view. Small things can be cloned out in post-processing but larger items will just distract the viewer. Shooting to a different aspect ratio or format makes a big difference to a landscape. It is usually possible to change the format in the camera before shooting the image. Some photographers use a framing device to frame the shot they want before they even pick up the camera, much like a film director might do. The panoramic format has become far more popular with greater use of wide-screen televisions.

CONTROLLING THE LIGHTING

The hardest thing about landscape photography is that, no matter how much effort you put into planning and preparation, if the lighting is not right then you will not get any good photographs.

The strength, direction and quality of the light on the scene make the differences to the quality of the final photograph. You control them by choosing the season, the time of day and the weather that will give the type of lighting you want. The effect of the lighting at any particular time will depend on whether you are looking at the scene from the north, south, east or west.

The lighting you use dictates the feel of the final scene you are shooting, while at other times it offers you a variety of compositional choices. Side-lighting, where the sun is coming from either the left or right of camera, is considered the most desirable for landscapes. This contrast between light and shadow adds depth to the photograph. However front- and backlighting, where you shoot directly away from or into the sun can also produce interesting photographs.

CREATING ATMOSPHERE

Shooting in rainy conditions can produce dramatic atmosphere and soft romantic scenes. Incredible cloud formations can produce exciting and impressive pictures. Reflections can produce mirrors of coloured blurs making the photography in rain beautiful and unpredictable.

▼ Panoramic shots that include a cloudy sky give the impression of the clouds moving forwards (Hermanus Bay, South Africa).

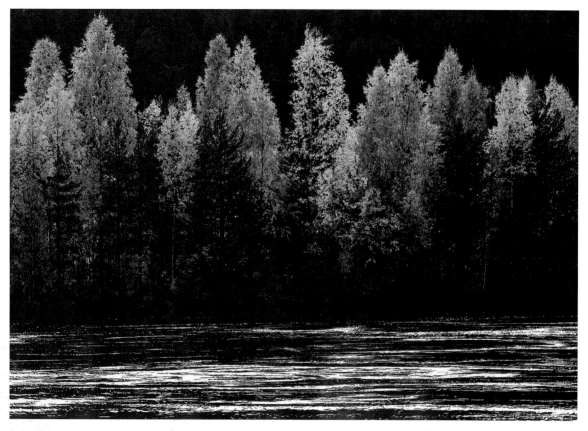

▲ Backlighting is used to enhance the colours in the treetops while rendering the water grey, giving contrast.

Photography in fog, mist or haze can be moody and atmospheric. However, it is also very easy to end up with photos that look washed-out and flat. Fog or mist usually forms in the mid to late evenings, and can last all day. It is also much more likely to form in low-lying areas and near the surface of water that is slightly warmer than the surrounding air. The scenes are not clear and defined, and are usually deprived of colour and contrast, and are dimly lit requiring longer exposure times.

Fog or mist often causes underexposure much like snow, or a beach scene, so requires additional exposure to create the right effect. Try having at least some of your subject close to the camera so a layer of your image will contain colour and contrast.

Water droplets in the fog or mist make light scatter, creating a soft light, as well as light streaks visible from a directional light source like the sun, such as a forest in early morning light, with the sun's rays streaking down from the trees. The key to making these rays stand out is your viewpoint. You need to be close to where you can see the light source. If you have a darker background the better it will appear.

COMPOSITION, NOT CROPPING

You should always do as much composition in the camera as possible, rather than afterwards. You are throwing away quality if you do your cropping in post-production. When you come to edit your photos in post-production, try experimenting with different types of cropping to alter the impact they might have if shot differently. Do this for practice. But don't rely on this technique to produce interesting pictures after you have taken them.

▲ Early morning mist softens this shot of seagulls on a field (Petersfield, Hampshire).

Fog can emphasize the subject shape because it disguises its texture and contrast. Often, the subject can even be reduced to nothing more than a simple silhouette. If you photograph fog or mist from a distance rather than within it, you capture its unique atmospheric effects without its contrast-reducing disadvantages. A short exposure does a much better job of freezing the fog's movement.

Shooting lightning you will need a long shutter speed, or set the camera on the B setting. Point your camera towards the sky where the action is. You will need some sort of foreground interest to balance your composition to create a good photograph.

Cloudy days can make your landscape photography more interesting. It is easier to get successful photographs in densely wooded areas on cloudy days. In sunny conditions, the sunlight will be patchy and make lighting very tricky. HDR photography is really useful on cloudy days, capturing a greater range of tones. Cloudy day pictures can become interesting as far more colour is captured and revealed. A picture of a rainbow will have more vibrant colours if shot through a circular polarizer.

COPING WITH
THE WEATHER

Some of the best shots are taken during unfavourable weather conditions. Weather can be unpredictable, but most twenty-four hour forecasts are reasonably accurate and can offer an idea of what you will be faced with during the day, so you have an idea of the clothes and equipment you will need. You can also get hourly forecasts, which in remote areas and extreme conditions can be indispensable. If you are photographing in coastal regions, tide tables are a must.

You face four elements when it comes to extreme weather conditions – water, cold, heat, and wind. Dress correctly, and keep your equipment clean and dry. You often have to react fast in extreme weather, and you will not want to expose yourself and your equipment to the conditions for too long.

Water

Moisture is one of the biggest enemies of your equipment. If you go out to shoot in wet conditions consider covering the camera and lens. You can buy, quite cheaply, clear waterproof bags to put your camera and lens in. Or if you intend to do a lot of work in watery conditions, a rain cover is a camera cover that keeps the camera dry while allowing you to access all the camera controls. A cheap quick alternative could be a clear plastic bag with a hole cut in it and secured with a rubber band or use cling film around the body and lens. A lens hood, and UV filter will also offer some protection.

If you are photographing lightning beware of water droplets condensing out of the air onto your camera and lens. You are at more risk than the average person – avoid water, high ground, open spaces, all metal objects including using a tripod and avoid unsafe places underneath canopies, small picnic or rain shelters, or near trees. Lightning, particularly if you are in an open space, is best shot from a car as it has rubber tyres.

▲ A weatherproof housing and an underwater housing.

Cold

Shooting in cold temperatures causes serious problems if the camera and lenses are brought into a warm environment. Condensation on lenses and cameras is a big problem but can be managed by allowing the equipment to warm slowly. Keep camera batteries inside your coat next to your body. Once the battery gets low on power swap it for another and let the low one recover in your coat.

If you are using a DSLR camera for shooting video or in live view you will find the battery and camera body gets very warm. For dusting snow off lenses and bodies, and for removing exterior dust and debris, I use a small one-inch-wide high-quality paintbrush. When working with tripods in cold or very hot weather check the condition of the legs and leg locks to see if they need lubrication – some do, some do not. I use a wooden tripod, which is warmer to the touch in cold weather and cooler in hot.

Heat

In hot dusty conditions a moist towel over your camera and lenses keeps dust off the equipment. Dust and debris on the digital sensor is a serious issue and one that should best be left to a professional camera repairer. Try to keep one lens on one camera body and not change it. Have another body with a different lens on. Only changing lenses in a clean area will cut down on getting a dirty sensor.

Wind

Shooting in very windy conditions on or near the beach or in any other sandy or dusty areas, you should consider taping up all seals on your camera to avoid sand or dust finding its way inside. Weigh down your tripod if you need to.

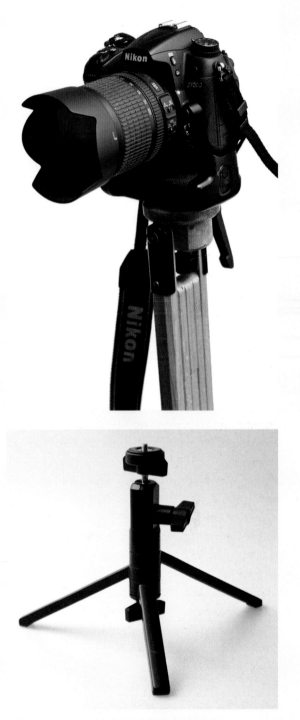

▲ A wooden monopod and a small folding low tripod.

SYMMETRY
AND REPETITION

Filling your frame with a repetitive pattern can give the impression of size and large numbers. The key to this is to attempt to zoom in close enough to the pattern so that it fills the frame and portrays the repetition. Almost any repeated appearance of objects can work. Repetition can be used to capture the interruption of the flow of a pattern, using broken patterns appearing naturally around you, and on other occasions you might need to manipulate the situation a little and interrupt a pattern with your framing. Pay particular attention to where your frame breaks the pattern.

FOREGROUND INTEREST

It is easy to concentrate on the view and sky when you are shooting landscapes, and easy to forget the foreground – the most important features of successful landscape. Any good landscape photograph has three layers: a foreground, middle ground and a background, which together create a feeling of depth.

The foreground adds the depth, interest and structure and entices the viewer to look into the picture. Rocks, foliage and man-made structures – indeed almost any object – add interest to the foreground. If there is a strong element in the background it helps to balance the composition and also provides a sense of scale and distance.

Using the right viewpoint is the key to success. A lower viewpoint will make anything near the camera look larger, or the foreground can be framed with something to create a lead in to a line of something. Leading lines might be objects, patterns or shapes that create flow from the bottom edge of the image up into the focus of the picture.

▲ The symmetry of this beach scene is interrupted only by the shadow.

A wide-angle lens allows you to get close to the foreground subject while still including plenty of the scene beyond. You then have a choice as to whether to keep the whole scene in focus with a large depth of field or use a narrow depth of field. If you have a very interesting foreground you will generally want a higher horizon. Putting the horizon on the top third line accentuates the foreground. If you have a featureless sky, maybe cut it out altogether and concentrate on the features within the landscape, such as a meandering stream or a line of trees in the distance.

When you have a strong subject, like the setting sun, a strong foreground can help balance the composition. Once you have decided on your subject and point of focus, find something that you can use to create foreground interest. Having found both, you can then recompose your shot to include both subjects, but also make sure to try different perspectives. The perfect foreground interest is one

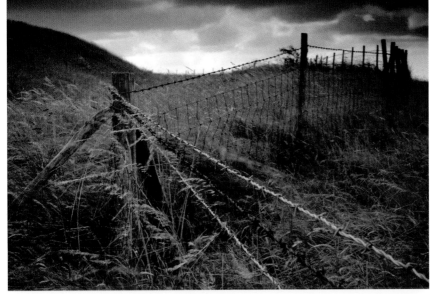

◄ The Z-shape of the fence allows the viewer to travel through the scene from front to back.

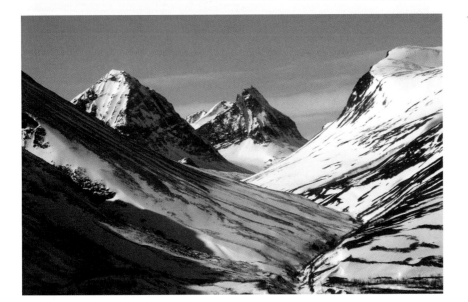

◄ When photographing mountains, using a horizontal format softens the peaks.

that complements the overall composition rather than overpowering it.

Use a narrow depth of field to focus on either the foreground or your subject. This creates interest in the sharper areas and defines where you want your viewer to focus. The focal length of the lens you choose will affect relative distances in your scene. Focal length also affects the foreground interest and how much interest you want in the foreground in

the overall composition.

The upright format is more powerful because the eye has further to travel from bottom to top of a picture. Tension and excitement are added by emphasizing vertical lines and height, or even capturing rivers and roads snaking away into the distance. The horizontal format is much more restful to look at, so is often preferred by landscape photographers and artists.

STRONG COLOUR

Colour is one of the most effective methods of grabbing attention and conveying mood in an image. If the viewer's eyes wander, a bold colour will bring the attention back to the picture. One of the most important elements of composition is its colour depth and saturation.

Intense colours attract attention. This is the reason there are so many sunsets and blue skies in landscape photography. Using bold colours or a mix of contrasting colours will attract the viewer's attention. Colour contrast also works better with fewer and larger colour elements. A contrasting darker background can emphasize the main subject colour. A photograph that has lots of different colours present will be less dynamic than one that has few colours and larger differences between complementary colours.

Certain colours set the mood for an image. Different colours create moods. Blue tends to bring feelings of calm or cold. We naturally have blue in deep calm seas, lakes, rivers and streams reflected from a blue cloudless sky. Ice also has a blue tint. We associate green with spring and new growth; green meadows, plants, and fields convey the mood of a flourishing scene.

Yellow, orange, and red are associated with feelings of warmth and comfort. Early morning and evening provide coloured light, which can be used to good effect. Before sunrise and after sunset, everything is lit in a soft blue light, which can be used to create a calming mood. After sunrise, and before sunset, the light is often very warm with red, orange, or yellow hues. This light can be used to create feelings of comfort.

If you have a landscape with an area of bright colour then consider making it your point of interest, and compose the shot so that the element of colour is well placed.

The colours in the raw files are pale compared to the original scene; even processed JPEGs do not often do justice to the subject, and it is not how you remember the original scene. Boosting the colour present can turn an uninteresting image into one that stands out. In post-production you can increase the colour intensity, hue and saturation, and control the colour balance of different elements of the picture.

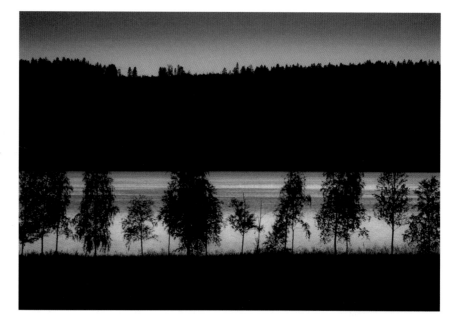

▶ The strong colours are the key element in this graphic night shot of the sun setting over a lake.

▲ An urban interior.

PANORAMIC PHOTOGRAPHY

Panoramic photography can be carried out using specialized equipment, compact phones and DSLR cameras or software, but whatever you use the result is the same: it can capture images with a longer field of view than normal. Panoramic images differ from wide-angle images by their aspect ratio. The simplest form of panoramic image can be obtained by cropping a wide-angle image into a wide aspect ratio (like the APS film cameras).

Multi-shot panoramas are comprised of two or more images shot along a single horizontal or vertical axis and then stitched together with software. This technique – shooting multiple images of a single scene and combining them to form a single image – encompasses far more than the human eye's natural field of view. It is the most popular

form of panoramic photography, as it can be carried out with any digital camera and easily processed. Problems occur however with scenes that contain movement or with changing light in the areas where frames will be stitched.

It is important to know where your panorama will begin and end, so set up and check the start and finish positions so you know where to set focus and set the exposure. I suggest an average exposure setting. Once done, set on manual, so it does not move. Frames should overlap by at least 30 per cent on each side in order to blend correctly. Smaller objects and bright objects create spectacular reflections, which can distort during stitching, so use a single frame to record the area if possible.

I always use the equivalent of a standard lens in order to minimize optical effects, and I shoot on a tripod with a good panoramic head with marked degrees so I know where I am. Use mirror lock or the self-timer on your camera to prevent camera

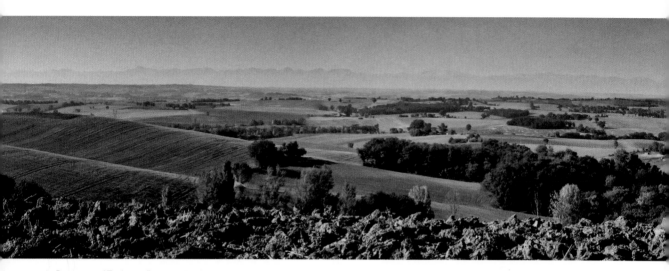

▲ Panorama of Toulouse, France, taken from a high viewpoint.

shake and movement during exposure. Do not use a circular polarizer, because it will cause you problems in your sky area.

Vertical images capture more of the sky and ground and yield higher-resolution panoramas compared to horizontal ones, so it is well worth considering shooting this way. The best pictures for panoramic images are overlooks, that is, standing on the top of a mountain or hill, or looking down from an elevated area with no near objects. If you are shooting a scene that is far away from you, the panorama should stitch perfectly. Avoid shooting panoramas with trees, bushes and other objects in the foreground.

Wind can move tree leaves, grass, water and sand in different directions, which will spoil your panorama. Only shoot in windy conditions when the wind strongly moves everything in one direction. Avoid taking pictures of moving water waves. Once you have shot all the pictures, inspect all images on the LCD to check them. The biggest challenge with panoramic photography is stitching problems due to parallax errors.

CREATING DEPTH

One of the most difficult visual concepts to communicate in a landscape photograph is depth. To make more interesting landscape shots, pick the right subject, one that has something for the eye to focus on, giving it the potential to create depth. A low viewpoint increases the feeling of depth.

To create a feeling of space and distance, there is a series of depth cues or optical tricks to create the illusion of depth. The simplest depth-illusion to exploit is linear perspective by using lines to lead the eye to a distant spot. There are usually lots of cues in landscapes, such as roads, railway tracks, tree lines and fences, and you can use them in combination to strengthen the illusion. These lines work best when they start wider and nearer and then go to the horizon ending up at a single point (the vanishing point).

Aerial perspective is formed when a haze, mist or fog is present on distance objects in a landscape such as mountains or hills. As they get more distant the ones at greater distance look lighter and we interpret this tone change as distance.

Use longer lenses to compress the lightening layers of a subject and exaggerate the feeling of depth.

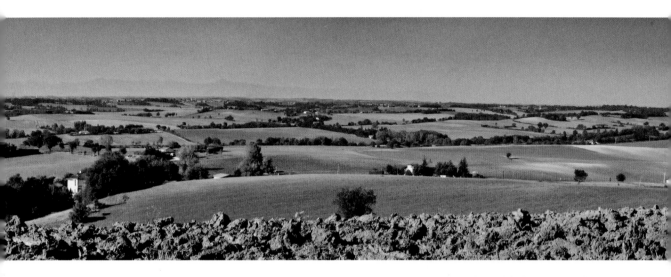

Wide-angle lenses can create depth using a strong foreground.

Think of a scene in three sections: foreground, middle ground and background. Emphasizing the foreground will create an entry-point for the eye, so have a point of interest in the foreground that acts as a framing device to draw the eye. The background should be simple – the sky can create an interesting background – or if you cannot create a good background, blur it out.

MOOD

Good landscape photography relies upon mood, atmosphere and light. Photographs of the same scene taken at different times of the day, under different lighting conditions, will look completely different and will produce totally different emotional responses.

Anticipation, awareness, persistence and luck are all qualities for the landscape photographer. The more you go out in unsettled and changeable conditions, the longer you wait and the more you practise, the more you make your own luck. One viewpoint can provide infinite possibilities,

▲ The wild flowers in this overcast landscape add the colour necessary to prevent the day's shooting from turning into a disappointment.

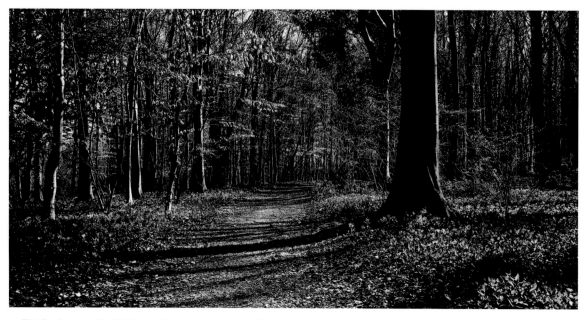

▲ Woodland can create a slightly haunting look when rendered black and white.

▶ A combination of the land mass silhouetted by the setting sun should create a calming effect, but when the sky is black and a cloud bursts the mood becomes more foreboding.

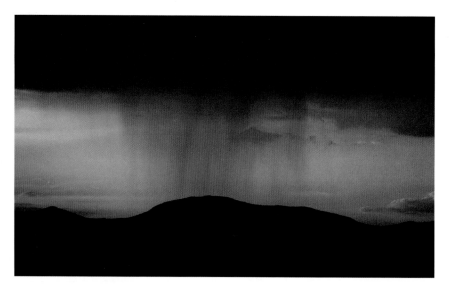

depending on the weather, time of day, and season. You should be able to anticipate the appearance of a scene at different times, and work out your preferred one.

When dark clouds dominate the sky, objects may be caught by a shaft of sunlight, seeming to almost leap out of the scene against this backdrop, contrasting the two different types of light. These moments

rarely last for long and the window of opportunity closes very quickly. Where cloud cover is complete, choosing shots of the landscapes in woodland where the sky could be excluded and the softer light used with a dynamic foreground and strong shapes or details, will offer surprising results. You can establish a desolate mood with these sorts of conditions.

Where you have clear blue, cloudless skies, they can lack any drama or mood. However they can make a good backdrop against which bold shapes or colours of objects can be used.

Photographs taken against the light are most often associated with sunset and sunrise but this technique can be used at other times of day. The sun becomes stronger and brighter as it rises, and flare becomes more difficult to control or avoid. When the sun is within the field of view you cannot shield it, but you can use an object from within the composition to shield it or partly obscure it. If you are using a UV filter remove it before shooting as these often cause flare, particularly if dirty. At sunrise, as the sun rapidly warms the Earth and its atmosphere, causing moisture to condense as mist, the mood is of excitement and anticipation.

A hazy sunset is caused by the build-up of pollution throughout the day. This often results in richer, stronger and more vibrant colours. Its mood is replete and content, rather than the paler pastel tones that are often found at dawn. Both times of day can evoke a feeling of calm, but sunset also has an atmosphere of tranquillity.

Of course winter introduces shorter days, so even the midday sun is relatively low in the sky, and the time for early or late photography does not apply.

DEVELOPING AS A PHOTOGRAPHER

You can benefit from a more focused approach to your landscape photography by determining what are the major themes in your existing photographs. Then maybe by expanding and looking at the subjects in closer detail you will find that some are more promising than others. Consider what matters to you, and the themes that you are most interested in and passionate about.

Take your photographs with the idea of creating something, such as a portfolio, a book, a digital slide show, or an exhibition. Being more selective with your good editing elevates you to being a better photographer, giving a sense of achievement and ability, and is a positive experience. By removing weaker images, the best ones define a stronger portfolio, and the photographer instantly becomes a better photographer. Remember that weaker images shown with strong ones weaken the overall impression of your work. It may be tempting to include a weaker shot because of an emotional attachment to it, for example where it was shot or the circumstances surrounding it, but only you know that. All the viewer will see is a weak picture.

There are an infinite number of subjects, and ways to interpret them, and we all interpret things in a unique way, according to our experiences. You could pick a theme of landscapes that relate to water, and possible images could include waterfalls, rivers and lakes. Our emotional response can change in different seasons in a particular area.

Think about the graphic elements within your main theme: unusual patterns, colours, textures, lines, contrasts, and shapes. Remember, it is the light that adds the air of drama to any landscape. Dramatic lighting creates the mood and the impact.

Once you have explored a theme in depth, you will want to find other themes. Creativity comes with the experience of image making, editing and the photographer's unique style and unique perspective on a subject.

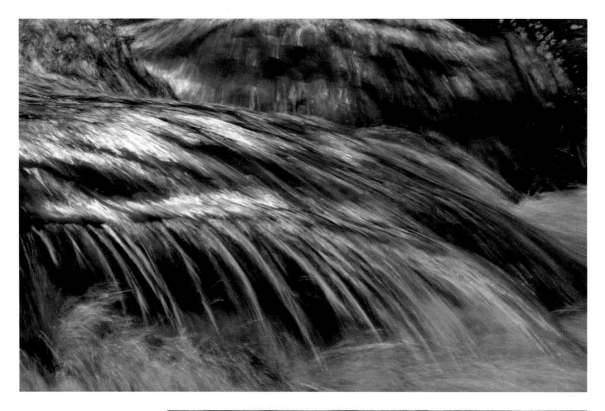

▲▶ Concentrating on a theme, in this case moving water, enables you to explore a range of techniques and lighting conditions.

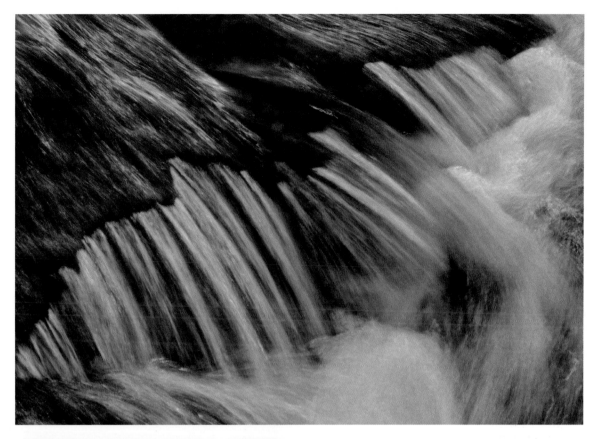

CHECKLIST

▷ Match the right location and the right viewpoint.
▷ Think about the composition and the light.
▷ Begin to use the rule of thirds.
▷ Consider the possibilities in extreme/poor weather conditions.
▷ Look for patterns and symmetry.
▷ Consider the effect of strong colours and complementary colours.
▷ Practise creating varieties of space, depth, light, mood and atmosphere.
▷ Focus on a theme and explore its possibilities.

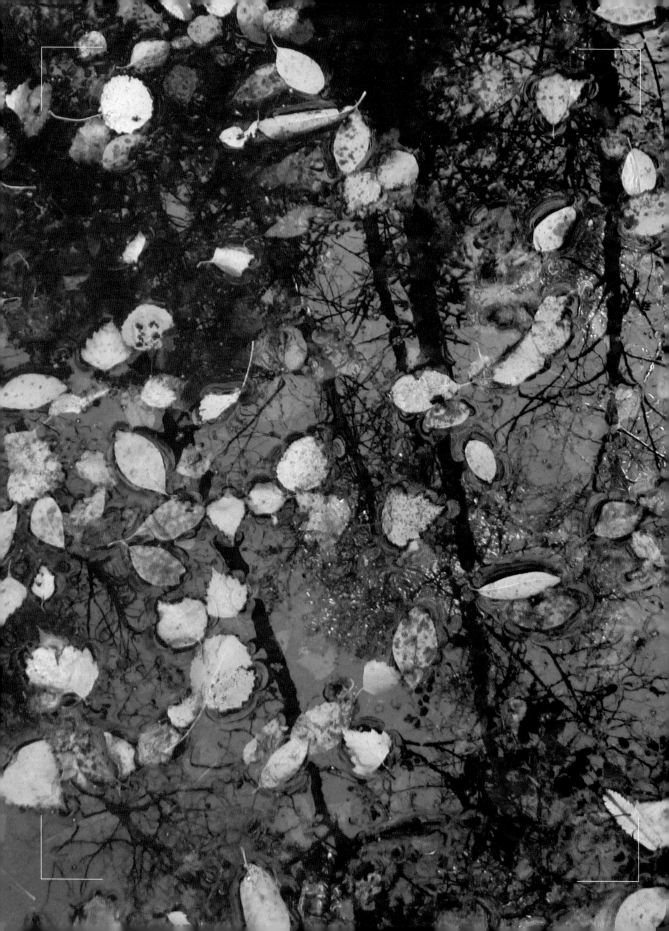

Composition

So, once you have made the decision on what elements you want to photograph, you then need to decide how to arrange the composition in the frame.

ON THE LEVEL

In landscape photography it is essential always to maintain a level horizon. A photograph in which a long, straight horizon line slants in one direction makes it appear as if everything is going to slide right out of the image. In order to prevent this, as well as preventing a tilting horizon line or shoreline, use a tripod.

A tripod not only helps keep your camera steady in any position but also allows you to compose your picture more precisely. Some tripods come equipped with a spirit level. Some DSLR cameras also accept interchangeable viewfinders with a grid that comes with etched lines (both horizontal and vertical) that assist with lining up horizons and aid composition. Others are equipped with a grid and a virtual horizon. Or you can add a bubble level that slips onto the camera's flash shoe.

Sometimes the horizon may not look right even if the camera appears perfectly level. It happens most often with slightly sloping ridgelines, or lakes that include opposite shorelines. In these cases just slope the camera so that the horizon looks correct.

A deliberate slant can also result in a visually striking diagonal image, so go for either a level horizon or a deliberate slant.

Obviously a sloping horizon can be fixed in post-processing software, but it is better to get it right in camera.

▲ A hot shoe-mounted bubble level.

▲ An electronic level.

◀ Autumn leaves and reflected trees in water.

THE RULE OF THIRDS AND THE GOLDEN RATIO

In the rule of thirds, imagine breaking the image down into thirds both horizontally and vertically so that you have nine areas. This grid enables you to identify important parts of the image that you should consider placing at the four points of interest or the intersecting lines. It also gives you four lines that are also useful positions for elements in your image. The theory is that by placing points of interest in the intersections or along the lines the image becomes balanced and a viewer of the image can read it naturally. When viewing images, your eyes usually go to one of the intersection points naturally rather than the centre of the shot.

A good technique for landscape shots is to position the horizon along one of the horizontal lines. Consider what are the points of interest in your shot, and where should they be placed. However, also remember that breaking the rules can also result in some great shots. Try experimenting with some of your old images to see what happens if you crop in different ways, and then apply what you discover when you are taking new photos.

The Golden Triangle and Golden Spiral

A slightly more sophisticated compositional concept is the golden ratio or mean. The golden triangle is used for implementing the golden ratio diagonally, where the plane is divided into two equal halves diagonally and a perpendicular line is drawn from the opposite corners. The points where the lines intersect form the power points. The golden spiral, on the other hand, replicates the golden mean exemplified by the curves of the nautilus shell (exhibiting logarithmic spiral growth).

The golden ratio itself does not make a great photograph; it aids to the composition by creating a level of interest. It does take time getting used to composing in the golden ratio since the viewfinder is not very helpful in framing such a composition.

▼ Diagram of the rule of thirds.

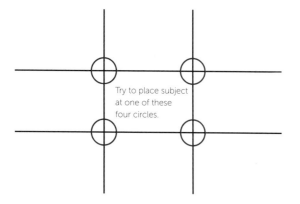

▼ An electronic grid.

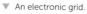
Try to place subject at one of these four circles.

FOREGROUND
INTEREST

The foreground, middle ground and a background layer of an image together create a feeling of depth on a 2D medium. Foreground interest is a good way to take an ordinary image and make it more stunning. Landscapes with foreground interest are generally more visually intriguing as they create a layered photograph that provides a focal point and then allows you to expand into other parts of the image. This concept works especially well when you have a good subject; a strong foreground can help balance out the composition. Foreground interest is much more than just putting your subject front and centre. It is a focal point that complements your subject and adds interest.

Once you have found your focal point, look at your surrounding area and find something that you can use to create foreground interest. This could be a tree, rock formations, or interesting ground. Having found both your focal point and an interesting foreground, you can then recompose your shot to include both subjects exploring different perspectives. The best images have foreground interest that complements the overall composition or subject.

The selection of lens and aperture can control the focus on either the foreground or the subject, defining where you want your audience to focus in the image. Moving into the main subject can also help as much as getting in close to the foreground details. Try getting the detail at the edge of the frame to draw the viewer's eye to the main subject. Try using the foreground interest on different sides of the image. It does not have to be at the bottom. It could be an overhanging branch at the top of the image.

▼ Diagram of the golden triangle.

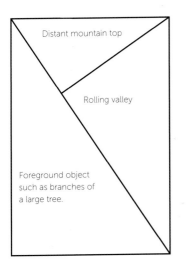

Distant mountain top

Rolling valley

Foreground object
such as branches of
a large tree.

▼ Diagram of the golden spiral.

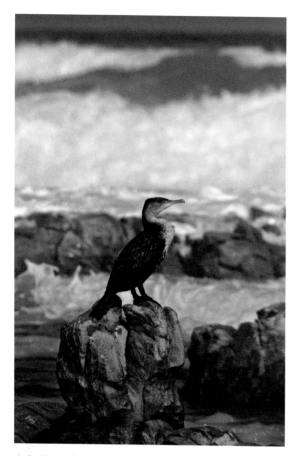

▲ Seabird on rock, from a high viewpoint (Struisbaii, South Africa).

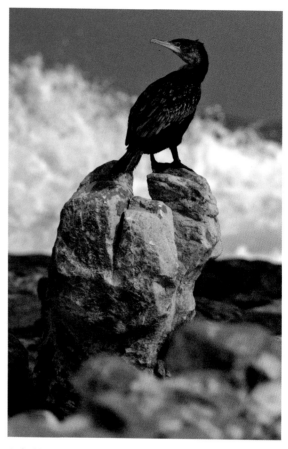

▲ Seabird on rock, from a low viewpoint (Struisbaii, South Africa).

Try using part of a wall or a rock at the side of the image. Check the foreground for distracting elements, but also check that you are not missing something from your foreground that could add something to your shot. Good foregrounds do not just happen; you generally have to search for them.

To accentuate the foreground, lower the height that you are shooting from and you will find that the perspective of your shot changes. Positioning the horizon changes the influence that the foreground has on the image. It is better to place the horizon on one of the thirds lines. If you place it on the bottom third line you will emphasize the sky. However, putting the horizon on the top third line will accentuate the foreground. Either can work depending on what is in the sky or the foreground.

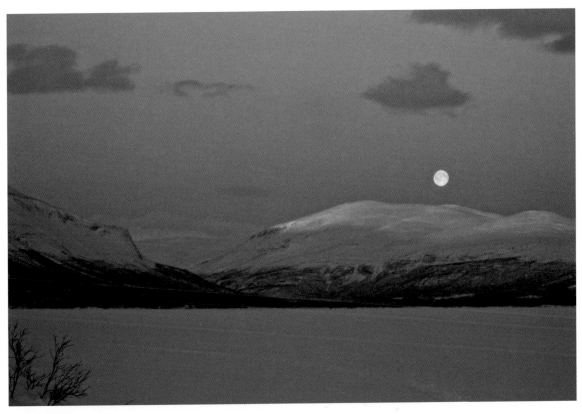

▲ Low horizon with moonlit mountains and moon, using a wide shot.

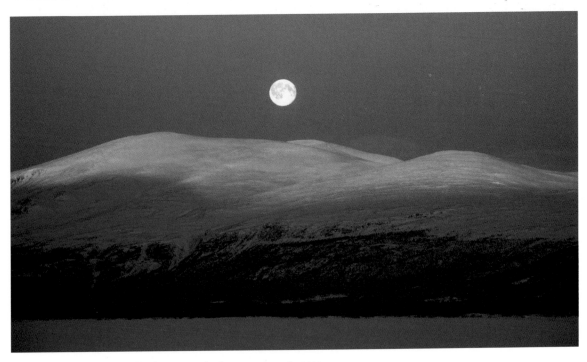

▲ Using a longer lens and centring the moon makes for a more dramatic scene.

LINES AND PATTERNS

Lines Leading into an Image

Leading lines are lines that will draw the viewer's eyes into the image. They are usually vertical lines, sometimes with a diagonal direction. They may be actual lines or objects, patterns or shapes that create a virtual line from an edge up into the main part of the frame. You may need a small aperture like ƒ16 in order to have a large depth of field to emphasize this line.

The dominant line of the picture also affects its general mood. Vertical lines convey strength and

▶ The S-shape lines of the sheeps' backs are reinforced by the S-shape of the vertical posts.

massiveness. Horizontal lines generally convey calm. Diagonal lines tend to be dynamic. Lines that occur naturally in the environment, such as roads, railings, railway lines, streams, shorelines should be placed so that the lines run at an angle diagonally through the image. This gives your image a sense of direction, and the viewer is directed where you want them to go – towards the focal point.

Leading lines will draw you from the front to the back of an image, and are most effective when they lead you from an object in the foreground, to a middle ground, and end up at the background subject, but only if your background subject is interesting enough.

Diagonal lines help create tension in an image, and if they attract your attention, they will do the same for the viewer. Try using strong diagonal lines of deep shadows or rays of light. Repetition of lines and shapes creates a sense of rhythm. Triangles are very strong shapes composed of diagonal lines.

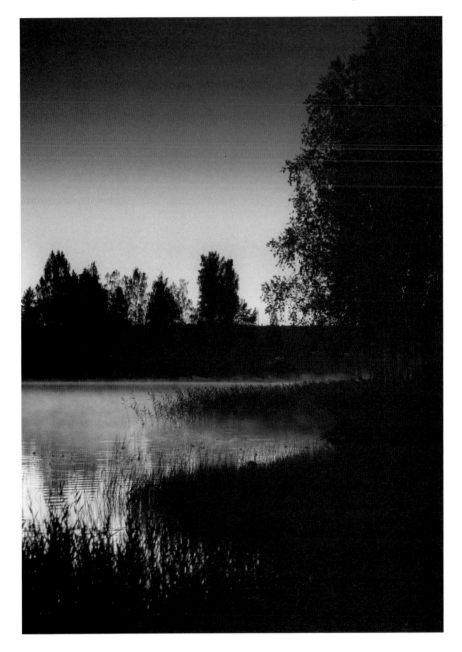

◀ The riverbank forms its own S-shape.

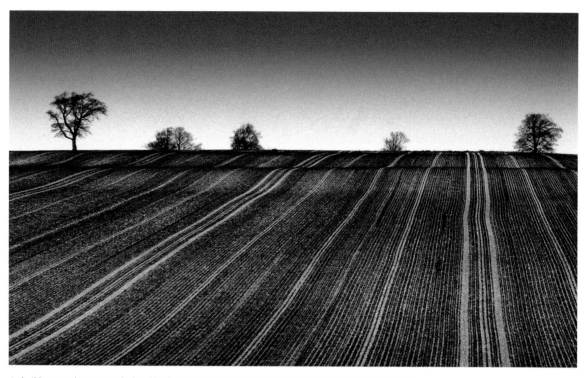

▲ In this monochromatc agricultural landscape, the strong converging lines lead to the trees on the horizon.

The S-Curve/Lead-in Lines

Curved lines can convey a sense of movement into an image. S-curves move your eye around an image. A gentle curve, such as a path, or a river, leads the eye into an image, but does not, however, need to be an exact S-shape. Positioning lines or objects diagonally towards the main point of interest in the scene will draw your viewer into the picture.

This technique works with wide-angle and telephoto lenses, but the effects are very different. Viewed from a distance through a telephoto or long zoom lens, the elements of a landscape will be compressed so the lead-in line needs to be bigger and more prominent for the effect to work. If a riverbank, stream, fence, rocks and roads are shot using a wide-angle lens you will find yourself much closer to the object you are using as a lead-in line, and the foreground will appear much larger in the frame. This lets you use smaller objects as a lead-in. Skilfully applied, the S-curve/lead-in line technique works really well.

Point of Focus

When you set your point of focus in your image do not focus on infinity, the horizon or the clouds, but set it on the foreground subject or something one third into the frame. Generally if you focus too far into your image you will end up with the distance sharp but anything closer to you out of focus.

If your focus is in the lower third you increase the depth of field in the foreground, and as depth of field extends further behind a focal point than in front of it, the distant objects will be reasonably sharp. You can increase this depth of field by stopping down the aperture (making it smaller) or using tilt and shift lenses, or camera movements with the necessary equipment. Of course smaller apertures mean less light so you will need to compensate using your exposure, by increasing either your ISO or the shutter speed. Wide-angle lenses will always provide greater depth of field for landscapes.

To obtain maximum depth of field, you need to use hyperfocal distance. Hyperfocal distance is a point where a lens is focused at a given distance, so that everything from half that distance all the way to infinity will be in focus. This maximizes the depth of field that can be achieved with any lens. Hyperfocal focusing is based on the fact that depth of field extends about two-thirds behind the point focused on and one third in front. If you focus on infinity, you are limiting the depth of field to behind you and not using the additional third in front.

You can extend your depth of field by refocusing and pulling back from the infinity mark, and in some cameras you have a depth of field preview button which will give you a good indication of your depth of field for any given aperture and point of focus. This is if you are focusing in manual mode. Autofocus may shift the point of focus to one that is in the wrong area. If you can control the point of focus by locking the position in auto, that is fine. If not, you need to use manual focus. At the opposite end of the scale you may want limited depth of field and limited hyperfocal distance.

DIGITAL FOCUS LIMITED

Digital cameras have difficulty in getting nice out-of-focus backgrounds because generally they use imaging chips that are smaller than 35mm film size, and in some cases, about the size of a small fingernail. A normal lens for a format that small is as short as 15mm, and at an aperture of $f5.6$ it has a depth of field of about 1 metre to infinity. So not much opportunity for selective focus.

High-end DSLRs like the Nikon and Canon have chips close to the size of a 35mm frame, and therefore offer enough DOF to allow creative control over out-of-focus backgrounds. You can help by choosing to work with lenses with large maximum backgrounds.

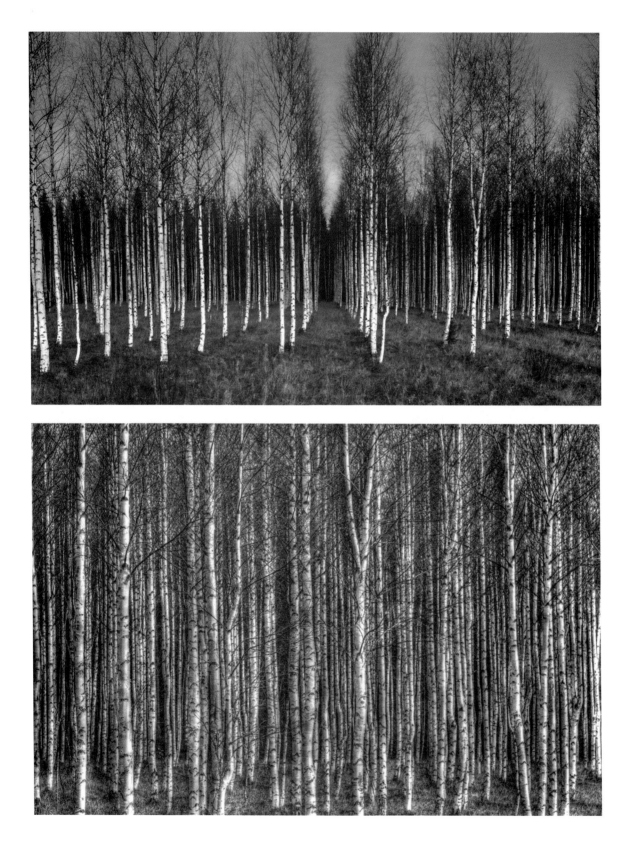

Frames

Closely related to the S-curve, frames such as an overhanging bough, or an archway or doorway, can be used to frame the principal subject. Frames can be overdone, but sometimes if you don't use one, you may find that your picture just peters out towards the edges.

Whatever you do, don't put your point of interest smack bang in the middle of your photo. Once you have chosen your point of interest then move around and decide what angle looks best for your photo. Many people want to get lazy and use the zoom. It is always better to walk than use the zoom.

By framing the scene, all the attention is concentrated on the main part of the picture. Rock formations, archways or trees with overhanging branches make great natural frames. It is best to be bold when using such frames for your landscapes. A few leaves or branches hanging at the top of the frame can look messy and unnatural, so try to include the whole tree to link the elements in the scene and join the trunk to the ground.

The shape of the primary subject often dictates whether a scene is best shot as a vertical or a horizontal image. Tall, thin subjects such as trees lend themselves to vertical compositions. I often try to shoot a scene both as a vertical and a horizontal, so that I can later choose which one I like best. Sometimes I like both. Horizontal compositions are frequently used for creating panoramic shots. However, a common problem with this type of shot is that it can leave too much bare sky or negative space in your composition. Nevertheless, you can create a feeling of three dimensions by using frames to outline your main subject. I may use an overhanging tree branch and reeds to frame the main subject. This not only creates a sense of depth, but it also avoids filling too much of the scene with negative space.

◄ The horizontal framing of the trees and the use of different focal lengths reinforces the dense planting of the cultivated silver birch.

ELIMINATION OF DISTRACTIONS

One of the biggest challenges in landscape photography is that it is more important to decide what to exclude from a composition than it is to decide what to include. Always be on the look-out for distracting items. Is there litter in the photo? Are there wires, damaged plants or the remains of old buildings or industrial activity that will not enhance the image? Think about what you can do to eliminate those distractions.

Eliminating distractions leads to an increased emphasis on your main subject and improves your shot. Hot spots and other distractions detract from your main subject and can quickly ruin an image. In agricultural shots those distracting white hay bags immediately catch your eye, and have become the bane of every photographer wanting to photograph the countryside. Always watch out for UFOs, or Unidentified Fringe Objects. Most cameras do not have a 100 per cent viewfinder, making it easier for these things to creep in.

▼ The complementary colours of red and green are illustrated in this shot of lichen on rose granite.

One of the most common distractions encountered by landscape photographers is a dull sky. An overcast day has great light for photographing the colours of autumn foliage, but be sure to avoid including light-grey sky in the image. It always records as dull and uninteresting. The easiest way to solve this problem is to compose the scene to completely crop the sky out of the image.

However dark grey clouds on stormy days do photograph well, and can help create very moody images. In macro photography make sure that your backgrounds are not distracting. The easiest way to accomplish this is throw your background out of focus by using selective focus. Telephoto lenses are particularly effective at accomplishing this.

AERIAL PERSPECTIVE

The effect that the atmosphere has on the appearance of an object when viewed from a distance is known as aerial perspective. As the distance between an object and a viewer increases, the contrast decreases and details become less distinct; colour becomes less saturated and shifts towards the background colour. Some of the greatest painters have used this to dramatic effect, creating an illusion of depth by depicting distant objects as paler and less detailed. It is often used in landscape photography to show distance.

Different times of the day will create different effects. Early mornings from sunrise, and late evenings, are some of the best times to capture this effect. Mists over low-lying areas and water also provide evocative subjects for this effect.

An object such as a tree against different layers of distant hills fading into the horizon is also most effective, especially with limited or mono tones. Distant objects have less contrast in them and in their surroundings. Creating contrast in the image will give you the strongest spatial illusion.

Colours also change with depth. All of the colours are clearer and brighter on near objects, with warm colours more pronounced. When the objects get farther away the colours become duller and eventually turn grey.

Focus also gives depth clues, with close objects generally sharper than distant objects. However there are times when for compositional reasons it is better to soften the focus of close objects in an image to draw the viewer's attention to something farther back. As with focus, the detail of objects closer to the viewer is much more apparent.

Linear perspective makes distant details too small to see, but it is low contrast that tends to flatten distant objects. As the trees in a landscape get farther away they blend into the landscape and eventually become flat, almost like cut-outs, as do hills, especially on a hazy day or when viewed looking into the sun.

Telephoto or longer zoom lenses compress the layers of a subject and further exaggerate the feeling of space, helping to create depth. If the subject is higher in the frame, it also appears to us to be farther away. If you direct the lens down to include more foreground space in the frame this will emphasize the foreground, creating the impression that it is a very long distance to the horizon, giving even greater depth to the image.

SILHOUETTES

Nothing does a better job to define the shape or form of an object than to put it in silhouette. An object is silhouetted when it is much darker than its lighter background. One example where the narrow contrast range can work for you rather than against you is in sunrise shots in a mountainous landscape. The contrast range between the sky and mountain is so great that a proper exposure of the sky will always render the mountain black.

If there are trees in the distance, your eye gravitates to the shape of the tree in silhouette, even though there is no detail. Combined with the strong form of a mountain in the background, and the dramatic colour in the sky, adding a tree to the shot helps create a much stronger image.

Obey the rule of thirds here, placing the centre of interest one-third of the way from the edge of the frame. Even though you are trying to show the shape of a mountain, your primary subject is really the colour in the sky. By placing the horizon near the bottom, you allow the sky to take up about two-thirds of the image, emphasizing its colours.

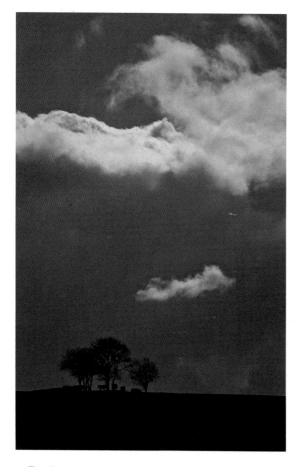

▲ The silhouetted landscape below the white clouds is balanced by the trees on the left of the horizon and the stray cloud, which links the landscape to the sky.

GRAPHIC COMPOSITION

Graphic elements such as shapes, lines and colours appear more powerful when they are repeated and become patterns; in a composition they can provide strong visual impact to an image. Patterns can be found in nature, from the petals of flowers to rows of tall trees, as well as in man-made structures such as buildings and bridges. Filling an image frame with patterns will make your composition more graphic and visually interesting. You can create patterns that can extend beyond the edges of the image frame and give an impression that they are endless. The more times the elements are repeated, the stronger the pattern becomes, to the point where it becomes an optical illusion.

Patterns in compositions also can evoke an emotional response from the viewer. Patterns of water on a beach can be soothing to look at, whilst an image of a red mark on a stark white background can be disturbing. Repetitive elements can evoke the sense of consistency and predictability, whilst a break in a pattern will surprise the viewer, and be effective in adding to the visual impact, and it can become the focal point in the image.

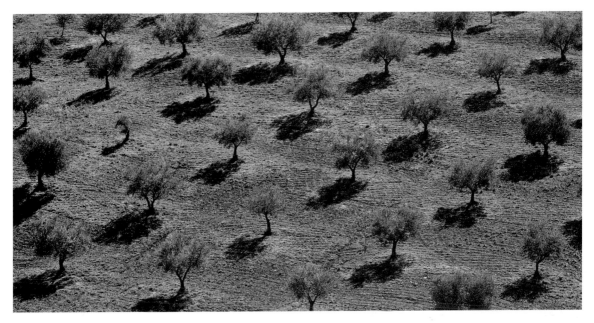

▲ The repetitive pattern of this Portuguese orchard is made more dramatic and graphic by the shadows of the trees and by being shot in black and white.

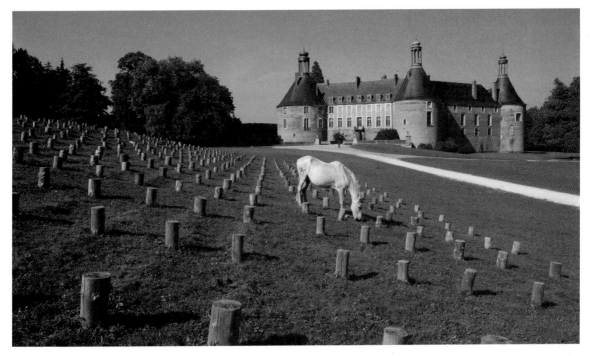

▲ On its own the pattern of the sapling stakes would have been less interesting, but the sudden appearance of the white horse gave this chateau in St Fargeau, France a mediaeval quality.

A graphic composition that has an absence of colour and contains one coloured element can become visually interesting. Shapes, lines and forms are more obvious and can provide strong graphic imagery. A black and white image with good tonal contrast and a distinct pattern will keep viewers interested. Natural patterns can transform ordinary objects and mundane scenes into excellent graphic images.

FOREGROUND COLOUR

To make something stand out try using complementary colours, such as blue and yellow. The contrast of yellow reflections against blue grey rocks will catch the viewer's eye, and emphasize the shapes of the rocks. Red and green are also complementary colours that work the same way.

Harmonious colours such as blue and green occur frequently in nature and often work well together. The similar colour tones draw your attention to the shapes, forms and texture in an image. Dominant colours such as deep red immediately capture your attention, and can sometimes make an image work, on simply colour alone. Blue is a cool tone and projects images of cold and winter. Pastel colours are soothing in nature. The light-toned pinks and blues of a sunrise are very pleasing to the eye.

▼ The brilliant red of the cannas in the foreground contrasts with the blue-grey of the mountains and the white clouds.

SENSE OF SCALE

A key compositional technique in landscape photography is the use of scale. Objects of known size give us clues as to the scale and depth of a scene. Without any reference point, huge sweeping landscapes can end up looking small and insignificant.

Finding something in the scene that the viewer can relate to, such as placing someone or something in the foreground, will add foreground interest and provide a visual reference. Objects such as buildings, boats or wildlife lend a sense of scale. An empty landscape may be considered sterile, and may only come to life if it contains a reference to the human condition. Most landscape photographers, however, go to great lengths to avoid showing the impact of humans on the landscape, preferring to use plants, trees, stones and rocks for a natural sense of scale.

How we arrange objects within the frame, such as the foreground and background, can help determine the scale. The choice of lens can help; if you use a telephoto lens to photograph a range of mountains, they will look taller, but use a wide-angle lens for the same shot, and the mountains will shrink in size. When large and small elements are used together they give us a sense of scale.

◀ Marker buoys.

REFLECTIONS
OF THE LANDSCAPE

Showing reflections of the landscape in a lake or some form of water is a favourite in landscape photography and landscape painting. You can shoot mirror-smooth reflections, which require calm conditions with no wind, or you can use the wind to create impressionistic reflections or abstracts. Abstract images can, however, get the viewer confused, so try to include the shoreline or a reference in the image.

The position of the horizon line is very important in composing reflection images. Central horizons can be boring, particularly if the scene is symmetrical. However, it can be effective if the shapes of the subject and its reflection are interesting enough. The reflected scene is always much brighter than the reflection, so a graduated neutral density filter can help to even out the general exposure.

Streams, waterfalls and ponds are good for reflections of plants, particularly reflections of autumn foliage, which make a strong use of warm colours. Where trees are in direct sunlight and the reflection is in the shade interesting reflections can occur. The late afternoon light is usually good for reflected images, and the sun is low enough to create warm colours on the trees, even if the water is in shadow. Rocks or stones can be used to lead into the image, framing around the reflections in the water. Waterfalls can create some interesting colours in water.

▼ The strong converging lines in this natural lake landscape are balanced by the reeds in the foreground.

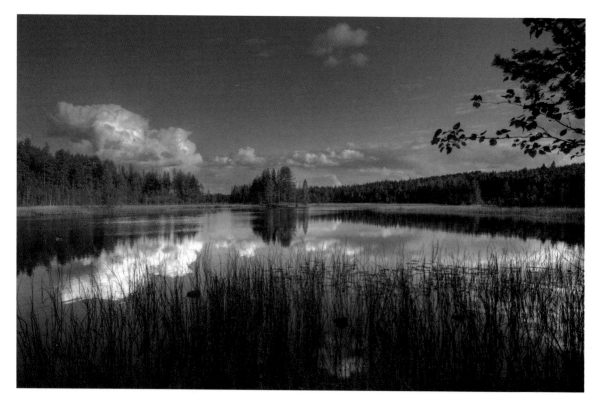

SHOOTING IN MONO

Black and white landscape photography has benefited from minimalism by reducing particular objects to the smallest number of colours, textures, shapes and lines. Black and white images also have the effect of taking away colour and vibrancy as potential distractions, leaving the viewer to focus on the basic parts of the picture.

Training your mind to think in black and white is the first step to understanding minimalism. Monochrome relies heavily on contrasting colours, textures and shadows, making the images look more dramatic and basic. Digital photography naturally sees the world in colour, so it takes practice to see the world in monochrome. Colours take on various grey tones, which are translated to extreme shades of dark to light. It is important to know how to distinguish these tones when shooting the image. An artist's trick is to narrow the eyes, which minimizes the light falling on the retina, thus subduing the colours. Alternatively, changing colour photographs to black and white in post production, and then looking carefully at the tonal range of the greys, will help to train your eyes to distinguish them.

Landscape photography applies the minimalist principle by presenting an entire area such as a mountain range or lake horizon as one large, open space. The emptiness of this space allows the viewer to paint their own personal story, without having to regard the photographer's own interpretation. The encompassing and somewhat infinite nature of the landscape captures a sense of emptiness that gives a dramatic atmosphere.

▼ Shot originally in colour, the image works equally well in monochrome because of the strength of the elements and the linear perspective.

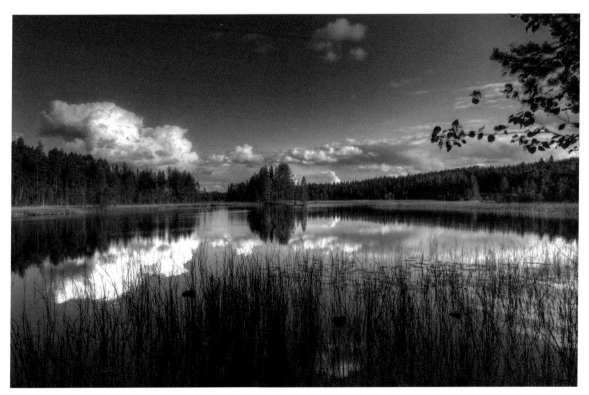

To maximize the vast space provided by a land-scape, it is best to eliminate distracting elements. These unnecessary aspects can be avoided by shooting at sunrise, late at night, or early morning. Working with a landscape's infinite space, minimal-ist photography can also focus on a single subject but still use the rest of nature as its background. The subject can dominate the landscape either from the centre or from the farthest location. Zooming in can intensify the focus by eliminating possible distractions. The opposite action of zooming out brings back a larger sense of space and also removes distractions by decreasing their size.

Applying depth of field is always used for landscapes, and is particularly helpful in achiev-ing minimalism. Maximum depth of field is most effective when shooting long exposures. The subject should contrast with the surroundings, like a black sea under a clear sky or a solid, textured rock against smooth, silky waters. You can also create horizontal contrasts by shooting a clear body of water against weather that appears dark. Cold conditions such as fog, frost and shorter days can provide a good mini-malist setting. Familiarize yourself with the mood the weather brings and how it will appear before and after processing.

Other subjects from minimalist art can be geometric shapes and patterns: outlines from a mountain range, rocks resting within water, or a bridge with an interesting design. Patterns also make suitable subjects, from repetitive slopes of several hills to a row of poles emerging from water. Vast natural spaces provide many possibilities for minimalist landscape photography.

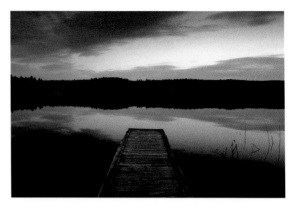

▲ A perfectly calm lake was needed to repeat the shapes above the horizon in the lake, with the pontoon acting as the lead-in.

▲ The graphic result lends itself to the use of a false colour tint in post-production.

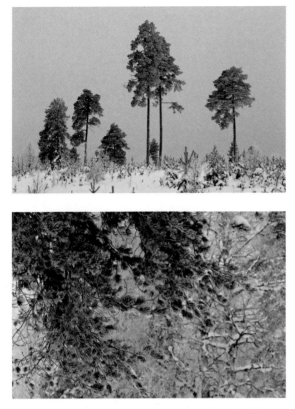

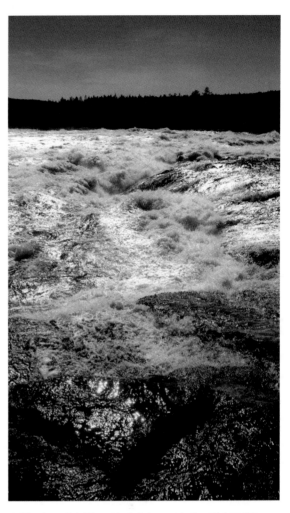

▲ Shot in the extreme cold, trees take on a monochromatic effect.

▲ The elements in this rapids shot decrease in strength from the massive rocks in the foreground to the cloudless sky (Vormsele, Sweden).

CHECKLIST

▷ Always check your horizon.
▷ Learn to apply the rule of thirds.
▷ Look for lines, patterns, curves and frames to lead into the image.
▷ Know where you want your point of focus to be.
▷ Consider alternative perspectives.
▷ Look for opportunities for graphic effects.
▷ Consider including reflections as an element in your photograph.

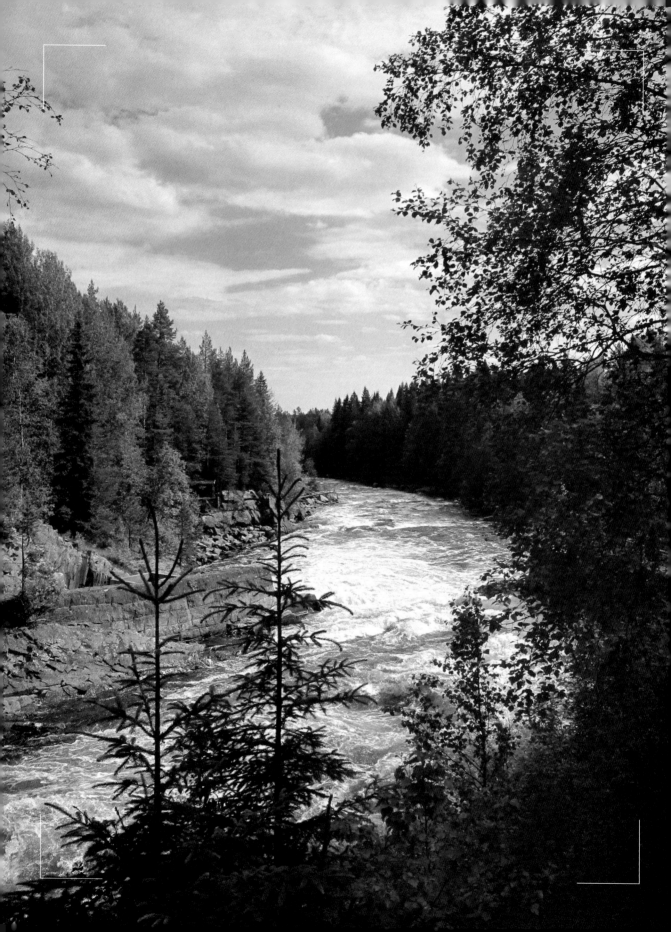

Chapter 6

What Determines a Good Landscape?

Generally, photographers want to focus on the beauty of the natural landscape. So why include extraneous reference points that only detract from the simplicity of the scenery? The answer is that if the idea of the photo is to show just how enormous the landscape is, you have to include something that provides a sense of scale.

In order to create a sense of scale in a landscape, many professionals prefer to shoot landscape and travel images that include people. However most landscape photographers avoid showing the impact of people on the landscape. So the best compromise is to find an object or subject you are going to include to show scale, and this is sometimes the greatest challenge. By including foreground subjects such as rocks or trees or flowers in front of mountains, the photographer can convey depth in the scene. Objects of known size give us clues as to the scale and depth.

A sense of scale in an image can be affected in several ways. One is the selection of objects we arrange within the frame, such as the foreground or background. Another is the choice of lens. Contrasting large and small objects together is another technique to convey scale: without showing a whole larger tree, a massive difference in size is implied. When composing elements within the camera frame, keep them simple so that the difference is clear without being confusing.

ELEMENTS IN A LANDSCAPE

Skies and Clouds

Landscapes almost always have a sky that is full of interest, and that interest comes from clouds. A weather forecast that is mixed sun and cloud is, usually, at the edges of changing weather fronts, which can produce interesting clouds. Likewise clouds are often caused to form at the edges of the day (sunrise and sunset) because of differences in temperatures (cool to warm in morning, and warm to cool in evening).

If you wish to shoot serious landscapes you need to check on weather forecasts and learn about atmospheric changes. Some of the most colourful skies happen at sunrise and sunset. Even on a clear

▼ The aerial haze on the wooded hillside gives this shot a layered effect; the use of the trees along the field margin emphasizes the steepness of the hills (Rogate, West Sussex).

◄ Salmon Ladder, River Byske at Fällfors, Västerbottens lan, Sweden.

▶ Migrating birds against a
stormy skyline at dusk.

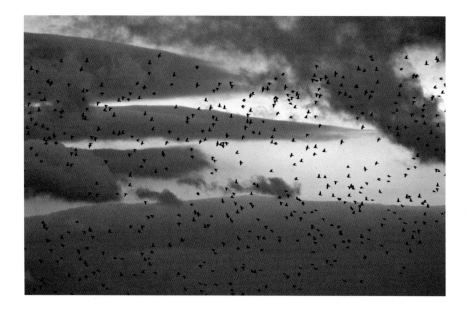

day, the sky can take on an orange glow at dawn and dusk. Given a few clouds the sky will often turn to fire as the sun underlights the clouds. You need to be in position before the light changes, camera ready, and that may mean getting up before the dawn or staying out as the sun sets.

Cloud patterns are compositional elements, and need to have a foreground that is complementary to the patterns in the sky. All sorts of foregrounds will work to complement the sky, from stark ground or agricultural crops to fields of flowers. Try to narrow the contrast range between the bright sky and the darker foreground.

A sunrise or sunset sky will often be two to five stops brighter than the foreground. The thing to do here is correctly expose for the sky, and then for the landscape use neutral density grad filters or different exposures to layer later. Graduated ND filters are designed to hold back exposure in bright areas while allowing more exposure to the foreground. Sometimes you can use fill-flash to brighten your foreground, but often this is not viable because it is impossible to light properly due to the vastness of the foreground. Fill-flash works well when you have a close, isolated object set against the brightly lit sky, slightly underexposing the flash (one to two stops)

so that the object does not look too stark.

Sometimes neither a grad filter nor fill-flash will work to balance exposure between the bright sky and dark landscape. In this case, I expose one image properly for the sky, and one image properly for the foreground and then stitch the two together later in Photoshop. This, of course, requires you to have a digital camera or the ability to scan your negatives or slides and have the knowledge necessary to make a realistic blend. Sometimes your software can give you the desired result.

When the sun is above the horizon, and the landscape and sky are more evenly lit, consider fitting a polarizing filter. A polarizer can bring out even the subtlest sky, and deepen blue skies. They are most effective when the light is at a 90-degree angle to the camera. At sunrise or sunset, a polarizer works best when shooting landscapes side-lit to the sun. At midday, when the sun is directly overhead, the light will generally polarize in all directions except directly up or down. The advantage with polarizers is that you can see exactly what you are going to get. Rotating the filter will directly change the way the sky looks. You can always try different effects and shoot different shots, so that you can decide later on which you prefer to use.

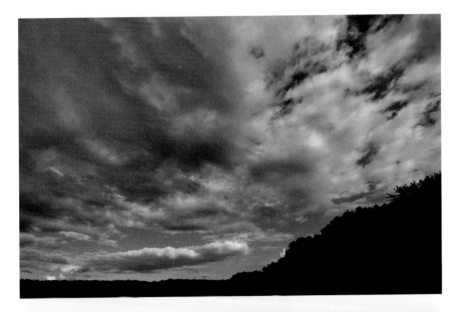

◀ Sky before a storm (white clouds).

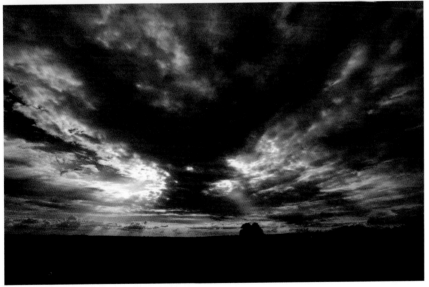

◀ Sky before a storm (grey clouds).

Sometimes it is not enough just to have an interesting sky; it is also critical that the sky and the cloud formation work with the compositional elements of the landscape. The viewer's eye should be able to move between the landscape and the sky, using elements from both to tie the two halves together creating one image. Use the same guidelines of composition – leading lines, S-curves, negative space, the rule of thirds, balance – in your skies. However, because clouds are fluid and dynamic it can be difficult to make a perfect composition before the clouds change. It always seems to me that there are two tactics: either work fast, before the clouds change, or wait for the clouds to move into position. It is up to you which you choose.

Including Buildings and Cities

Early landscape paintings often included imaginary townscapes that were intended to represent actual places. These days the conventional definition of 'landscape' is challenged by urban landscapes, cultural landscapes, industrial landscapes and landscape architecture. Landscape photography can also be used as a medium to raise awareness of conservation concerns.

The landscape continues to be a subject for photographers when contemplating the ways we relate to the places where we live and the impact we have on the land. Buildings and other man-made structures from materials such as concrete or wood are more interesting if they have texture and are lit with lower or side directional light. Cityscapes in silhouette are particularly striking. Photographing your surroundings in a way that puts them in context and says something, good or bad, about the place is, in my opinion, an important part of the landscape genre.

Figures and Animals

People add interest and intrigue to a photograph. The human figure draws the eye and can easily dominate the scene. Even a tiny figure on the horizon is a counterpoint to a towering landscape. In an unfamiliar environment, the eye seeks out familiar objects. The presence of a human, an animal or a man-made structure triggers personal cues inside us.

Depending on the colours and patterns in the photograph, the human figure may not be the principal interest, but eventually the eye recognizes the figure and the mind registers empathy. Since the human figure is instantly recognizable and is relatively constant in size, it becomes a yardstick for assessing distance in landscape images.

A human element can also improve or enhance a composition as long as it is in an appropriate position in the picture. A human figure or activity, such as a fishing boat or a group of people, can provide a dramatic focus. I prefer to simplify as

▲ Devoid of people, this urban landscape shot early morning has its own graphic simplicity.

▲ The yellow Labrador balances against the blue sky; using fill-in flash gives a sense of scale through personal cues.

The figure in this landscape allows the size of the waterfalls to become more apparent.

much as possible, deleting any element that does not make a contribution to the picture, yet adding people to landscape photographs can make the image more publishable. Photojournalism magazines are interested in photographs that set the stage for the action and give readers more information about the subject's life and work. This is where a wide-angle lens works perfectly. It can create a sense of closeness and involvement between subjects and their environments.

Man-made structures, animals or human figures can enhance the centre of interest. The surrounding elements should direct or lead the viewer to that centre of interest by means of visual clues. They should not be placed in the centre or halfway, but preferably in any of the third portions of the picture. Animals and people should always be facing and looking inwards in the picture. Group subjects of importance within the centre of interest; do not scatter them around where they compete for attention.

Selective focus close-up using a wide-angle lens gives more expression to the cow's face.

COMPOSING
THE ELEMENTS

Figures as a Primary Subject

When photographing groups of animals or people, avoid grouping them in even numbers. It is preferable not to position animals sideways, which gives them a flat pasted look; when positioned at three-quarters they will have a more three-dimensional look.

When shooting a landscape where human figures appear, the biggest mistake to make is shooting when the subject is too far away. Every step the person moves away just makes the person much smaller and the lens cannot reproduce them to the size that the viewer imagines the person to be. When the figure is too near the camera, on the other hand, it takes up too much space and the landscape will become diminished.

Consider, when making a landscape picture, having the figure as an accessory to help convey an idea. When your figure appears in the foreground and you have a low horizon the figure will be distorted and appear huge. If there are a number of figures in the landscape scattered through the picture, the viewer's eye will be distracted and causing uneasiness. Figures should be grouped to convey the idea of the landscape, and should be arranged according to tonal hue or shades of light or dark, in order to create a harmonious composition.

From the point of view of composition, the foreground should receive the greatest amount of attention. With the majority of unsuccessful landscapes the problem is due to poorly arranged objects, figures, plants and animal life. A second and very common difficulty which leads to valueless foregrounds is the use of a too wide-angle lens.

When including elements whose nature is usually in movement, if possible indicate their movement but without putting them into compromising positions that would make them look like they are posing. Avoid duplicating forms, lines, movement, and size, as this will make the elements compete and conflict with each other.

▼ Bicycles at the beach indicate the presence of people without using anyone as a dominant element in the picture.

▲◀ Access to an endangered species, in this case the African or Jackass penguin, can be used as an opportunity to tell a story (Betty's Bay, near Cape Town, South Africa).

What Determines a Good Landscape? [**113**]

If you are including silhouettes of people, shoot them as a profile, as you will be able to see more features than you would if they were face on. Do not have too many objects too close together either, as they will all merge into one indistinct shape. Avoid figures that 'kiss' the edges of any other elements of the picture.

Simplification and Abstraction

There should not be that much difference in the mass on any of the four sides of the picture, either right, left, top, or bottom; otherwise this will make it feel like it is leaning and out of balance. Keep the corners subdued with little texture and the values dark.

▶ The S-shape of the track allows the viewer to take a slow leisurely walk.

▶ The contrast of colours and the position of the rowing boat give this image its graphic quality.

Never divide your picture into equal parts – this will make it look too deliberate and artificial. Do not show geometrical forms such as squares, rectangles, triangles, ovals or circles together; even when these appear in nature, break up the form with an overlapping tree branch. Elements such as rivers, streams and roads should enter the picture with the S-movement or a curve. Straight lines should be avoided, as the velocity is too fast; allow the viewer to take a slow visual walk.

Soft edges in the background will enhance the illusion of distance. Leave hard edges for the foreground or within the centre of interest. Do not abruptly end an element when it runs into another but try to overlap them. If you have round summer trees avoid using a sky with round clouds in it. Sharp peaks of mountains or pine trees will look nicer when surrounded by round clouds. Never lean your objects outwards, always have them leaning inwards, and do not line them parallel to the frame.

Most people prefer photographs with predominant warm colours rather than cool ones. One hue and temperature should predominate in your picture, with the strongest colour reserved for the centre of interest, while a touch of its complementary colour will make the surrounding colour stand out more. Try not to repeat in the foreground the same colour that appears in the background. Warm colours will look good against cool colours and also complement them. Cool colours recede perspective and warm colours bring things closer; you can use this to create depth. Touches of colour that are out of the general colour scheme of your photograph will strongly draw the viewer's attention to that area. If your photograph is predominantly green, a bluish-green sky is better than a blue one.

Silhouettes at Dusk

Silhouettes make impressive landscape shots at dusk. Look for subjects to photograph that have simple, strong, graphic shapes, like trees against the sky. When shooting silhouettes, ensure that subjects do not overlap or merge into another or you will end up with odd-looking black shapes in your images. It is best to focus on one main subject and keep its outline distinct. For the best results, take a standard meter reading of the scene. Alternatively take a spot reading from the brightest part of the sky and then bracket your exposures.

▶ The potential blur caused by movement is eliminated in this silhouette of a stag walking across a hilltop.

▲ Silhouettes of people on a beach need to be carefully positioned in the frame, and they need to have interesting shapes to make the shot work.

Silhouettes are particularly associated with beach sunsets, but they can be created by placing your subject in front of any source of light. The camera then is set to expose for the background, leaving the subject underexposed so that a silhouette is created. Plain but bright backgrounds such as a cloudless sunset sky work the best but remember, you will not have any textures or tones to make the subject stand out so they will need to be interesting or have distinctive shapes.

Nearly all digital cameras can automatically meter, but this will not always give you the silhouette you are looking for. You can trick the camera by half pressing the shutter button while focused on the brightest part of your scene before moving back to reframe the shot. Some cameras have a silhouette mode which means you do not have to worry about camera settings and can focus on getting the framing right.

KNOWING THE SEASONS

Early spring and late autumn are perfect times for shooting. You enjoy good lighting and can photograph during the whole day. Visibility is better than in summer, as there is no haze. Changeable weather at this time also creates good conditions for shooting.

Spring

In spring everything about the natural environment is changing at a pace, from the blossoming flowers and trees to the weather itself, so take advantage of the extended magic hours after dawn and before dusk. If you want to shoot spring flowers, you should shoot on a cloudy day and avoid bright sun, which creates a harsh light. This also works for forest and abstracts. In such conditions the light is soft and shades are not too sharp, thus contrast is not very high, which allows you to capture a wide range of colour and details.

Summer

Summer weather conditions can vary greatly from country to country, but generally days grow long and the weather gets warmer. However summer lighting can be too harsh; the sky is often cloudless when the sun rises and sets. The sun is often too intense. If there are clouds, they can serve as a diffuser. Moreover, at sunset, clouds may acquire different colours.

In summer the sun quickly rises, and that is why only a few hours after sunrise the lighting can be too intense, while heat haze may make the sky look white rather than blue. For summer shooting, you need to get up and arrive early in the morning and also take advantage of the evening lighting. Summer morning landscapes can often have washed-out colours. When the sun is at midday, lighting becomes harsh and shadows are too short and dark. A polarizing filter is very effective and useful on a cloudless summer day, even when the sun is at its highest. However, at this time you can successfully take photos of architecture, patterns, graphic details and other objects that benefit from harsh light. Full sun is perfect for the beach scenes, brightly lit with dark shadows, and a great opportunity for HDR work or dramatic, high-contrast compositions.

Autumn

Autumn is traditionally known as the most beautiful season of the year. The foliage is spectacular, and open rolling countryside gives better views. In landscapes that show broad panoramas of hillsides and valleys, you can see expanses of brilliant colour that would normally be hidden by dense forests. Wooded

▼ Frost on fallen leaves.

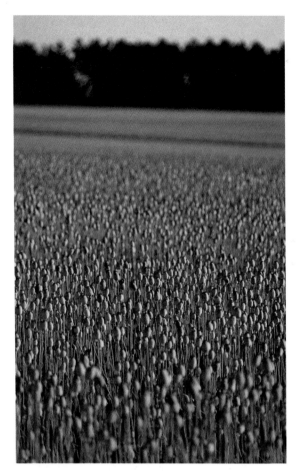

▲ Selective focus in this shot of agricultural poppies allows for deliberate blurring of the foreground and distance.

Winter

Winter photography requires an outstanding imagination, good luck (we all know that winter scenery is not very diverse) and of course some technical knowledge. The major difficulty relating to winter photography is connected with exposure. If you manage to set the correct exposure, you are sure to get good images. The problem is that a sunny winter landscape has such intense light that neither a film nor a sensor of a digital camera are able to express its intensity.

As a rule, an auto mode of a camera does not show good results in such conditions. When shooting in an auto mode, you may lose some details either on a bright or dark part of an image. In other words, you risk getting a dark silhouette of a subject on a bright background. You would be better using a centre-spot metering in combination with auto exposure (AE) lock. Just set a centre-spot metering (as a rule you can do it through the menu), then focus on your subject so that it is in the centre of a frame and half press a shutter button. The camera will automatically set a correct exposure for an object, without taking into account the brightness of the whole image, and will fix this exposure. Now you can move the camera and change composition, without releasing a shutter button. The exposure will not change and you will be able to take a nice winter image and achieve technically good photos.

Winter scenery is not as colourful as summer, though on a sunny day you can take a magnificent photo of snowy landscapes which will render an atmosphere of a crispy winter day. For this you just have to learn how to use to your advantage a contrast of sparkling white snow and deep shadows.

paths that thread through the area are a highlight of the autumn landscapes. On the ground there is a rich diversity of patterns, colours and textures in fallen leaves.

Brightly coloured leaves look beautiful in water and on grey stones. In the early morning you may be able to shoot fog or mist hanging over water with the sun creating an intense light effect. Set a slow shutter speed to create a silky water effect. Lakes reflect the foliage colours of the mixed trees, hedgerows and forests and give autumn landscapes their continuing appeal. Farm fields often contrast with the trees that line their edges. The countryside becomes a perfect setting for photographing landscapes.

▲ Close detail of ice in water as an abstract.

Winter is also the season that responds best to black and white, giving you another set of options in the field and the digital darkroom. The lush, seductive colours have faded, and the photographer can concentrate on the basics of composition – light, mass and form. The old barn or snow-blasted shoreline is just right for you to test your composition skills and abstract compositions of light and dark.

CHECKLIST

▷ Learn how to create a sense of scale.
▷ Understand the reason for different elements in your image.
▷ Consider elements that will convey meaning.
▷ Look for elements that will balance the image.
▷ Understand the seasons where you will be taking photographs.

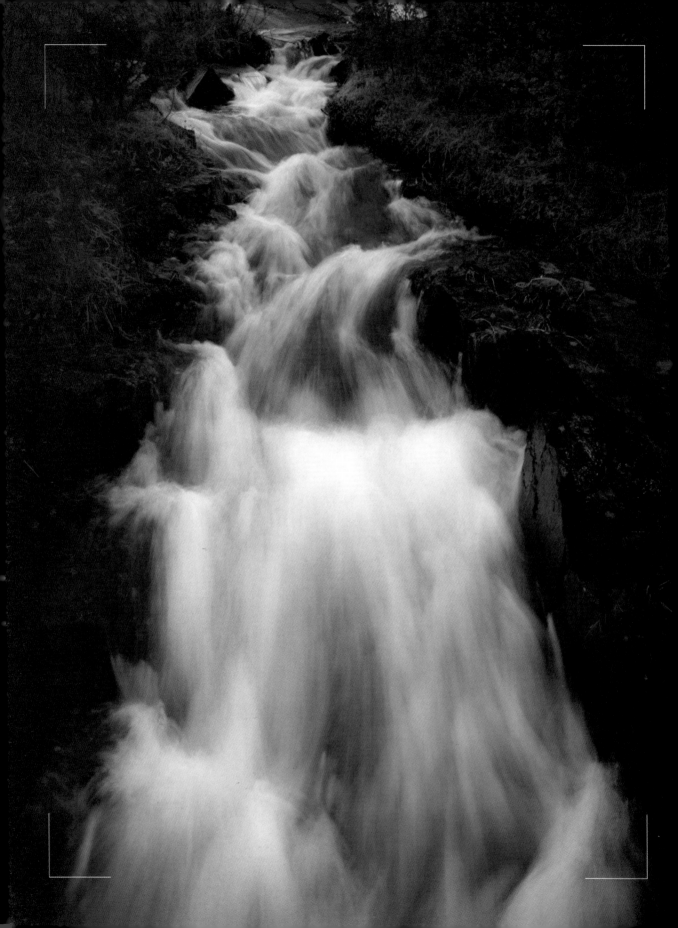

Chapter 7

Using Time and Motion

Lighting is everything. It defines space, place, time of day and general mood. Light can be used creatively for dramatic impact, to add extra depth, and to the general composition of the image. At different times of the year in the UK, the sun will set at different points. It is not just a case of the sun rising in the east and setting in the west. In the summer, the sun rises to the southeast and sets to the northwest. In the winter it rises in the southeast and sets in the southwest. An Ordnance Survey map of an area where you intend to do photography is extremely useful for working out your position in relation to the sun at any given time, but local knowledge of the area is also very useful.

There are certain times of the day that are fixed by human conditions, seasons and quality of light. Most street cleaning happens overnight and in the early morning. Trains and buses only run at certain times, so they can fix a particular landscape image to a particular time of the day. Photographs around dawn are less likely to have lots of people in them. An image of a city can look really lonely if there are few or even no people in it. The same city shot can change dramatically if taken during the rush hour or at a midday weekend when lots of shoppers are on the streets. So we can create the mood we are looking for in an urban landscape just by the time we shoot, and the profile of the people at a given time of day or night.

▼ Stockholm Central Station.

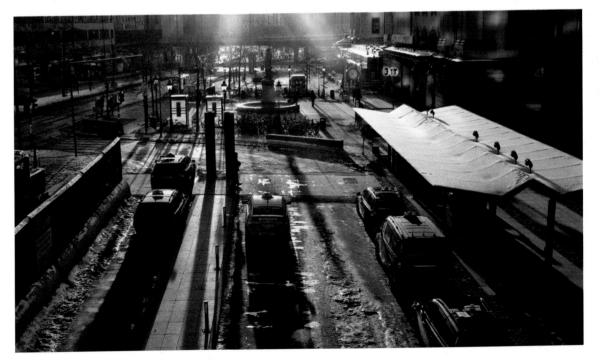

◀ Waterfall in motion.

Good urban landscape photography can be some of the most creative, but these photographs are usually a result of careful planning. It is best to research how a particular location can change depending upon the time of day and as a result of changes in the angles of light. Visiting the potential locations at different times of the day and in different lighting conditions will focus your plans as to the mood you want to create. Some of the best shots in an urban landscape can be taken during early morning, late afternoon or on overcast days. My preference is winter light and long shadows.

GET YOUR TIMING RIGHT

Long Exposures

Using long exposures in urban landscapes and time-lapse photography can capture a series of movements instead of just a frozen moment in time. Time-lapse photography will tell a story, while long exposures can be used to capture the effect of time on an image.

Moving objects such as clouds and water can create almost abstract and ghostly effects like transparent silhouettes and eerie streets devoid of people even during the busiest times of the day.

A good way to capture time in an image is to combine both a short and a long exposure in one shot or use multiple exposures, or combine two different exposures of the same subject, or by using a combination of flash and long exposure. A short exposure captures an instant of time, something that happens in a fraction of a second.

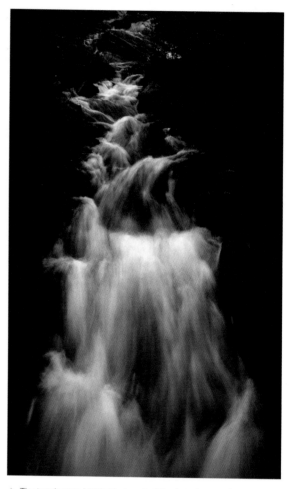

▲ The tonal range in this black and white shot of a waterfall is emphasized by the long exposure on the moving water.

Coastal landscapes containing wave action are good areas to try this technique. You can capture the instant that waves splash rocks and at the same time smooth the water to create a moody atmosphere. With software such as Photoshop you can load the long and short exposures as layers, and using a mask brush in and out the parts that you like from each image. Time-lapse and long-exposure photography can capture a series of movements.

Long-exposure images of urban or industrial scenes seem to manage to make subjects such as industrial power plants and chemical works really interesting, particularly if shot at dusk or at night.

▲ Detail in an urban landscape.

LONG EXPOSURE HINTS

Long exposures can be used to remove unwanted details from an image that might distract the viewer. They can also be used to 'paint' light onto the subject to emphasize it or create lit areas of the scene.

Painting with Light

Mixing existing light with 'painting with light' involves moving with electronic flash and using it on open flash or using high-powered battery torches. A tripod or a camera placed on a steady flat object like a wall or the ground is essential due to the long exposure times involved. A remote shutter release, self-timer or at least a lens cap is needed to reduce the risk of camera shake when the shutter is released. Manual focus is also essential, as the auto-focus will not operate under very poor lighting conditions. Some cameras have 'live view' which enables accurate manual focusing. A stopwatch, remote timer or watch will be required to time the exposures. The camera's own exposure time will be limited, depending upon the camera system used, but usually down to only a few minutes.

The technique of painting with light is, in industrial photography, combined with using coloured gels on the flash unit to provide different colours in order to illuminate the subjects, and adding multiple flash exposures to create the effect required. This technique requires skill, experience and imagination since you will not see how the effect will turn out until the exposure is complete. Using this technique you can illuminate specific parts of the subject in different colours and create your own shadow areas. This technique requires a good firm tripod and the shutter set on B (Bulb). The image will be created using your chosen subject and illuminating it by moving a light or any small lights in various patterns.

Experimenting with this technique will produce interesting creative and artistic results. Again skill and experience are required to get the best results plus possibly several attempts to produce the desired result. Some of the most suitable locations will have some ambient light. Finding subjects that are less hit by that light and using the light painting method, whilst using the ambient light to capture the background, it is possible to create a surreal foreground against a normal background. You can also use a difference in the white balance between the ambient and painted light areas for a creative effect. Exposure balance is key to a successful image. An over lit subject can look as if it has been shot in a studio.

CAPTURING MOVEMENT

Movement in landscape photography can create drama, mood, and a point of interest. Waves hitting a beach, waterfalls, moving clouds, wind in the trees, and flying birds enable you to capture movement within the landscape. It is usually better to shoot movement early or late in the day when there is less light. Keeping your camera completely still using a tripod and planning or anticipating the movement, as well as framing your shot so that your main subject is well positioned is the key. Selection of a slow shutter speed will enhance the movement.

Apart from their intrinsic beauty, trees are useful in landscape composition. The foreground use of branches will often mask a bald sky, and will also assist in preserving the impression of space by throwing back a distant hill outline, a valley seen from a ridge, or other open landscape. The movement of swaying tree branches, ocean waves, water flowing over a waterfall or in a stream and moving clouds can all be captured using a longer shutter speed. Experimentation is needed on the day to establish the best long exposure. Sometimes you may find speeds of less than 1/15 sec will give the desired effect, whilst the same time on the same subject may need nearer a minute. Ultimately, it depends of the effect you wish to achieve.

Wind also causes the various elements that make up a landscape to move, and gauging the appropriate amount and direction of the wind can add life to the landscape. Capturing a degree of motion and the resulting blur is one creative way of making use of wind which is otherwise a problem for landscape photographers.

When shooting a scene with movement, it is always a good idea to include some element in the foreground that does not move, such as rocks or a tree trunk, to emphasize the effect.

▲ Movement in lakeside reeds.

PANNING

If looking for a more abstract way to portray the subject and the feeling of the scene, you could consider using intentional camera movement, where the camera is rotated or moved in a horizontal, diagonal or vertical direction while photographing a static object. Using a panning technique is a good way of producing abstract landscapes. You can pan using a tripod, monopod or handheld depending on the effect you are looking for.

Try selecting a slightly slower shutter speed than you normally would, that is, 1/30 sec and then try even slower ones. At the slower end you will probably end up with camera shake on top of your motion blur, so you will need to judge which is the slowest speed you can work with. Consider the elements in your composition, as you would do with any other landscape photograph, even though they will be blurred. The same rules of composition apply. Once the shutter is open, move as gently as possible to reduce camera shake and continue to pan even after you have heard the shutter close. This will ensure the motion blur is smooth from start to finish in your shot and minimizes camera shake.

You will need to practise panning in order to get the best results. Try panning through the trees, or using your flash whilst panning. If your main subject is close you will probably need to decrease the strength of your flash by a half or a third. The right combination of shutter speed, aperture setting, and

▼ Using a panning technique to give the boat huts an impressionistic effect.

ISO setting, along with the actual camera movement will produce the desired blur and an artistic abstraction of the scenery. A long enough shutter speed is the key ingredient for intentional camera movement and allows the camera to paint the photographic object in abstract form.

Again, low light is the secret of success in using this technique, but successful results can also be achieved in good lighting – by using a polarizing or neutral density filter and low ISO setting in combination with a small aperture setting. The use of a polarizing filter will increase colour saturation, boost blue sky, add cloud contrast, control reflections, and add neutral density to lengthen exposure times for blurred, impressionistic images. Shutter speeds of around 1/30 sec and lower 1/2 sec can

produce interesting pictures. Side lighting works well, because it defines one side of the subject more than the other, adding more interest to the overall composition.

Trees make good subjects with panning in a vertical direction in line with the tree trunk. Flowers, landscapes, seascapes, and buildings are best panned sideways following the horizon. You could also rotate the camera to shoot tree canopies in the autumn and spring.

The smoothness of the final image is an important factor and that is achieved by continuous movement very much like panning with a moving figure. You always need to continue panning beyond the shutter's closure. Try moving the camera before you release the camera shutter, and keep panning beyond the closure of the shutter. A self timer may help, but you certainly need to practise to get it smooth enough.

▼ Treetops against a stormy sky at sunset.

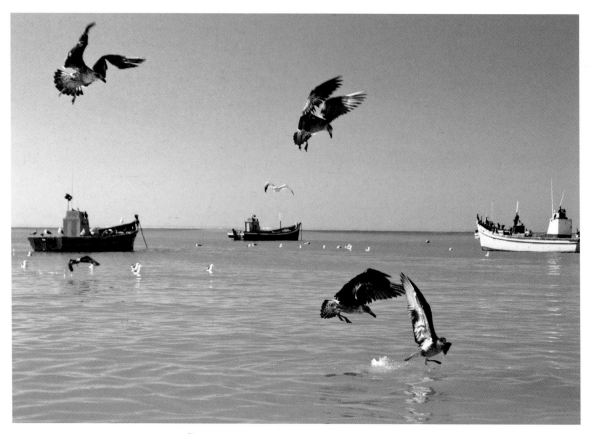

▲ Birds frozen in movement using a selective shutter speed.

A fairground landscape presents another exciting opportunity for motion photography. Rides have elements of movement as well as stationary components that can create wonderful effects. They also often have another exciting element, their own light, which makes twilight photography perfect.

Bird photography can produce some of the best motion shots. There are two ways to photograph birds in motion. You can shoot them as though they have been frozen, or show motion in the flapping wing by slightly blurring any movement. A shutter speed faster than the bird or its wings will freeze the bird although this can change from one shot to another; but a speed of about 1/500 of a second should be about right. Choose a shutter speed that is slow enough to get wing movement but fast enough

to keep the rest of the moving bird sharp. You can of course try panning with the subject using a slower speed.

Star Trails

Star trails can produce spectacular images, capturing star motion blur. You can get either a static shot of the stars as points of light, or star trails where the movement streaks across the sky. The length of exposure determines the effect you get.

As the earth rotates, the light from a star begins to move, usually after about fifteen seconds exposure. Its movement is dependent on the focal length of the lens – the longer the lens, the more apparent the movement. Wide-angle lenses do not show much movement because of the relative size of the stars in the image, unless you use much longer exposures.

Star trails.

Star trails.

The other way to record stars is to take a series of images at different times, then layer them together into one image (stacking). There are two problems associated with this technique. Firstly, the gap between exposures creates a gap in the motion, which then needs to be filled using the necessary software; and secondly, it also means dealing with a lot of large image files. Exposures are in the region of at least 30secs with a low ISO and relatively fast lenses,

using focusing on manual.

The direction of movement of the stars is an important consideration in choosing your image compositions. Choice of night conditions can help. On a dark night with a new moon, you will not see much other than stars. However a crescent moon can illuminate the foreground enough to light it to provide some detail and also to get longer star trails as it gets darker.

It is a good idea to identify the northern hemisphere pole star as a centre point of reference for the composition. As the earth rotates, stars will appear to spin around it. When choosing a foreground, remember you will need to keep that in focus along with the stars, which may require a smaller aperture, to give less light, so the choice of ISO and wide aperture lens is very important to getting a successful result. The best scenes have the closest subject to the lens at least three metres in front, using a semi-wide-angle lens. Whilst you will gain depth of field, try not to increase the ISO because that will create more digital noise.

Most conventional film cameras have a B setting to keep the shutter open for any length of time, and some professional cameras have a T setting allowing the shutter to remain open until the shutter is released a second time and the shutter is closed.

DSLR cameras usually have a B setting, but you will use your battery power to keep the shutter open, and this will drain the batteries quite quickly especially in colder conditions at night. Mirror lock up, available in some DSLR cameras, will improve the sharpness in the image, but sometimes you only have a choice of one action on the camera. Electronic releases are available for most DSLR cameras and can be programmed for sequences and different times.

If you are near a power supply you may be able to use a DC power adaptor plugged into the car or an AC nearby power supply to power the camera. Check what power supplies are available for your camera if you intend to do a lot of this type of digital photography.

Black Frame Images

With long exposures also comes the problem of increased digital noise. The black-frame method can reduce noise, by shooting your long exposure night picture and then putting a lens cap on the lens to take another picture with the same exposure time. Always shoot your black frame during the same session as your pictures so that the temperature of chip is the same as the earlier shot. It is best to take a black frame after your shots, or if you have long pauses between shots.

Most DSLR cameras have a feature on the menu system known as 'Long exp. NR' (Long Exposure Noise Reduction) designed to reduce noise in long exposures. When selected, the camera will take two exposures with approximately the same time for each. The first exposure is the normal picture-taking exposure, and the second one is a black-frame subtraction exposure, which is a second image that is exposed for about the same duration as the first image, but the shutter is closed. The noise in the black-frame exposure is then subtracted from the original image.

To process in Adobe Photoshop open your black-frame image and the original image; with the black-frame image window active, select all and copy. Then paste the black frame into the original image. This will place it directly over the original image onto a separate layer so that both layers are aligned. Select the black-frame layer and change the blending mode to difference. This will get rid of the noise by inverting the image only where the black frame is not 'black'. Change the opacity of the black-frame layer; if the balance is too great, usually 50 per cent opacity works well. Once you have finished you can flatten the image and carry on editing it as usual.

Image stacking

You can also shoot a sequence of images and 'stack' them together in post-processing to get star trails. The exposure should be just long enough to record the stars as bright objects in the sky before moving on to the next shot. It is not uncommon to have several hundred images to stack, taken over the course of a few hours. (A benefit of image stacking is that you have all the necessary photos to make a time-lapse video if you wish.)

Post-process software such as ImageStacker, DeepSkyStacker and Adobe Lightroom will automatically throw all your images together. You can blend images of different exposures together in order to create a natural-looking image with a greater dynamic range. Blend a series of images where the focus point is different in order to create an image with a greater depth of field, or blend a series of images for night photography image stacking in order to create an image with a longer exposure than is possible with a single frame.

Tidal Waters, Movement and Water Flow

People tend to like landscape shots that contain water. Try using slow shutter speeds for shots of moving water in streams and rivers, or if you are shooting fast-moving water try fast shutter speeds that freeze the action. Raindrops can provide texture. With a slow shutter speed try shooting raindrops falling into calm water in a lake or slow-moving streams, strengthening what could otherwise be a weak composition.

Water is one of the most versatile elements in a landscape, providing a wide range of subjects to work with. It could be the point of focus of the shot or could serve as an element in composition. Water can be used in different ways in a frame, as diagonal or leading lines, as a horizontal line, or as a shape that complements other elements in the frame. Water sources like ponds and lakes can be used to represent the sky.

Waterfalls

Waterfalls present themselves as a wonderful and challenging subject. They are often in difficult lighting situations, and they are dynamic because of their movement. As with any moving subject, there are two options – to freeze the motion by using a fast shutter speed or enhance the motion by using a longer shutter speed that blurs the moving elements in the picture.

Use your camera's built-in exposure bracketing and bracket your shots, taking a series of shots at different shutter speeds and apertures. You can then have a variety of very different images of exactly the same scene with changes in the extent that the water blurs, changes in the depth of field and changes in the way the camera captures the colours. You can then decide which of the images is best or maybe combine them in HDR software.

Waterfalls can be photographed from many angles and in different ways, from the wide angle that puts the waterfall into a wider context, down to tightly cropped shots that focus upon just one small part of the waterfall. Look at the different ways the water flows and consider contrasting slow against fast flow. Before taking your shots check your frame to see if there are any distracting elements. Look for litter and debris washed down by the river and consider removing it if possible and not dangerous to do so. Also consider natural debris, such as leaves or old wood trapped on rocks.

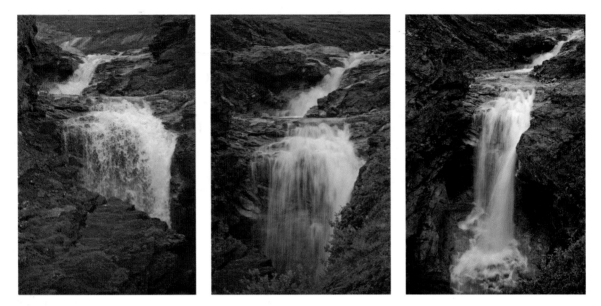

▲ Finding the right angle to photograph a waterfall.

The effect of silky smooth moving water in your shots is difficult to resist, but do not let it become the only type of waterfall picture. Take some shots with fast shutter speeds as well. This can be a good technique to use on raging waterfalls where there is a lot of spray and splashes. You will use larger apertures giving you a narrower depth of field, but also giving your shots a very different feel.

Flash can also be tried on waterfalls, if you are within a reasonable range of the flash's maximum distance. This can add sparkle to the water and freeze the action in its own right. Try mixing slow shutter speed with flash and maybe set your camera on rear flash sync, which will trip the flashgun at the end of the shutter closing.

Take care with exposure, as water in large areas can lead to underexposure, making the picture look dark. It is worth bracketing and allowing an extra 1/2 to one stop increase in exposure to compensate. A low viewpoint will make the falls look more dominating, while a high viewpoint may make them look insignificant. Try moving to one side or shoot head-on for interesting patterns.

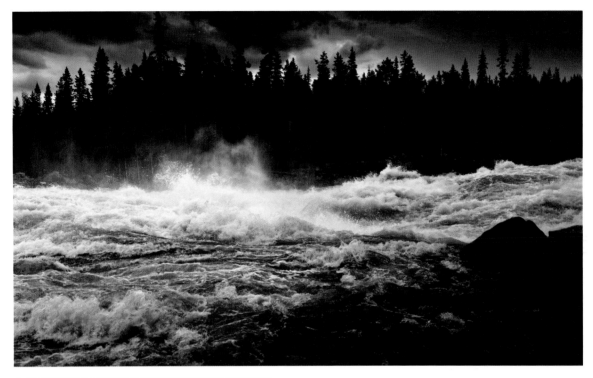

▲ Waterfall from a low angle, using flash to freeze the water spray.

Lakes and Rivers

A lake on a sunlit day provides colourful reflections and when calm provides an almost mirror image of the surrounding landscape. Adding foreground interest will prevent it looking dull, and shooting where the bank has shape will lead you into the picture, placing the horizon on the bottom third so that the sky dominates or on the top third so that the water dominates.

A river can be shot from a high viewpoint showing its path through the landscape, or from a low viewpoint to increase perspective as the river narrows dramatically into the distance. A polarizing filter will help to minimize reflections and ensure that you see the river in the distance. It can also be used to see under the surface when used closer to a watery foreground.

If you are shooting around sunrise get to the location in plenty of time to set up and take several shots around the sunrise, as the light will get stronger and you will get the sort of picture you are after. If it is a sunset shot that you want then start taking shots just before and after the sunset. If you want a misty water effect, take your landscape or seascape photography well before the sun rises or well after the sun sets, in low light conditions to achieve this affect.

Coastal areas can be great places to capture movement and create intentional blur. At the water's edge where waves roll in over stationary rocks, piers or sand, you can create a soft fog effect when shooting with a very long shutter speed.

MULTIPLE EXPOSURE

Most cameras have an option for multiple expo-
sures, although the maximum number of shots for
multiple exposures varies from camera to camera.
When preparing to take a multiple image, you will
need to plan exactly the position of each image and
set the appropriate exposure for each shot. Getting
the alignment right is difficult, but a grid in the
viewfinder or using live view with a grid on, helps
compose the final shot.

Multiple exposures require you to overexpose
and underexpose the consecutive shots so that in
the final image each shot stands out with its effect.
If you decide to shoot at different time intervals you
will need to use your camera on a tripod and again
you will need to plan exactly the time, position and
duration of each shot. However the results can be
very interesting and dynamic.

Of course you can also use techniques like
zooming in and out and focus shift. For focus shift
technique, you take two shots of the same scene,
one sharp and the other one blurred and then com-
bine the two images as layers, with the combination
resulting in a halo effect on the sharp subject.

Panning with a subject induces the feeling of
motion while keeping the subject sharp. The results
produced by moving the camera along with the
subject enable you to get unusual and creative
images, and you can apply this to moving trees and
grasses on a windy day or to any subjects that will
move in the landscape. You need to set a slower
shutter speed say of around 1/15 to 1/30 of sec, the
slow shutter speed blurring the background. Practice
will enable you to shoot at slower speeds and create
better backgrounds. It is best to adjust your focus
before you pan so that you are only doing one
movement. In rear curtain flash sync mode, the
shutter opens first allowing exposure of the ambi-
ent light with the flash firing just before the shutter
is about to close; this freezes the subject and blurs
the background following the subject, creating an
interesting effect.

SHOOTING TO THE PANORAMIC FORMAT

Sometimes even the widest-angle lens is not
enough to produce the view you want. An ordinary
wide-angle shot can work well, but you cannot
seem to get the sense of the scale of the landscape.
This is where panoramic images excel. The best
landscapes to shoot as a panorama are ones with
broad lines, patterns, textures, or shapes, with points
of interest throughout the scene. They need to be
evenly lit, without broad areas of dense shadow
or bright highlights. Shooting panoramas around
sunrise or sunset is difficult, due to the quality and
quantity of light changing rapidly.

The Canon EOS Digital Solutions disk sup-
plied with every EOS digital camera has a stitch
panoramic program called PhotoStitch. This sort
of program examines each image and establishes
areas of overlapping similarity between adjacent
pictures. It then merges the images together and,
depending on how good your images are, it stitches
them seamlessly together. If a slight join is visible,
it is usually possible to edit it out in Photoshop or a
similar imaging program.

▼ A panoramic tripod head.

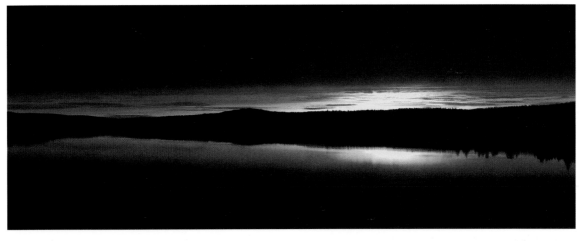

▲ A lake at sunset, shot as a panorama.

Shooting a horizontal panorama in portrait format will mean you have to shoot more images than if you shoot it with the camera in landscape format. This will mean more stitches, any of which may be visible in the final image. However, the bonus of shooting in portrait format is that you have a greater vertical field of view to include more sky and foreground in your image and reduce the effects of converging verticals. On the downside, you will have a larger image to work with afterwards.

The number of shots you need to create your panorama is determined by four things: the focal length of the lens, the choice between landscape or portrait format, the overlap on each shot (a 50 per cent overlap produces good results) and the width of the final picture. Use a tripod with a built-in spirit level or a hotshoe level (some newer cameras have a built-in electronic level accessed via the menu), a standard focal length lens, manual exposure and focus. When shooting, the camera should ideally be rotated around the nodal point of the lens (the centre of the optical lens) to avoid parallax error.

Exposure times are long, and often have different colour balances and brightness levels. Shoot the images in raw format for maximum exposure latitude. Avoid auto white balance, as each image could show a different colour balance, so set the white balance manually. Make sure the camera pivots over a horizontally level base. Shoot slowly, making sure the exposure has been made before rotating the camera to the next shot. Overlap your shots between 30 and 50 per cent of the image area to make them easier to stitch together. Camera settings such as aperture, shutter speed, ISO, focal length, white balance, and focus should be identical. Shoot using manual exposure and focus. Meters should be set for the average setting of the scene.

In processing you will probably not encounter any problems with the Adobe Photomerge feature unless you are working with strong lines in the immediate foreground. If you are using an old computer you may need to downsize very large images in order that the software can process the number of files produced, and so the resultant file will be large.

CHECKLIST

▷ Research and know the positions of the sun in a given location.
▷ Look for the potential to include movement in your images.
▷ Learn and practise how to adjust, manipulate and paint light to enhance your images.
▷ Determine how well your camera copes with long exposures and how to maximize their effect.
▷ Consider using multiple exposures and understand how they can be used.
▷ Research the possibilities for panoramic images and how to use your software to stitch a panorama together.

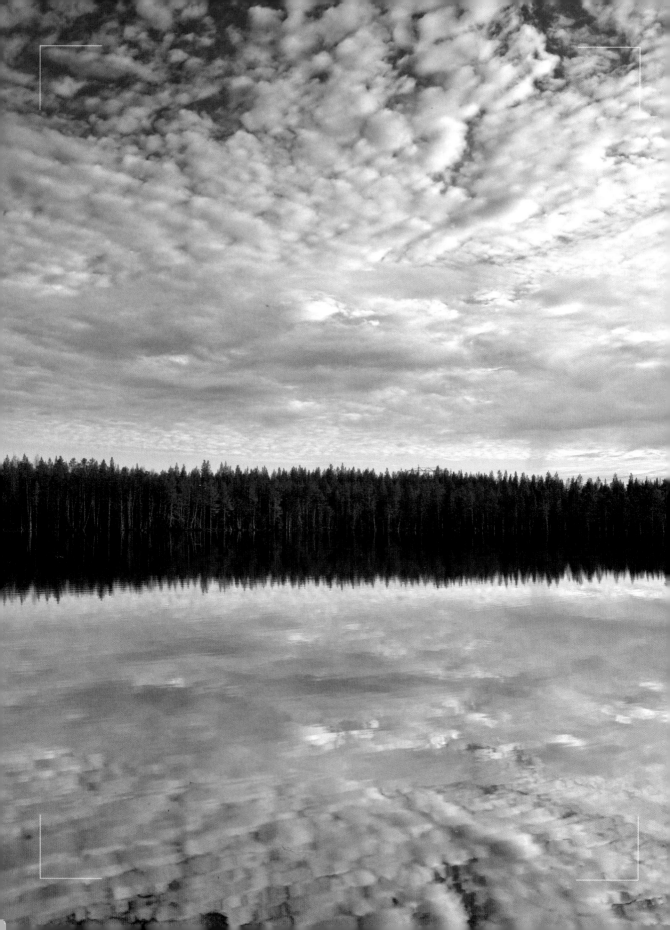

Chapter 8

Coastal Scenery

Coastal scenery and boats have always inspired photographers and artists. From creeks and tidal rivers to beach scenes, boats and harbours we have tried to capture the mood, drama and beauty of the coast and sea. The coast is the most varied and rapidly changing of all landforms and ecosystems, and its development is affected by the interrelationships between terrestrial, atmospheric, marine and human activities.

Recently coastal environments such as sand dunes and salt marshes have come under pressure. Climate change is causing sea levels to rise, resulting in flooding of low-level land adjacent to the coast, and coastal erosion is also becoming greater due to increased storminess, leading to cliff collapse, all of which offer the landscape photographer visual potential. Coast roads can offer the opportunity for fine views, rocky beaches, rolling waves and surf, sandy coves, bird life and fishing villages.

▼ This backlit shot of kite flyers walking along a beach allows the colours in the kites to be visible while rendering the sea and beach in grey tones.

◀ Clouds reflected in a lake.

PLANNING AHEAD

If you are not familiar with a particular area, recce it first, noting any interesting rock formations, beach perspectives, or features. Are you on a sunrise or sunset coast? Will your chosen scene be hidden by shadows during the golden hours? If you are on an east coast where the sun will rise on the ocean horizon, you can capture stunning light with the sun setting. It would be a good idea to check your location first to find out how long the landscape will be front lit.

Know the approximate high and low tide times so you can make sure that your composition will not be affected by a rising tide. Within the BBC Weather website (UK) they produce a guide of tide times, but if you are going to spend any time on the coast it is certainly worth getting a local tide table. Check with local people on the conditions in the area where you are photographing. Beware of beaches and estuaries that have extreme tidal conditions. Check how quickly the tide comes in if you intend to work under cliffs, in caves, or on a long stretch of sandy beach. And wear old shoes that can get wet and won't slip on rocks.

If low tide coincides with a sunrise or sunset you will get something special. Sand bars, sand ripples and tidal pools create great subjects, particularly when the shadows highlight patterns in the sand and where vertical and diagonal patterns lead the viewer's eye. Try combining the reflection of a sky in a tidal pool with ripples in the sand, and shoot low using a wide-angle lens.

High tides when they are coming in tend to be the roughest water conditions, leaving a lot less beach, if any, to photograph. Sometimes the only way you can get the shot you want is to get into the water, but keep your eye out for larger than average waves that could knock you off balance or damage your equipment.

▼ Sand patterns.

PROTECT YOUR CAMERA

If you intend to take your camera on the beach you are going to need to take precautions against the sand and salt water to keep your equipment from being ruined by the harsh elements. Once exposed to the atmosphere your lenses, camera body and accessories will begin picking up sand and salt residue from the ocean. Wind can be a big problem, getting salt and sand into your equipment.

Consider wrapping lenses and accessories in plastic bags, or plastic ziplock bags.

A damp cloth, preferably the microfibre variety, can be used to clean off particles of salt and sand; you can wash the cloths later to remove the salt and any sand.

You can get special bags for photographic equipment to keep them clean in this harsh environment.

Use a lens hood and UV filter to protect the surface of your lenses. Generally putting everything away as soon as you are finished with it is a good idea. Always clean your camera and equipment with clean fresh water when you return from a shoot at the beach, as the corrosive nature of the salt will attack any metal.

ON LOCATION

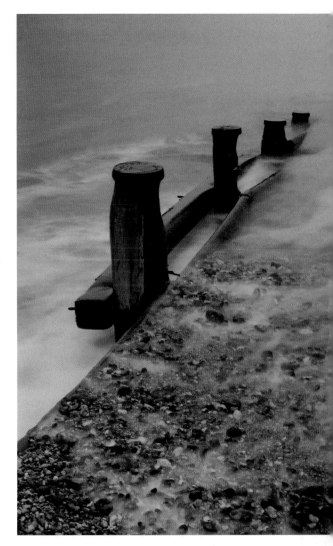

▲ Moving water over beach groynes, using a long exposure.

Photograph your coastal scene with the sun behind you. The best lighting conditions are as usual around sunrise and sunset, when the sun is still low in the sky, which will produce soft shadows and beautiful tones. Rainy days and stormy weather can provide great cloud formations for powerful landscapes.

Midsummer on a beach can be incredibly bright, and if your camera is set on auto it will underexpose it, so do one of the following: either use manual and increase your exposure by one stop generally; set the meter for spot-metering; bracket the exposure; or use +1 compensation. There are a lot of different ways of getting the correct exposure. A good black and white shot at the beach changes the mood and feel of a shot. It is also a great way to bring to life beach shots taken on dull or overcast days.

Since water is a moving subject, a long exposure can create wonderful images by showing the flow of water. There are two types of long-exposure photography when it comes to moving water: photos that have silky soft movement, and photos of water that appear to be frozen in time. To capture the silky effect of the water an ND or polarizing filter can be use to lower the shutter speeds enough. Generally you will need an exposure time of 1/2 sec or slower to achieve such an effect. To freeze the water splashing in the air after smashing into rocks, a shutter speed of 1/500 sec or higher is going to be needed.

You can also use the water as a reflective surface to capture reflections of a cloudy sky or a boat, producing mirror effects.

When shooting tidal movement, try to photograph the tide as it goes out instead of approaching, as this is when directional lines are formed. Have a very long shutter speed using one or more ND filters and keep the ISO as low as possible. This will allow you to shoot even the choppiest waters as a flat, smooth surface, with the added bonus that any moving clouds are also blurred.

Remember to keep your horizon line straight. Consider lowering your perspective if you are in an environment where it is difficult to capture all the elements in your field of view, such as the entire beach. A wide-angle lens will work especially well for moving water along the sand or in between rocks.

A common problem with landscape beach photographs is lack of a point of interest, and that can lead to a beautiful scene looking empty and boring. Look for pattern or texture in the sand – footprints or waves, or maybe tell the story of going to the beach by looking for something like shoes at the water's edge, sand castles or sunglasses. Find an element to emphasize within your composition. It could be some interesting rocks, a boat in the sea, or a log on a beach. Whatever the element, frame it in a way so as to make it prominent in the composition.

SHOOTING WAVES

If you are setting out to photograph waves, start shooting a few seconds before a wave crashes and shoot continuously throughout. The most interesting photos could be right before the wave breaks.

If you are in an unsecured location where the water can reach you, take precautions with your equipment, especially when photographing approaching waves on the beach. The tide can be unpredictable. Waves come in sets. Just when you think you know how far the water reaches, a rogue wave will come over it. Calculate how far you think a wave can reach and add twenty feet.

Whatever you do, never leave your camera bag on the sand and never leave your camera on a tripod unattended. You can leave your camera bag on your back, or put it high up on a rock.

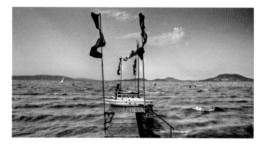

▲ Monochromatic shot of a surfer's pontoon.

▲ Detail of flaking paint on a boat provides for an interesting abstract image.

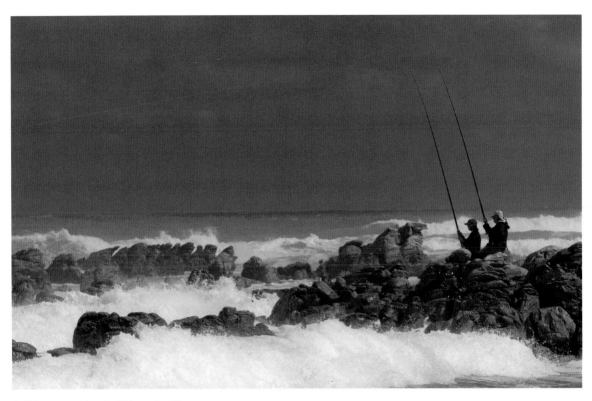

▲ Fishermen on a beach with incoming tide.

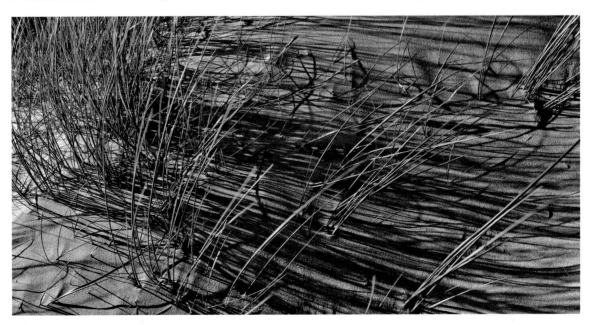

▲ Close detail of wood and foliage on a beach, in monochrome.

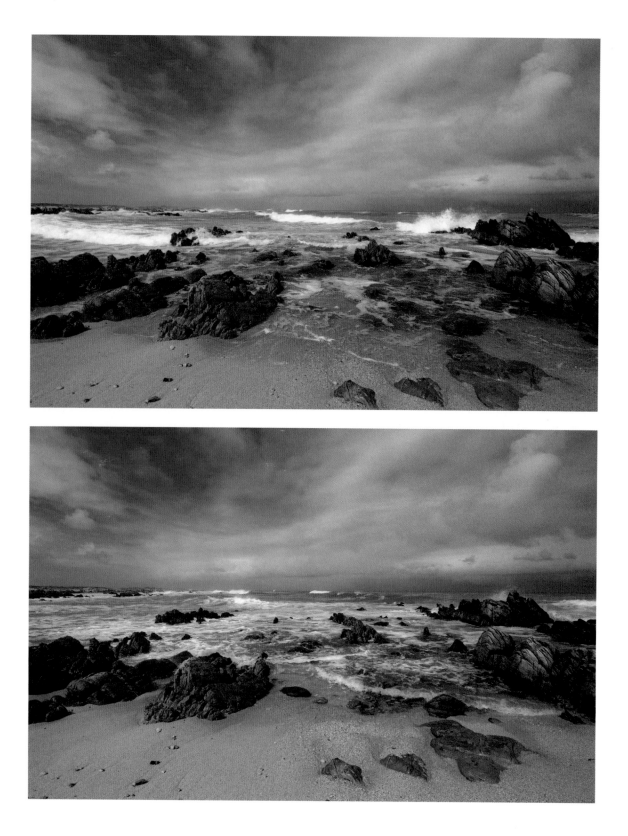

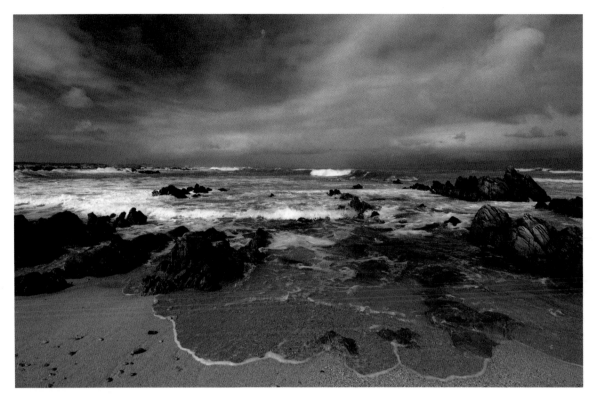

▲ ◄ A sequence showing waves breaking on a beach.

Seaside resorts out of season change into places that can be desolate, moody and full of photographic potential. The low-angled winter light will give colourful beach huts more colour, while a bright blue sky dotted with white clouds will add a bit of life to what can be drab-looking shops and piers. Even with grey skies the sea can look good and there is always the option to shoot details of nets, ropes and wet pebbles on the beach.

A common mistake to make when photographing the beach is putting the horizon line dead centre. Remember the rule of thirds and place the horizon in the bottom or top third of the picture. Look for something that places a frame around the point of focus of your picture and make sure your horizon is straight. No matter how good all the elements of your beach or seascape are, they will be ruined by a sloping horizon.

A slightly overcast day can actually be better than a sunny day. Beaches often feature rather pale colours, so it is worth looking out for interesting splashes of colour, and strong graphic images. Cliff views can be particularly stunning, with dramatic clifftop walks. If you are shooting along the edge of a cliff, the upright format can often work better.

CHECKLIST

▷ Research, visit and understand your locations.
▷ Be aware of the tidal times, and prepare for low or high tide.
▷ Take steps to protect your equipment.
▷ Know lighting exposure for bright sun.
▷ Learn how to shoot water so it shows movement and stillness.
▷ Look for patterns, points of interest.
▷ Exploit out of season places for their atmosphere.

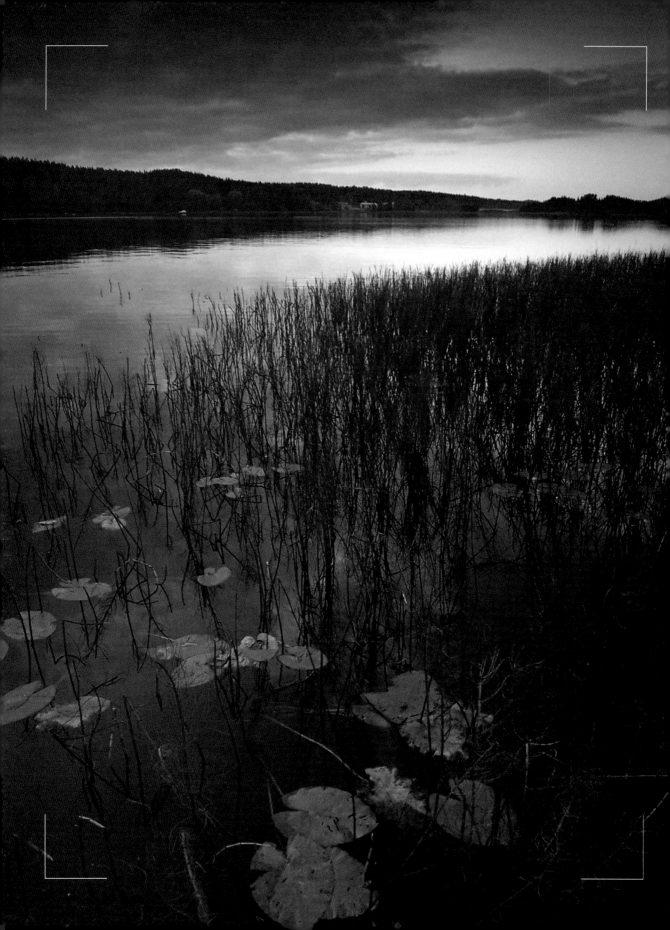

Chapter 9
The Landscape at Night

Night or dusk photography can take a scene that is relatively uninteresting in daylight and by casting it in an unusual light can make it an interesting one. Look for suitable locations during the day and try to visualize how these will look at night or dusk. Work out suitable compositions and carefully search the area for potential hazards. Find subjects that have a strong outline against the sky. Windmills, churches, trees or farm machinery can make for interesting pictures. A low viewpoint will add drama to an interesting sky. Shooting at dusk it is easy to forget to look around. You could be missing some potentially great shots. Use long night-time exposures and immediately explore and take note of the variables, such as colour shifts.

Planning how to get the best available light to your advantage is an important part of getting good pictures. Despite being dark, a variety of lighting conditions are possible. Weather conditions and light pollution can have a dramatic effect. For startrails it is essential to pick a clear night. Although cloudy weather means you will not be able to record star trails, moving clouds can still make for some stunning pictures, particularly when they take on colours.

▼ The bottom of a tree canopy and lake at night.

◀ Lake at Night – Finland.

SHOOTING AT NIGHT

--

When in a naturally dark area you will have a choice of three light sources to illuminate your subject: moonlight, flash or tungsten/torchlight, each with a different colour temperature. I have on occasions used car headlights. Moonlight is probably the most powerful natural light source at night, and has dramatic effects. Both torchlight/tungsten and flash are great for lighting most subjects and offer good control over the areas of the scene you wish to illuminate. With a torch it is possible to light just one particular subject or a small area in a scene. An open shutter technique will allow you to paint the areas you need to light. A good quality flashgun is a must.

I have found that lighting landscapes you need as much light as you can get. Using a flashgun that was designed for film use will give you a far more powerful light source, and, preferably a professional gun type, will allow you to illuminate relatively small sections of an image with the bonus of being able to control the power output. When fitted with coloured gels a flashgun can add a splash of colour to scenes.

The essential items are a DSLR with a B bulb facility, a lens, a sturdy tripod, a release (or setting the camera's menu to remote to keep open the camera's shutter) and a light source to illuminate the subject.

Arrive at the chosen location while it is fairly light to allow plenty of time to set up the camera before dark, and to compose and set the focus ready for darkness. You should only try to shoot one location at a time and not rush from one to another. Make sure the tripod is on secure ground and weighted down to steady the camera and ensure it is not going to blow over.

Keep the ISO as low as possible to minimize the digital noise, and set your camera to long-exposure noise reduction. The downside is that the exposure time is effectively doubled while the camera takes a dark frame to identify the noise. I find it is generally acceptable to use four exposures of up to five minutes. For longer exposures I turn off the noise reduction feature and apply any required noise reduction in post-processing.

Use mirror lock-up if you have it, or set on self-timer to open the start of the exposure or lock open the shutter using a remote release, noting the start time. While the shutter is open you can begin illuminating your main subject, using a tungsten lamp, torch or flashgun, making sure to stand to one side of the camera and avoid walking into the scene with the light source. If you are dressed in dark colours, or you can hide behind something, you may be able to get away with being in the scene yourself, but walk around quickly so the camera does not record you.

The amount of light required depends on several things including the actual subject and the distance from the camera. When painting by torchlight it is important to use slow and even strokes without leaving the torch shining on a particular part of the image for too long. If the subject is more than 20 metres away from the camera then it will require a lot more light. Getting the correct exposure is trial and error, so it is important to remember the length of the overall exposures and roughly the number of flashes or the amount of time you illuminated the subject. Once you feel you have given the subject long enough, then release the shutter or cable release lock and review the completed image on the LCD screen of your camera.

A location that has some man-made lighting at night can transform the landscape into an interesting, maybe unearthly, place. Foggy nights tend to diffuse the light and create shadowy glows. A landscape that is lit from below is unusual and could form an interesting subject. You just need some light, but not a lot, so don't worry about the brightness of the light as much as the quality.

Daylight casts crisp edges on landscapes, but night landscapes have a softer light unless they are illuminated by man-made sources that create harder shadows. Composition is still very important at night, but you are also trying to shoot mood. Try

DEW FOGGING

Working at night has its own special problems, such as dew fogging, which raises the amount of humidity in the air. Older metal and high-quality metal digital lenses will become colder than the ambient temperature, but even lenses that are predominately plastic can suffer from the problem because of their glass components.

There are commercially available dew heaters on the market, but you can build your own dew heater for lenses, details of which can be found on various web pages. Pocket chemical hand-warmers in an old sock with the bottom cut off around the lens will work as well and are a quick, easy and cheap solution to the problem.

several different exposures to balance the light. If you are shooting early evening for a deep blue sky instead of the blackness of night the light is going to be changing constantly. Once it starts getting dark so that the man-made lights are showing expose correctly for the lights; at this point the sky may be too bright for the mood you want. Just wait till the sky gets a little darker, taking a shot every so often.

Colour Balance

Your eyes are getting adjusted to the lower lighting, but the camera will see it differently. Be aware of changes in subject colours due to different types of illumination being different colours and thus having different colour temperatures. Artificial illumina tion displays a variety of colour casts. Fluorescent

▼ Power lines.

lighting has a greenish tint, while tungsten-lit scenes are reddish. These lighting conditions are extreme enough that they will exceed your camera's ability to correct them using auto white balance.

In your camera's menu for colour balance you will be able to use preset colour balances such as sun, cloud, light bulb, fluorescent tube, and maybe a few others as well. You can deliberately set up your colour balance to shift it to a particular colour. Or if you want a neutral balance you can use custom white balance, which allows you to take a colour reading off a white sheet of paper. The camera will attempt to adjust the colour temperature for that specific lighting as measured from the white paper. The artificial lighting remains the same while the natural light changes.

If you are not sure, shoot on raw, and decide later using the processing software exactly what colour balance you want. Some night shots look good as black and white images, and again you can convert them in the software. I have heard of a couple of ways to determine the longest exposure that is possible for any given focal length lens. One is to divide that focal length into 600 (for a full frame sensor). The second is by taking the camera's meter reading which, say, gives you 10 sec at ƒ4: set the ISO to 100, then multiply the camera's exposure by 16, then divide by 60 to get the exposure in minutes. In this case the answer is three minutes.

When focusing in the dark carry a torch. Shine the torch on your chosen subject. Once your camera gets a focus lock, switch your lens to manual focus. At night compose using a high ISO, the most sensitive, then change the ISO setting back to a lower one for your main shot. Make sure that the camera's noise reduction is turned on.

TUNGSTEN TORCH AND PORTABLE FLASH

In light painting, a photographic technique used usually at night, exposures are made by moving a handheld light source or by moving the light source. The light can be used to selectively illuminate parts of the subject or to paint a picture by shining it directly into the camera lens. It usually requires a slow shutter speed, or long exposure.

You can use a torch with an opaque object attached to the front of it, which will create a nice flat fill light. Alternatively you can use an electronic flash-gun and move it around your subject firing the flash as you move; the lighting needs to be even and it is easier to use a diffuser over the flash to achieve the best results. Never allow the front of the light source to be in line of sight of the camera or you will get flare. (You can of course use a portable generator to provide power to tungsten halogen lights or studio flash, but this tends only to be used professionally.)

When using flash photography on location you need to balance your flash with the available light. So you will be working with at least two exposures – the flash exposure, and the ambient exposure. You will need to adjust the ambient exposure for correct background illumination, then adjust the flash to match the ambient light settings to get a balanced fill light. It works well when the sun is low in the sky. Most photographers prefer to shoot during the golden hour because if you shoot during the day you will get harsh shadows and high-contrast scenes.

EVER READY

Always dress warmly – it gets very cold at night when standing around waiting for long exposures.

Beware of wet conditions when using electrical devices outside. Take a torch, to help focusing as well as for safety.

If you are shooting with your studio flash, you will have to set your camera's shutter speed to your flash sync speed or lower. Most cameras have a flash sync speed of 1/125 to 1/250 so your shutter speed cannot go any faster than that if you are using flash. If you are shooting with the intention of using the images as black and white, Mag-Lites and halogen lamps can be used to paint foreground details of landscapes. It is a technique that is primarily used outdoors at night to make scenes look more dramatic than they would under normal conditions.

USING FILL-IN FLASH

If your landscapes are heavily weighted to the foreground, with a key element at the front leading the eye outwards to the rest of the image, you will need to light detail adequately in the immediate foreground. Fill-in with flash is a perfect solution. However it must be powerful enough to compete with the natural light.

Battery-powered studio flash or generator-powered studio flash units can be one answer, but using reflectors rather than softboxes or umbrellas will tend to lose too much light. The aperture is set at the aperture required for the flash exposure, and then balanced by the shutter speed for the ambient exposure at that aperture. You can also change the ratio of the flash to ambient exposures by changing the aperture or shutter speed. How far a flash is effective is based on its power output. To extend this, units can be placed near the subject area out of the field of view.

The angle of illumination is important as it needs to cover the angle of the view of the camera but should only illuminate the nearest element and not the scene. Only the flash is regulated by the aperture. If you can tilt the flash, your ground will not look like you are using flash at all. Tilting the flash is done by pointing the flash higher, or up towards the trees or sideways from the main element in the front, remembering that the light from the flash will only go a certain distance and then fall off dramatically after that.

In order to get a more natural light, about one stop underexposure for the flash is likely to give a naturalist fill for the shadows. If necessary a graded neutral density filter will hold the sky back a little. Try filling in from the side and underexposing the ambient light, keeping the flash at the correct exposure. You can create drama in your landscapes with this technique. If you are shooting into a setting sun you will require greater flash exposure to fill in. If your flash at full strength leaves your front elements looking washed-out and artificial and you can't decrease the flash strength, move it back a little from the subject. You can of course just add flash to specific areas of the scene.

With fill-in flash, the highlights on your subject have their exposure determined by ambient or natural light. The fill-in flash technique uses the flash to fill in the shadows or add a little highlight to dark areas. TTL flashes connected to your camera handle the difficult calculations for you. The camera flash setting or default setting for your camera will have the flash operating generally in a range from 1/60 sec up to the sync speed of the camera. The sync speed is the maximum speed at which the camera and flash will synchronize.

▼ Flash slave cells.

Most cameras are capable of firing at a much slower speeds. The camera setting allows us to use fill-in flash to selectively fill in the shadow areas of our photograph. Light fall-off is still present, and you will not be able to light a dark section that is a mile away, but you will be able to fill in shadow areas that are within the operating range of your flash and expose the front elements of the scene correctly. Most external TTL flash units have a setting that indicates the effectiveness of the flash unit. For most fill-in work you will find that a handheld unit is preferable to locate it where it is needed, and gives better control over the flash.

When shooting in flat light situations, there will be little contrast. Fill-in flash can be used to increase the contrast or add a little highlight giving depth to the scene. Setting your camera on rear-curtain sync tends to produce a much more natural-looking image than the default front-curtain sync. Remember to match the colour temperature of the ambient light. The light from a flash is extremely cool and blue when compared to most ambient light situations, so you can use a coloured gel over the flash to try and match the natural ambient light.

The idea of fill-flash is to subtly fill in the harsh shadows, not to create studio lighting which, if it is overdone, is what the results look like. Less is more. Just light the subject with a tiny bit of light and the picture will look much more natural. You will probably find that TTL flashes tend to overlight, and usually need reducing in intensity.

▼ Church at night, using fill-in flash.

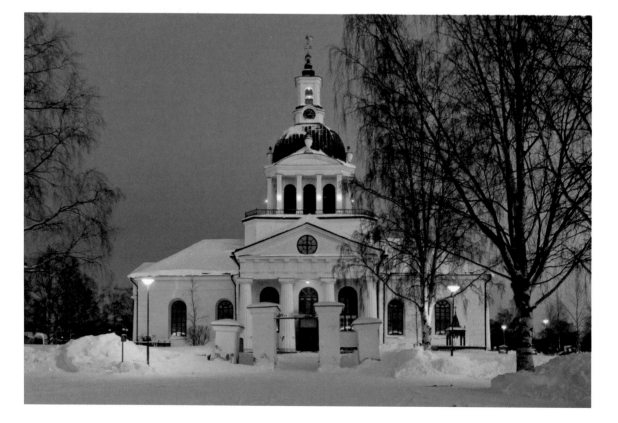

USING MULTIPLE EXPOSURES

Multiple exposures differ from continuous shooting or bracketing in that it is the camera's ability to take a number of shots on the same file, so that for ten shutter exposures you only have one file image. Most DSLR cameras offer multiple exposure, but some are limited to the number of exposures you can make on one frame. The only real equipment requirement for multiple exposures is a tripod.

Multiple exposures can be used to photograph moving subjects in two different ways. (1) They can be used to extend the shutter speed, to enhance the movement of a subject in situations where the light is too bright for a single, long exposure. Slow-moving water, a small slow moving waterfall or ripples on a lake can be smoothed out, or clouds moving across a sky using a multiple exposure technique. Try shooting a three-shot multi-exposure, if you have a metered exposure of, say, 1/30 sec at ƒ2.8, the effective exposure on the completed multi-exposures will be 3× 1/90, or a 1/30 exposure at ƒ2.8 which (with auto gain on) is still exposed correctly.

Multiple exposures can be used to combine a range of very high shutter speed shots, giving an effect of a very sharp image with a sense of movement. With a waterfall on a sunny day, a high shutter speed retains the feeling of sunlit sparkle, but the multiple exposures preserve a feeling of movement. It also works with trees and plants. Depending on the number of exposures used you will need to reduce the exposure, say for four shots about −2 stops. Of course there is nothing stopping you shooting different subjects and overlaying them using this technique, but the downside is you need to plan your shots. Better to do that later using software and layering.

Often fast-moving subjects will not work as well with multi-exposure techniques as these show too much subject movement and loss of detail.

HIGH DYNAMIC RANGE RECORDING

Dynamic range is the range of luminance values from the darkest to the brightest that is discernable to the human eye, film or digital sensor. The dynamic range of a digital camera is the scene that can be recorded without clipping the highlight and dramatically increasing noise levels in the shadows. Using HDR techniques in photography we can create an image requiring no use of filters in the field, and relatively easy to use automated software, with maybe a little fine-tuning work in Photoshop.

The software to prepare the files is straightforward, and once that is done the tone-mapping process of converting the HDR image back into an 8-bit or 16-bit image file can be done. I usually start with raw files, adjust them as I want, then convert to TIFFs.

Once converted the sequence of different exposures of the same subject is loaded into Photomatix Pro; there are however other such programs, as well as Photoshop. The HDR image reveals more of the original scene's drama than a blended version. More detail is visible in the sky, due to local contrast adjustments that emphasize tonal transitions, details, contrast and colour tones. HDR represents the full range of tonality present in the scene.

A DSLR camera can capture a range of perhaps 8.5 stops of luminance in one image, or about 400:1. By altering the exposure to take images that range from very underexposed to very overexposed, you can capture a series of slices across the subject. These slices will form a much larger dynamic range when combined together. So by shooting multiple exposures or bracketed exposures of the same scene, you can cover the entire dynamic range of the scene, properly exposed, from shadows to highlights. Using a series of exposures and processing software, you can produce a single HDR image file. A typical sunlit landscape may have a DR of

100,000:1 or more. HDR can also be used in architectural photography, where natural and artificial light combined with shadows can produce a wide DR over various materials and surfaces.

The blending techniques produce higher-quality results when software does not have to attempt to compensate for alignment errors in between frames, caused by camera movement. The HDR software needs to map the luminance values at each corresponding pixel from the series of frames, so it is important to have the images lined up with each other as closely as possible.

Shooting HDR images benefits from using a tripod support for the camera. However if the shutter speeds are all relatively fast and your hands are steady, you may be able to handhold the camera. If the light or any subject elements change, blurring and ghosting as well as exposure inconsistencies can result, especially for multi-frame panoramas.

You do need to consider some basic camera settings. Fundamental is the number of images and exposure interval of the sequence. You can take them by automatic bracketing if your camera has that, or manually. You do not want the aperture or ISO settings being changed. Try setting three shots at first of +/-1 stop difference in exposure; capturing one overexposed, one correctly and one underexposed. However you need not limit it to that. You could try 5, 7 or 9. It will depend on the original scene's dynamic range and what is the most effective range.

You may find after tone mapping the sequence that there is not much difference between the resulting tone-mapped images. One based on a five-image sequence may be a little contrastier due to slightly deeper shadows, if sun is not directly within the frame, and there are no extreme shadows or highlights. Less may be more.

▼ People at a music festival, using HDR.

EXTENDING THE TONAL RANGE

How to bring out all the tonal range in a scene, perfectly? The Zone System, developed by Ansel Adams, uses a technique for getting the correct exposure of a given scene with good contrast and smooth yet widest tonal range, with details in the highlights and in the shadow areas of the photograph.

The dynamic range of naturally available light is vast. The human eye can perceive a tonal range of approximately twenty-four stops. Yet a camera has a dynamic range up to ten stops on the best available chip. So how can you increase its range? Adams devised the Zone System as a guide for photographers to control light levels and to visualize exposure for the scene or the subject. You can use the Zone System for recording highlight and shadow details as you visualized it. The system uses correct metering of the dynamic range of the scene to enable the camera to record it as you, the photographer, saw it. The principle of the Zone System is understanding the varying levels of light, ranging from pure white as the brightest to black as the darkest value, and then dividing the levels of tones into eleven zones.

If the scene falls beyond the range that the camera can record we then need to control dynamic range. If you have a handheld meter (in particular, a spot meter) or if you have spot-metering on your camera you can check.

Controlling Dynamic Range

In landscape photography we have four different ways to control the dynamic range:

(1) Reduce the highlight area, usually the sky area, by using a graduated ND filter. The filter helps in reducing the brightness of the sky and bringing it within the dynamic range of the camera's chip, giving it better tonal gradation.

(2) Add light to the shadow areas or underexposed areas using additional lighting in the form of lights or flash and reflectors, to add detail into shadow areas, which will generally balance the scene. A well-exposed image results in producing an even histogram with extended tonal range, in order to differentiate one tone from another – particularly important if your final result is going to be black and white.

(3) Use multiple exposures of different exposures, based on overexposure for detail in shadows and underexposure for details in highlights as well as a range around the indicated correct exposure; then use layers in software to recombine the image into one flattened layer which would be the final picture.

(4) Use HDR photography and tonal mapping software to produce the final picture.

INFRARED PHOTOGRAPHY

Digital cameras are particularly sensitive to infrared light, some more than others. The Bayer filters in most digital cameras absorb a significant fraction of the infrared light, but these cameras are sometimes not as sensitive as infrared cameras, and can produce false colours in the images, as they use infrared filters to block the sensitivity of the chip.

An infrared filter (which is almost black) over the lens creates a long exposure often in the range of thirty seconds, creating noise and blur in the

images. Often lenses will also show a hot spot in the centre of the image, as the lens coating is optimized for visible light and not for IR. A deep red absorption filter can create a variety of artistic results by passing a mixture of visible and IR light and enabling your SLR viewfinder still to be effective. Stopping down the lens also allows for the difference in point of focus of visible light to that of IR light. Some older film lenses used to have a marked difference in IR focus. This technique cuts through haze and creates darkened skies in black and white.

The best way to shoot infrared photography is to remove the infrared blocker in front of the sensor and replace it with a filter that removes visible light. This filter is behind the mirror, so the camera can be used normally, handheld, using normal shutter speeds. Normal composition through the

▲ Infrared filter.

▲ Infrared focus setting on an older lens.

viewfinder, and focus, all work like a normal camera. Metering can be used but it is not always accurate because of the difference between visible and infrared reflection.

When the IR blocker is removed, most lenses become perfectly usable for infrared photography. Zoom lenses scatter more light through their optical systems than prime lenses. An infrared photo taken with a prime lens may give better contrast than one taken with a zoom lens. Alternatively you can use a Foveon X3 sensor, which does not have absorptive filters on it. Sigma DSLRs have a removable IR blocking filter and dust protector, which can be simply omitted or replaced by a deep red or complete visible light-blocking filter. The Sigma SD14 has an IR/UV blocking filter that can be removed and installed without tools. Several Sony cameras used a night shot facility, which move the IR blocking filter, making the cameras very sensitive to infrared light. Yet soon after this discovery the facility was restricted to using the camera in this way and exposure times were limited to 1/30 sec and longer, so you needed to add neutral density filters to reduce the camera's sensitivity. Fuji produce a dedicated DSLR for IR use in forensic and medical photography.

Infrared photography gives you a different tonal distribution from normal visible light. Some objects become brighter in IR, some darker. Some rocks will go lighter and some darker than they look to the eye. You can shoot IR anytime. At night infrared photography will give you much longer exposure times, but there is still enough IR from the sun hitting the atmosphere. The moon is also a source of infrared illumination, and some artificial lighting produces IR. Interestingly a polarizing filter when used in infrared photography can increase contrast and change the tones in parts of the image. It will also reduce reflections in the water and darken the sky, and the overall tonal range of the image is increased, from lightest to darkest.

▲ Infrared industrial landscape.

<div>

CHECKLIST

▷ Research locations for night photography.
▷ Learn how to use additional lighting to illuminate a scene.
▷ Research the Zone System and how its principles can be applied to your photography.
▷ Know how to extend the tonal range on your images.

</div>

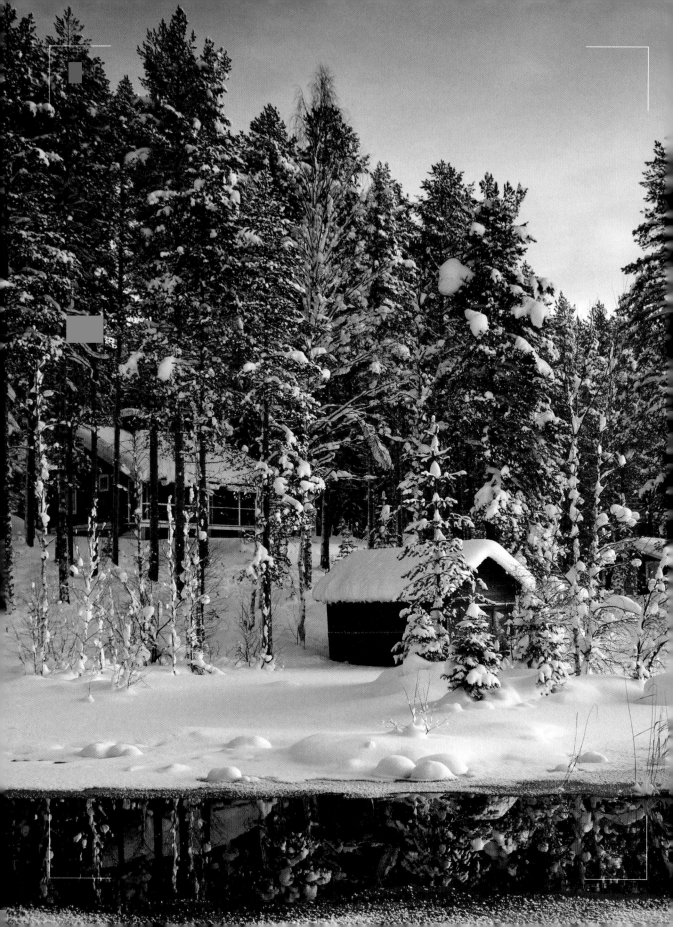

Chapter 10

Processing Techniques

You should consider before you start shooting digital images how you are going to organize them and store them. Look at the process carefully and decide how you want to use your images, because that will determine your workflow and storage requirements.

Each photographer tends to develop their own routines for shooting, downloading, and processing digital photographs. These routines need to be organized so they can develop into a consistent workflow that speeds up the entire editing process. Consistency in how you handle your images after they are shot is as important as the techniques you use to compose and shoot your images.

WORKFLOW

From Camera to Computer

Immediately after shooting – it may be one card or several – I copy them either to my desktop computer or, if I am working away from the office, I will be using a laptop. I always use a multi-card reader as it is quicker and does not waste the camera battery, allowing you to carry on using the camera. Most multi-card readers connect directly to the computer with USB 2.0 or Firewire.

Decide where you are going to file them, and your naming convention. I usually specify my images to be downloaded into folder named by date of the shoot and subject. You can use Photoshop Bridge to batch copy and rename if you wish. Some people add a short description along with the date as part of the naming process. For each shot, however, it tends to create long file names. You can also add keywords to the metadata for searching. If, like me, you have been brought up with film you can also create contact sheets with thumbnail images from each shoot to locate specific shots. Once the images have been copied onto your computer, you can remove your card from the reader. Remember to click on the remove hardware before pulling the card out.

At that point I usually reformat the disc in the camera that I am using so as not to add to existing images that I have just downloaded (if the card is only partially used). That way I know that I am always using newly formatted cards. It is also a good way of checking that the cards are working correctly.

I never use large cards. If they fail during shooting you could end up reshooting a lot of pictures. It also means that I can divide up the work and be more specific in naming the files. If I am shooting video on my stills camera that is the only time I use large cards. I may be shooting raw and small JPEGs at the same time to enable quick viewing of the shots in Windows viewer.

I convert my raw files to digital negatives (DNGs) to enable the files to load quicker in Adobe Lightroom, my chosen software program. I create a second backup copy of these files and these are written to a portable external hard drive in case of computer failure. You could of course write the files to DVD. The recommendation is to store your second copy in a different secure fireproof location.

◄ Sidtjärn, Boliden, Sweden.

Sorting, Adjustments and Tagging

When I am ready I open up the DNGs in Adobe Lightroom, going through each file in turn and sorting them out in terms of quality. Any that are substandard are deleted from the file.

Adobe Photoshop Bridge also allows you to rate your images either by colour or by assigning a one through five star rating. Rating your images can help you to quickly identify the shots that you may want to take further and continue processing.

You can also apply a copyright and keyword search information at this stage if you wish, though I prefer to do this at a later date when I have processed all the images that I feel are correct, and then I am ready to look again at the images and make any necessary adjustments in Lightroom, under the development tab, with final sharpening being the last action. Often I may use the copy paste tool to make adjustments to a number of images at the same time. Once I am happy with all the images, I add my copyright and metadata for searching.

I then save as high resolution TIFFs (300 DPI) for printing and lower resolution, files for use on my websites and for PowerPoint presentations. Any other work necessary is carried out using Photoshop. Some things are better done in Lightroom and others better in Photoshop. I find that Photoshop is now very much a secondary tool in my personal work. It may be because, personally, I find that using Lightroom is more like working in an old style darkroom.

IMAGE MANAGEMENT

Image management software will scan your hard drive for pictures and pull them into a digital library. From there you can browse, search, edit, share them if you wish. You can also download new shots direct from your memory card into the library if you so wish.

There are a number of free photographic management software programs available at time of writing: WindowsLivePhotogallery, GooglePicasam, Cam2pic, Digbookshelf, Irfanview, Faststone image viewer, Xnview, Studio Line Photo Basic, Preclick Photo Organizer, Pictomio and so on. Apple has iPhoto and Aperture, together with the mainstream software programs like Adobe, Lightroom and Photoshop, ACDSee photomanager, Corel for Windows.

Library arrangements differ according to the program. Preclick Organizer strings images across like a 35mm virtual film roll. You can also search by keyword, date, and rating. This sort of search is far more effective when your photographs are tagged, and makes it easy to change titles and dates, add captions, and include all sorts of other info.

▶ Photoshop: Bridge tool (screen shot).

You can also sort photos into virtual albums for convenient browsing. Organizing approaches differ among products, but the basic idea is the same. Picasa for example uses a timeline.

Most photo managers include some basic editing tools, such as cropping, rotating, removing red-eye, and a few other basic effects. Others go further including a histogram tool and colour-cast controls. Generally free digital photo software is designed for people who want to organize and share personal photos, but do not want to edit them. The digital tools usually do provide easy, one-click corrections plus printing and photo sharing features. Photo sharing tools vary, from simple methods based on e-mail to integration with some web services that lets you upload to a sharing service on the web. Some managers integrate with third-party services such as SnapFish and Shutterfly for printing services.

Photoshop v Lightroom

Photoshop was originally created as a tool for simple image editing, which has grown into a software suite with many functions and capabilities to accommodate graphic designers, architects, animators, publishers, photographers and 3D artists. Image editing, with an unlimited potential, grows with software updates and upgrades, but also with plug-ins from Adobe and other third-party companies. Photoshop can do almost whatever you want it to do, including alter images that might look realistic while being fake.

Photoshop is a very advanced image-editing tool, but when you edit hundreds of images, keeping them organized becomes a problem over time. Adobe Photoshop Lightroom was created to overcome that. Lightroom can be considered as part of Photoshop, with specific functions that Photoshop does not and probably will never have. It was created for managing a large number of images, and keeping them organized.

▲ Lightroom: metadata naming system.

▲ Photoshop work screen.

▲ Lightroom: Import Images.

▲ Lightroom: Minimum Keywords screen.

Lightroom is database image management software that automatically reads image metadata, camera, date/time captured, aperture, shutter speed, ISO, white balance and more, and writes information about the image into a new database. As images are imported, additional information can be added, allowing you to tag images with specific keywords, and star ratings. This makes it very easy to sort through large numbers of images, select the best ones, edit them individually or in batches, then export the best images directly into websites. This type of tagging and indexing is not available in Photoshop.

In addition to media management capabilities, Lightroom contains a set of tools that allow photographers to manipulate images. In short, think of Photoshop as an image-editing tool while Lightroom is an image-management tool with image-editing capabilities. Lightroom has a specific set of tools that make it easy to edit and manipulate images. In addition to the image-editing capabilities highlighted above, Lightroom also has built-in modules for creating slideshows, printing images, exporting image galleries for the web.

Lightroom image-editing capabilities are automatically included in Adobe Camera Raw, which fires up when a raw image is opened from Photoshop. While it looks different from Lightroom, the functions are mirrored in Camera Raw. When Adobe releases updates to Lightroom, it also releases updates to Camera Raw at the same time, so even small things like lens profiles get updated in both versions. Everything you can do in Lightroom can be done in Photoshop, plus much more.

Some photographers use Adobe Bridge with Photoshop as part of their workflow. While Bridge has some of the Lightroom functions, it is not a database. It is more of a browser or file manager, so searching for an image means going through all the files. A similar search in Lightroom could be done in a matter of seconds.

Histogram ▼

ISO 1600 145 mm ƒ / 5.6 1/45 sec

Quick Develop ▼

Saved Preset	Custom	⬍ ▼
Crop Ratio	Original	⬍
Treatment	Color	⬍

White Balance	As Shot	⬍ ▼
Temperature	◄◄ ◄ ▶ ▶▶	
Tint	◄◄ ◄ ▶ ▶▶	

Tone Control	Auto Tone	▼
Exposure	◄◄ ◄ ▶ ▶▶	
Recovery	◄◄ ◄ ▶ ▶▶	
Fill Light	◄◄ ◄ ▶ ▶▶	
Blacks	◄◄ ◄ ▶ ▶▶	
Brightness	◄◄ ◄ ▶ ▶▶	
Contrast	◄◄ ◄ ▶ ▶▶	
Clarity	◄◄ ◄ ▶ ▶▶	
Vibrance	◄◄ ◄ ▶ ▶▶	

Reset All

▲ Lightroom: Quick Develop.

Start with Lightroom

I recommend starting off with Lightroom, as it is easier to learn than Photoshop. Lightroom contains a larger number of post-processing tools, good for 90 per cent+ of editing. It will help you in establishing a solid photographic workflow process and make you more efficient, because you can process images quickly, without having to deal with opening and closing files. Lightroom will keep you organized by cataloguing all of your images in one place and allows you to create folders and sub-folders in your hard drive and can mass-rename files using templates.

Image editing in Lightroom is non-destructive, which means that the original file never gets permanently changed, whereas Photoshop is a mixture of destructive and non-destructive editing unless you save as PSD files where layers are kept. Photoshop does not keep historical changes. Lightroom can go back and restore earlier settings after making changes. Lightroom displays the image metadata as an overlay as you edit photos. Photoshop cannot do that once an image is opened. Lightroom is cheaper than Photoshop.

Photoshop is able to do things you cannot do in Lightroom. It could be used for something simple like removing an object from your image, to something more advanced like stitching panoramas. Adobe Photoshop Elements is a fraction of the cost of Photoshop, and has many of the features, tools and filters from Photoshop. Photoshop Elements combines a light version of Lightroom and a light

▲ Adobe Photoshop Elements: Import screen.

version of Photoshop. You can use Photoshop Elements to organize, edit, print and publish photographs.

The best photography workflow involves both image-editing and image-management software, working hand in hand like Lightroom and Photoshop. When you come across an image in Lightroom that you need to edit in Photoshop, you can right-click the image and edit in Adobe Photoshop. The image opens up in Photoshop and once you are done with all the changes, saving the image imports that new image back into Lightroom and this kind of two-way communication is automatic. You can simultaneously work in both.

RAW FILE PROCESSING

Raw files are the best type for their processing potential to help you get the most from your images. Raw files will, however, increase your file size, which in itself can cause problems in storage, speed of writing images to the camera and processing the raw files. Increasingly we need higher spec computers to deal with larger file sizes.

At the end of the day, as the photographer, in advance of your shooting you need to make decisions about file size and type, both to determine how the final image will be used, and to understand the advantages and disadvantages of different file types.

To describe the process using raw files rather than JPEGs, I would say it is like processing your own film and printing your own prints in a darkroom compared to handing over your film to a commercial processing laboratory and having them process and print your work. A raw file is comparable to the latent image in an exposed but undeveloped piece of film. It holds exactly what the imaging chip can record. The photographer is then able to extract the maximum possible image quality from the file using processing software.

With conventional film you have the opportunity to use a different type of developer or development time. The advantage of the digital raw file is that, if at any point in time you want to process the file differently, you can do so, as long as you have stored the raw file.

Raw files do not have a set white balance as they are only tagged with the camera's setting as it was shot. The actual data has not changed. This allows you to set the colour temperature and white balance after the photography has taken place with no change in the quality. However, if the file has been converted to a JPEG, a gamma curve has been applied and the white balance can no longer be properly applied. When file conversion is carried out on an external computer with a faster and more powerful microprocessor, this allows sophisticated algorithms to be applied to the file conversion compared to the internal system of the camera.

With contrast and saturation the raw file is tagged but the actual image data has not been changed. You are free to set these based on your image evaluation, not the evaluation made by the camera.

Certainly the biggest advantage of shooting raw is that you have a 16-bit image to work with: 65,536 levels rather than a JPEG's 8-bit image with 256 brightness levels. This is important, particularly if you are trying to increase shadows or highlight detail.

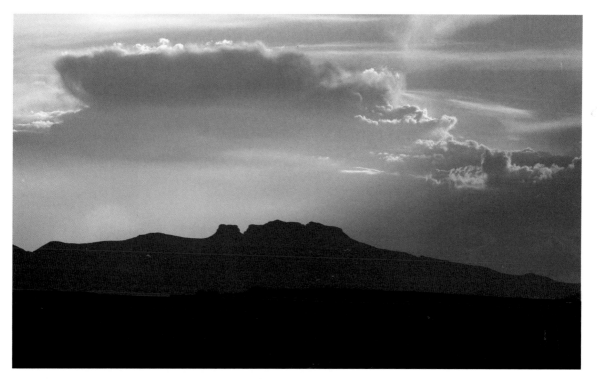

▲ Finished shot of landscape (Clarens, South Africa).

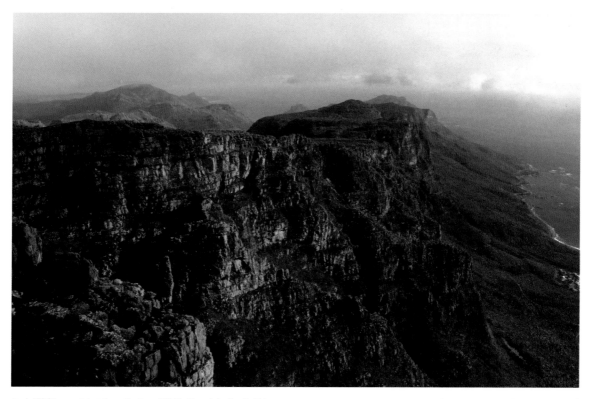

▲ A JPEG image taken from the top of Table Mountain, South Africa.

USING YOUR SOFTWARE

When working in raw in your chosen processing software, to get the most from your files you should make all of the possible major adjustments – brightness, contrast and colour – in that software. It is important to remember why you took the shot in the first place, as this will influence your choices in the way in which you handle the processing. Using your software should be about getting the most from your image, not getting the most from the software.

I tend to move from one control to the next, always looking at the overall impression of the picture and maybe revisiting some adjustments. Check for noise, particularly if you have used a high ISO in an image; it can be reduced, and particular software is very good at it, such as Lightroom. You can always adjust and readjust, as you have not saved the file. It is only when you are happy that you convert the file.

When you have finished all your adjustments you need to save the image by deciding on the file type you want: DNG, TIFF, PSD or JPEG; I use TIFFs, as these are industry standard. I tend to save the TIFFs for printing and save JPEG files for web usage, so in any one subject folder I have three folders: DNG, TIFF and web-sized JPEGs. If you think you will need to do more work on the image using Photoshop you may decide to save it as a PSD (Photoshop file).

USING THE BASIC TOOLS

Auto Settings
In Adobe Photoshop, all of the auto settings are turned on by default. The auto settings do work, but with varied amounts of success on different photos. You can always adjust any individual auto setting to see if it produces what you need. In any raw software conversions you should check to see what

▶ Lightroom: Basic Adjustments tool.

default has been set.

The colour space should be Adobe RGB 1998 (pretty much an industry standard, with the widest colour gamut) or if you prefer, Adobe sRGB which has a narrower colour gamut.

You generally have a choice of 8 or 16 bits – this is the output, but processing is done at 16-bit level. For most images, outputting at 8-bit is fine, but 16-bit increases the file size to twice the 8-bit size. At the time of writing, Photoshop has limited 16-bit editing facilities. Start with the file size that your camera produces. Do not during this process reduce the file size. Remember this is going to be your best quality file. When it comes to saving the files you can always increase or decrease each file from the original processed one and save them separately.

Resolution should be 300 DPI, but could be changed when you save the processed file, depending on what it is to be used for.

Brightness
The brightness of a photograph, its contrast and colour, will have a big effect. A calibrated monitor should be used at all times for the best results. It can be difficult to do this on laptop screens, as the image brightness will change depending on the viewing angle. Highlights, or the whites, should have a pure white, with graduation through to having some detail, just as the shadows should have a graduation from pure black with some small detail. Midtones contain most of the detail in a photograph, being the

▶ Lightroom: Tonal Curve tool.

straight line portion of the graph.

Making too great adjustments to the highlight and shadows will make the image too bright or dark overall. This adjustment is even more subjective than the others and is totally a matter of taste. A brighter image will let you see more detail, but it can lose some of the drama of a darker photo, so it is important to check it on Auto to see.

The Tonal Curve tool is an excellent tool to deal with midtones, giving you more control than Brightness. By clicking and dragging points on the curve you can adjust all three colours, or look at the separate colours.

Contrast

Contrast affects the overall appearance of the image, but you can gain better control of the contrast by separately adjusting the highlights, shadows and midtones. Most of the time, you can leave it at its default.

The Compare feature lets you see the difference between the original and the new corrected image. Small adjustments can make a big difference; small changes can be sufficient.

Colour

The colour balance of an image can be difficult to assess. A sunset image has a natural colour cast, and some require a neutral tonality with no colour cast at all. Working in raw files allows you to do both.

White Balance acts a little like your camera's white balance settings. You can choose from a number of white balance presets or use a custom setting that you determine. The white balance dropper tool allows you to pick an area of the image and make it a neutral grey. The temperature slider allows you to add warmth or add coolness. Effectively you are changing the colour temperature setting relative to the original colour temperature of the scene. The tint slider adds magenta or green to the image. I have rarely used this for anything other than adding tint to Northern Lights images.

Saturation

Saturation is another highly subjective control, and you have to be careful, as addition of saturation, which is the intensity of a colour, can make the image rather garish and may not reproduce correctly. However many subjects look better with a slight addition of saturation.

Luminance Smoothing

Luminance Smoothing affects the general noise that comes from a sensor and may be seen particularly in skies and other smooth midtone areas. Overuse can result in a very soft detail, as colour noise reduction affects colour noise that comes from shadow areas of an image, especially when that image is underexposed.

Sharpness

Sharpness should be set to minimum; certainly I would recommend no more than 30 per cent.

▲ Lightroom: Sharpness and Luminance Detail tool.

USING
THE GRADUATED FILTER

I consider the graduated filter in Lightroom one of the best tools for the landscape photographer. It is ideal for darkening skies or lightening foregrounds, since the transition line of the gradient can blend portions of the original and can be hidden along the horizon.

This is a digital post-processing tool that gives you control over exposure, brightness, contrast, saturation, clarity, sharpness and colour, using a gradient. It is fast and easy, and the changes are seamless thanks to the soft edge of the gradient. Like the adjustment brush, the graduated filter is non-destructive, allowing you to change your settings, reposition and alter the effect size at any time. The graduated filter enables you to do quick adjustments to large areas and the adjustment brush to do more localized work.

Raw files contain details in the highlights that you can recover using the recovery or exposure sliders in Lightroom (but JPEG files do not store this additional information and will not allow you to take full advantage of the graduated filter tool).

The graduated tool works by identifying the point you first click on the image. This is the beginning of the gradient transition. The midpoint of the gradient, indicated with a black and grey circle in the centre, marks the area where the gradient fades from corrected to unaffected. The final line, created when you release the mouse, shows the end of the gradient transition. The length that the gradient needs to be is not always obvious, but it needs to blend seamlessly into the image. Long gradients produce smooth transitions – ideal for images without an obvious break or horizon line, like mountains or a cityscape. Short gradients produce an abrupt transition, which generally work well on images with an obvious horizon line. To see a 'before and after' preview of the gradient's effect, toggle the on/off switch in the lower-left corner of the graduated filter tool drawer.

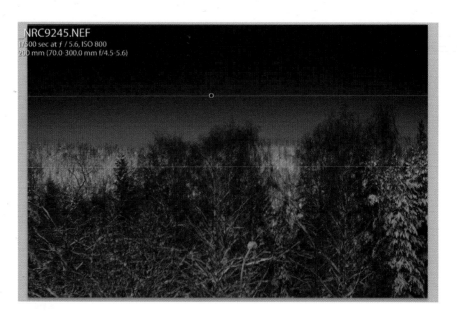

▶ Lightroom: Gradient tool with image.

Using Multiple Graduated Filters

Sometimes you may want to apply more than one graduated filter across an image. By selecting New you can select a new mask instead of editing the previous one. Create your new gradient correction, then adjust the effect sliders as necessary. You may want to select a second gradient mask to lighten the foreground, boost saturation, and increase sharpness slightly, making the foreground more prominent in the finished image.

Coloured Tint

One of the features in the graduated filter tool is the colour box, which will add a coloured tint to the gradient. The small box to the right of the colour heading opens the colour picker and enables you to select a colour to use as a tint. Try selecting a saturated colour, then use the saturation slider at the bottom of the colour picker to decrease the intensity of the tint being added to the image. You can often heighten the interest in an image by using a slight warm tint to the foreground and a faint, cool tint to the sky, improving the separation between the foreground and the sky.

▼ An urban landscape given a coloured tint.

Switching Between Multiple Gradients

To switch between gradients, simply click on the Graduated Filter pin (the grey and black circle in the centre of the gradient) to select the gradient. The Mask mode will return to the Edit mode and display the Effect settings associated with the gradient.

Graduated filters are non-destructive to your image. You can edit your gradients as often as you need without compromising the original image. If you ever need to delete a gradient, just click on the gradient's pin and delete it. Once you have finished with the graduated filter corrections, close the button in the lower-right corner to return to normal image editing.

The Graduated Filter tool is a quick way to enliven and enhance images. Use it to darken skies. A reduced exposure and brightness setting will create moody sky. Brighten the foreground to create attention to foreground elements and heighten depth and produce a three-dimensional effect. Selectively increase sharpness in one area of the image. The viewer's eye is naturally drawn to the sharpest area; this is particularly effective when the original has been taken with a shallow depth of field. Reducing the clarity setting can blur a background slightly, increasing the feeling of depth or distance between the foreground subject and the background.

PRESETS

Lightroom has a good set of Preset black and white conversions, split-toning, and selective control on colour and cross processing. You can create your own presets under Custom, or download some free and purchase others if you so wish. These are plug-ins to Lightroom.

▲ Lightroom: Presets tool.

Split toning

Split toning allows you to control a colour correction in the highlights separately from the shadows. Split toning is performed on black and white images to give a slight colour tint to the shadows and high-lights. The same technique can be used with colour images to create a special effect, much like cross processing with film or using gels on your lights.

The process works by first selecting a hue that you would like your highlights to display, and then using the saturation slider to introduce that hue into your image until you are happy with the results. You do the same process with the shadows, sliding both the highlights and shadows sliders until you get an effect that you like and works for your image. Working with the Split Toning feature is a little bit like working in the dark. You select a hue but you cannot see what colour you are using until you start increasing the saturation.

Selective Colour Correction

A big creative advantage in Lightroom, for me, is the selective colour correction. I start by using the eyedropper in the top left corner of the first panel, placing on the image a neutral grey or white or pure black to adjust it, by sampling different areas of the image until I get an adjustment that looks correct. You are looking to remove any overall colour cast in the image.

When you hold the eyedropper over the image a loupe shows a gird of pixels around the area, and it also shows the relative percentages of red, green and blue in the pixels. The colour in an image should be neutral grey. The values should be the same, and if they are not, there is a colour cast in that area.

If some individual colours are still incorrect you can adjust these using the HSL panel. To do this, select HSL and then Saturation and use the targeted adjustment tool to drag on an area of the image – downwards to decrease or upwards to increase the colour saturation at that point in the image.

▼ Plastic fleece on farmland, using Split Toning Effect.

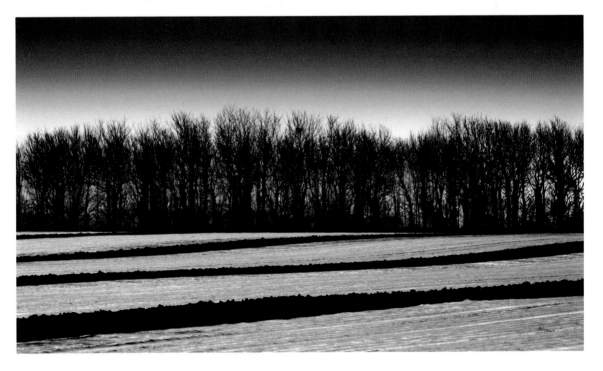

When you have adjusted saturation, click Luminance and, if necessary use the same targeted adjustment tool to increase or decrease the luminance in areas that are too dark or too light. Once you have fixed the colour, you can return to the basic panel and continue to adjust the image using the tools there.

▲ Selective Colour Correction used on the rock in the foreground.

MODIFICATIONS TO THE ORIGINAL PHOTOGRAPH

You will at some point need to change the size of your digital image. In most cases you will be reducing the size of the image, for example to email a smaller version of the original, but you may need to increase the original, or use a cropped image.

Digital images do not like being enlarged, and this generally should be avoided. Enlargement of a digital image is best done by software specifically designed for this purpose, such as Genuine Fractals. Metadata digital watermarking is distinctive in that the data is carried right in the original image, usually containing information about the original exposure and author, but can during software processing be embedded with keywords for searching.

BASIC PROBLEMS

Basic problems with digital images are often due to a lack of consideration and poor adjustments at the shooting stage. This may be due to lack of time, or limited knowledge of the subject or the camera. Most problems can be solved in processing by using minor adjustments available in software, particularly if you have shot raw files to start with, as no apparent loss of quality will be found in the final photograph. There are, however, some cases where problems cannot be successfully recovered, including lack of sharpness, extreme over- or underexposure and shooting at a too high ISO.

Lack of Sharpness

High-resolution digital cameras are unforgiving of any error by the photographer. It takes a great deal of skill to extract every pixel of sharpness. Cameras have zero tolerance if you are looking for the greatest sharpness. Modern viewfinders, I believe, are not as good for checking the sharpness of an image as the older film cameras, particularly if you are using either manual focus or lenses at the widest aperture in poor lighting conditions. Autofocus lenses become useless in poor light.

On your monitor check your images only at 100 per cent. Any other magnification obscures the image's own sharpness. At 100 per cent you will see slight errors in sharpness and camera shake effects. Images in Photoshop look good at even reductions like 50 per cent, 25 per cent and 12.5 per cent, but they become jagged at odd reductions like 67 per cent and 33 per cent. The software program uses different resampling algorithms to remap the actual pixels to the ones on your screen. Every program will have different apparent sharpness depending on their algorithms.

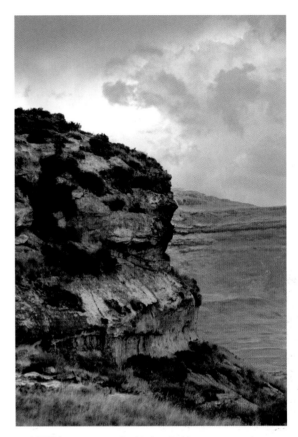

▲ A JPEG image converted to black and white.

Over- or Underexposure

An underexposed shot rather than an overexposed one still records most of the detail of your shot, even though you cannot always see it, and with a little work in Lightroom or Photoshop you can generally bring out the detail. Overexposed shots tend to record less of the detail, and it is difficult to bring it back. Going too far in either direction can result in an image that cannot be fixed afterwards. An image that is too underexposed does not pick up any of the light reflected by the subject, and an image that is too overexposed completely blows out the subject with light, eliminating all the details.

CHECKLIST

▷ Consider how you want to organize and store your images.
▷ Understand the image manipulation limitations of JPEGs over raw files.
▷ Be selective about the images you keep – master the art of eliminating weak images.
▷ Ensure that you have adequate storage potential, particularly if you are using big files.
▷ Ensure that your computer has enough capacity to open and use your editing software.
▷ Consider an auxiliary storage (an external hard drive) to maximize storage space and ensure back-up copies.
▷ Understand your editing software features and how to use them.

Chapter 11

Travelling with Your Camera

When planning a photographic journey, especially abroad, it is a good idea to start your research by acquiring general knowledge of the considered destination, either by using the internet, travel books or personal experiences from another person, or even better, another photographer. Researching a travel destination will help you stay clear of things that could ruin your visit, but do not let other people's experience and views cloud your own before you have experienced it. Good information is a tool and will enable you to make better, more productive plans.

Looking through magazines you will often see the same landscape locations. It is difficult to go to the same places and make different images. Just search Flickr or Google to see what photographs have been taken. However these classic locations still remain a draw to get your own image of the place, maybe at a different time of day or season.

You can use the internet to explore new possible locations, using Google maps and the satellite view of different places. When travelling in the UK, the Official Enjoy England app has fresh ideas and places to visit. You can personalize your search, and the results come up with a Google Map location, free access to travel content and readers' tips from the *Guardian* newspaper. You can also upload your suggestion to the interactive map and share with other users, connecting directly to Facebook and Twitter in order to share your whereabouts.

The Photographer's Ephemeris is available as a desktop application and can help with the planning of all types of outdoor photography, but particularly landscape. There is a map-centric sun and moon calculator to see how the light will fall on the land. It is not limited to a list of locations. You can search for any place name on the planet or position the map pin exactly where you want it to be. You can even determine when the sun or moon will be visible behind nearby hills and mountains, and slider controls allow you to predict exact positions of the sun at a particular time on your landscape, all before visiting the actual location.

◀ Railway track.

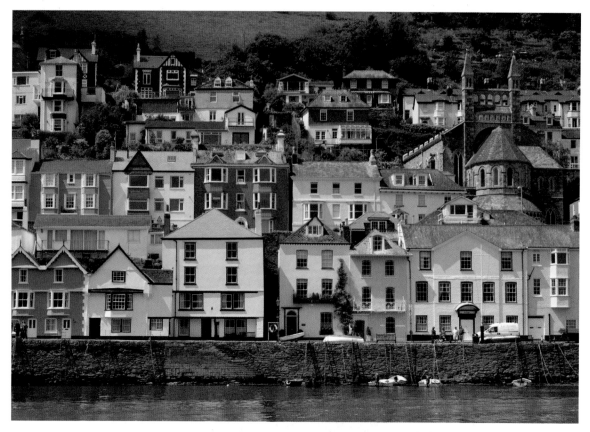

▲ Houses lining the River Dart (Dartmouth, Devon).

GETTING
TO YOUR LOCATION

By Air

Airline security has increased especially since 9/11, and travelling with luggage has become very time-consuming and inconvenient. Airports are looking more and more like bus terminals. The queues are out of hand, and the security equipment for screening of bags is taking space and causing more crowding in the terminals.

Air travel without luggage is a true luxury. If you have plenty of time, consider sending your equipment on to your destination by courier services before you go. It can save money and guarantee that your equipment will get to its final destination and be waiting there on your arrival. It will also be insured against loss.

Plan your air travel with as few changes as possible to avoid loss of luggage. Remember the budget airlines can work out more expensive than the scheduled if you are carrying a lot of equipment.

▲ Travelling by car across vast landscapes enables more equipment to be carried and allows for the possibility of stopping when a potential shot appears.

Car/Van

Travel by car or van allows you to carry much bulkier gear and not be inconvenienced by its size and weight. If you are travelling long distances in an area or country that you do not know, make sure your fuel tank is full whenever possible, and ensure that your car is in a good mechanical condition before you set out on any journey. If you are using a hire car check its general roadworthiness, as this may vary from country to country and hirer.

Beware of extreme heat build-up inside a hot car or near the engine or exhaust. When bringing cameras and lenses from a cold, dry environment into a warm, humid environment beware of condensation. Placing them in an airtight plastic bag when bringing them indoors allows them to warm up without being exposed to the humidity.

Walking

Most professional landscape photographers are not hikers – great scenic photographs are usually shot close to the road. Taking long hikes to get scenic pictures is not very efficient; walking through miles of woods or deserts does not mean you are going to get any more photo opportunities. As most professional landscape gear is very heavy and bulky and not easy to carry, trudging through difficult terrain is not a sensible option. Walking is the slowest method, and if you choose to do so, remember you will need to arrange your equipment carefully.

CAMERA-FRIENDLY TRANSPORT

Take your time when travelling to the area and to each location within the area. Your mode of transport may be dictated by accessibility or the weight of your equipment.

Boat
Travelling by sea is an excellent option if you do not mind sea travel. The advantage is that you are less restricted with luggage and equipment, and will gain the advantage of being able to take shots from the ship/ferry as it leaves and enters port.

Train
If travelling by train, have a camera bag which is comfortable because you will want to use it as a pillow for security in some countries.

Bus/Coach
The wide range in the level of bus and coach comfort in different countries can tell you far more about the people of a place and the places that people live than other modes of transport. It can inform you more about a country's social, political and economic condition than studying a guidebook can. Where possible you should opt for modern vehicles when travelling by bus. If fitted with seatbelts, use them. Never let your equipment be stored in the hold of a bus.

Motorcycle
To minimize vibrations I carry a camera and lenses in a tank bag on my motorcycle, with about 1 inch of padding around components. Vibrations can damage parts of your camera and lens, screws can get shaken loose and the lens focusing can be particularly affected if using optically stabilized lenses. Motorcycling is recommended for experienced motorcyclists only. In some countries having a guide or another companion is advisable.

Bicycle
A handlebar bag can carry a small amount of camera equipment, but even with good internal padding, vibration will hurt your equipment. Consider good quick-access backpacks, where your body will absorb any vibration. The ones with waist straps and chest straps can be good snug-fit, while a loose backpack induces more vibration and makes riding more difficult. Most quick-access packs only allow easy access to the camera, not the accessories.

Horseback
If you can ride, the quickest, most effective and most pleasant way to explore an area of remote or hilly countryside is by horseback. A waterproof daypack, worn high on the shoulders, doesn't rub against the saddle or back of the horse. An alternative is to hang the daypack on the pommel. It is important that the pack doesn't get in the way of normal horse control, and also cannot fall off. As most cameras are used in the right hand, you will need to control the reins with your left. Using a zoom lens can be a real problem; a fixed focal length lens when riding can be the best choice.

Helicopter
It may be possible to access particular locations by helicopter. Mountain areas are often served by helicopter, which may take you to a base camp location. Often these are not necessarily cheap, but can save considerable time in getting to a more remote location, and may be an advantage over travel by land vehicle. The biggest advantage of a helicopter flight is that it will enable you to view the landscape as you fly over it.

▲ Horses move more easily through difficult terrain than a human can on foot.

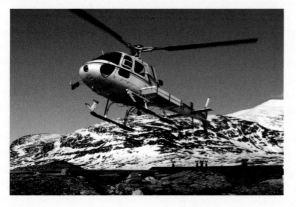

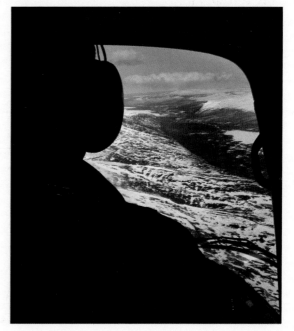

▲▶ Access to a remote location allows for a view of the landscape.

WHAT TO TAKE

Packing depends somewhat on how you are planning to travel. Whatever your mode of transport, however, be sure to insure yourself and the cameras and equipment you plan to take. Make sure you carry a list of your photographic equipment with serial numbers, make, model and descriptions, and the value of the equipment. You may need an official certificate to prove you have purchased all the equipment in the UK and all tax has been paid (you can download a copy from the IR website); this should always be done if you are travelling outside the EEC. If you are travelling through other countries to your destination, make several copies to give to customs, as they will also check them on exit.

Your mobile phone is as valuable to you as your cameras, especially with today's photography apps. Beware of hidden mobile phone charges. You may encounter international roaming charges even when a phone call is not answered and even when the handset is powered off. As soon as your handset registers itself on a foreign network, roaming charges can be applied by phone companies. iPhone customers should also be cautious about taking their phones overseas unless they have negotiated an international data services plan.

Flight Plan
If flying, the key is organization – pack only what you really need. Check your chosen airline website to see how you need to divide your equipment up among carry-ons and check-through bags.

I usually try to use a camera bag to carry most of my equipment, camera bodies and lenses on the plane, including a small high-spec laptop. These days security may ask you to unpack the bag so they can check the items, so be prepared to repack if you need to. Most international airlines are picky about the weight of carry-on bags. If your camera bag is too heavy, they will ask you to take things out of it or check it. Carry a small cloth shopping bag on your person. If necessary this will give you a place to put any equipment that you are forced to remove from your camera bag.

I have an old Linhof tripod that is very stable lightweight aluminium and will fit in my suitcase, and I have two heads for it, one for stills and one lightweight fluid head that will fit into my check-in case together with batteries and chargers, plus my clothes. All my rechargeable batteries are charged before I leave, and I usually also take a battery pack that will take AA batteries in case of rechargeable battery or charger failure. You can get these anywhere in the world in my experience.

If you have a huge amount of gear, you might want to consider a rolling case that can be checked in, as long as the equipment is carefully packed in the case. I use bubble wrap around each item, then dividers arranged to accommodate the larger than normal equipment. When I am shooting I do not carry all my gear with me. I may leave my computer and some equipment in my hotel room.

If you can, it is useful to pack a smaller practical camera bag to decant equipment for a day's shooting. On a recent trip to South Africa I used one carry-on bag with laptop and some camera kit, and another bag with more camera kit that was packed with my clothes, so splitting the equipment to safeguard any possible loss of equipment during the long journey. I usually split equipment if I know that I have different in-transit flights, in case the check-in case/cases go missing. They usually turn up a few days later in my experience, but not always.

Power Supply

Be aware of the different power supplies in different countries and check that your chargers will work. Some may need different adapters to change the input voltage to the charger, or you may need an inverter to work you chargers for a laptop from a DC car power supply. Some places may use three-phase power. If you are staying at a hotel check that you have enough power outlets to charge your equipment or you may need to bring a power block to plug everything into it. Always travel with the right adapters – do not rely on getting them locally. Some hotel rooms have a system using a magnetic card for power. When it is not in the holder you will not have any electricity in your room, so you may need a second card in order to charge your batteries while you are out of the room.

If you are going into the countryside, or travelling in a country where power is unpredictable, then you will need some portable power solutions. If you are travelling by vehicle, consider getting an inverter car charger or a lead-to connect to power outlets in the vehicle. A solar cell could be an option; larger higher-capacity ones are now available for caravanning. While shooting during the day, you could leave batteries on charge so that when you return you have charged batteries.

ESSENTIALS

▷ Photographic equipment: storage and transportation
▷ Communications: mobile phone, laptop
▷ GPS systems: cameras, car GPS, handheld
▷ Appropriate clothes and footwear

CLOTHING

Appropriate clothes for the climate and for what you are doing are as important as the photographic equipment you use, believe me. It is difficult to work if you are not comfortable. My cousin, a meteorologist, has always provided me with good accurate weather forecasts (to the hour) in whatever country I am working, making for a far more successful photographic shoot.

Keeping Warm

In a cold climate layers of lighter-weight clothes work well, but do not include cotton because it does not insulate when wet and dries slowly. Holding water against your body is not good, as the water acts a conductive cooler, transferring heat from the body into the air. Hypothermia is a real problem. Getting wet even at temperatures above freezing is life-threatening if you do not have the right clothing. In wet conditions waterproof over trousers or gaiters will keep you dry.

Lightweight clothes are the key to allow you to be warm but able to move with ease. If you are out for long periods or away from your car, in cold conditions you should consider wearing four layers: an inner warmth layer or base layer of full length underwear, then regular top layer, and then insulating layer and finally a weatherproof layer – at least water-resistant but preferably waterproof. A fleece vest or jacket is good and light to carry, and wool is good as an insulator when wet. Dressing in multiple appropriate layers allows you to regulate your body temperature perfectly. You will heat up while climbing or walking uphill and need to sweat, but once you reach the hilltop and are standing around taking photos, you quickly chill. So the solution is to strip off layers during the climb, and put them back on when you are standing around waiting for that perfect light.

▶ Appropriate clothing and a means of communication are essential.

▶ A mosquito net visor, even in temperate climates, will enable you to ignore the nuisance of midges and mosquitoes and continue shooting.

If you are used to being outside in all weathers you develop your own version of layering that suits you, including one for gloves. Keep the hands covered with a two-layers glove – or three-layers if in below-freezing weather for long periods of time. The inner layer should be a light synthetic glove, so that you can feel the camera controls but still have some protection against wind and cold. Two layers of gloves are light and easily packed. Some people prefer to use fingerless gloves or gloves that have peel-back fingers. If you need a third layer, try a warm mitten, so you can go from one thin layer to three full layers over your fingers. Try taking pictures with the gloves you think you will wear.

Remember when night falls, so do temperatures, and sometimes far more than you think. Even in the desert the night temperatures can get very low. A good tight-fitting but insulating hat is a must, although you can also take a multilayer approach. Like gloves, a hat and ear warmers are small, light and packable.

Keeping Cool

Outdoor photographers usually wear large brimmed hats instead of polarized sunglasses that alter your colour perception. LCD displays on your camera do not show well with polarized sunglasses. Hats with brims keep out glare and also prevent sunburn.

In hot climates, you probably will be in one layer, but I still think you should keep another layer handy. Get wet during the day and have a mild tropical night and you will still be chilled. Always assume it will get colder; you can always take clothing off if you get too hot. For the tropics, quick-drying fabrics are generally good.

Shorts and short sleeves are not necessarily the right choice with increased sun exposure. Nor are they a good idea if the risk from insect bites is high, or if you are walking through long grass, woodland, or rainforests. For hot climates lightweight clothes, maybe adaptable converter trousers to shorts give you a choice, along with T-shirts.

Dress in midtones so that you can include yourself in your shots, if necessary to pose in the landscape when you need a scale, a splash of colour, or another element in the scene. Carry a splash of colour as well – one of your layers could be orange, yellow, blue or red, which tend to work best.

Footwear

A good pair of walking shoes is essential. Most outdoor photographers have a waterproof trainer or running-shoe style with slightly beefed up treads. Make sure your shoes are comfortable and fit, so you will not get blisters, and are waterproof. If conditions are really wet, you might want a pair of lightweight waterproof gaiters that work with your boots.

In hot climates, you will want a good pair of walking shoes or canvas shoes rather than sandals, depending on conditions. Make sure that your shoes expel moisture and dry quickly, and carry a spare pair of socks, as sometimes you will get your socks wet.

ON LOCATION

When travelling abroad, especially beyond the EU, a good local guide will be as instrumental in getting you good pictures as your technique. Talking to local people can open up photo opportunities, not just in being able to photograph the essential elements of a country, but also by being provided with information on locations that might have taken weeks or months to find.

Be sensitive and careful not to flaunt your level of wealth. Your camera equipment probably costs more than many people in a third world country earn in a year, if not longer. Maybe even carry it in an old bag – I use a fishing bag equipped with foam compartments.

Regarding security, be aware of your surroundings, and be a bit more careful about what you are doing. If driving in a car, keep the doors locked at all times in city traffic. Do not drive with the windows down. When parking your vehicle anywhere, do not leave any valuables or any other possessions at all in sight. Always travel with a good, detailed, up-to-date map and plan your route in advance. Do not stop for hitchhikers or other persons seemingly in trouble on the open road. Carry a copy of your passport, and keep photocopies of your credit and debit cards in a safe place.

CHECKLIST

▷ Use the internet and photography apps to research your destination and prospective locations.
▷ Explore your transport options and plan accordingly, considering your equipment requirements.
▷ Insure your equipment and take the details with you.
▷ Pack carefully, and prepare for airport difficulties.
▷ Ensure you have a constant power supply.
▷ Take appropriate clothing for the climate you will face.
▷ Seek local advice – it will pay dividends.

▼ Local information provided the location of an ostrich farm in the Western Cape, South Africa.

Glossary

Advanced Photo System type-C (APS-C) – a particular image sensor format, smaller than 35mm, originally developed as a rival to the 35mm film format.

auto exposure lock (AE lock) – the ability to lock exposure settings (aperture and shutter speed) over a series of exposures.

auto white balance (AWB) – the automatic adjustment of the white balance of a scene to a neutral setting, regardless of the ambient light source.

Bayer Filter – used in most single-chip digital image sensors to create a colour image. The filter pattern is 50% green, 25% red and 25% blue.

bokeh – the Japanese-originated concept of the difference between out of focus areas of an image, and the areas that are in focus according to the focal construction and design of a particular lens.

depth of field (DOF) – the sharp area surrounding the point of focus.

digital negative (DNG) – an open raw image format owned by Adobe.

dynamic range – the range of luminance values from the darkest to the brightest that is discernable to the human eye, film or digital sensor.

focus shift – the effect when, with the lens aperture fully open or 'wide open', incoming rays of light converge at different focal points due to spherical aberration along the optical axis.

French flag – nickname given to a camera tool, usually a piece of black material or metal, used to block unwanted light from hitting the lens, to reduce lens flare.

golden hour – the first and last hour of daylight, when the light quality gives a unique effect.

golden ratio (also known as the golden mean) – when the proportions of the elements within an image give a balanced aesthetic effect.

golden triangle – the visual method by which an image is perceived as a composition of triangles with intersecting points, where the main elements of the image are placed, to achieve a balanced aesthetic effect.

golden spiral – the visual effect of using an element or elements in the image to lead to the central point of focus in a spiral movement.

high dynamic range (HDR) – a range of techniques geared towards increasing the dynamic range of a photograph.

ISO – the measurement of the sensitivity of the image sensor.

light painting – the method by which additional light is introduced, by a hand-held light source, to add light to under-lit areas of the image to enhance an element or create more balanced lighting.

mirror lock-up (MLU) – a camera feature that allows the photographer to reduce vibration-induced motion blur caused by the movement of the mirror.

neutral density filter (ND) – a range of grey filters, of different densities, which reduce or modify the intensity of colours of light, allowing for an equal rendition of colour hue, and a longer exposure.

noise – used to describe the occurrence of colour dots or specks where there should be none, usually occurring during long exposures.

photo stitching or image stitching – the process of combining multiple photographic images with overlapping fields of view to produce an extended panorama.

raw files – files that contain all the possible information recorded by a given chip.

tilt and shift lenses – a lens designed to create an optical effect where 'tilt' is used to control the part of the image that appears sharp, and 'shift' is used to adjust the position of the subject within the image area without the need to move the camera.

Further Information

The following represent a sound basis for information and reading, and where I would encourage readers to begin further research.

JOURNALS

Amateur Photographer
www.amateurphotographer.co.uk

The British Journal of Photography
www.bjp-online.com

National Geographic
www.nationalgeographic.com

Professional Photographer
www.ppmag.com

SOCIETIES

The Royal Photographic Society
www.rps.org

WEBSITES

Enjoy England
www.enjoyengland.com

Official Adobe Site (for products)
www.adobe.com

The Photographer's Ephemeris
www.photoephemeris.com

**UK Government
(for travel documents and advice)**
www.direct.gov.uk

Wise Weather (for UK and European forecasts)
www.wiseweather.co.uk

**World Health Organization
(international travel and health)**
www.who.int

GALLERIES

The Ansel Adams Gallery, Yosemite, USA
www.anseladams.com

Foam, Amsterdam, The Netherlands
www.foam.org

Fotografiska Museet, Stockholm, Sweden
www.fotografiska.eu

Fotoskolaochgalleri, Västerbotten, Sweden
www.fotoskolaochgalleri.com

National Media Museum
(for the RPS Collection), Bradford,
West Yorkshire, England
www.nationalmediamuseum.org.uk

The Photographer's Gallery, London,
England
www.photonet.org.uk

Royal Photographic Society, Bath, England
www.rps.org

Further Reading

Adams, Ansel *The Ansel Adams Guide – Basic Techniques of Photography, Book 2* (Little Brown, 1998)

Adams, Ansel, *The Eloquent Light* (Aperture, 1980)

Adams, Ansel *The Portfolios of Ansel Adams* (Bullfinch, 1977)

Bruck, Axel *Practical Composition in Photography* (Focal Press, 1981)

Farace, Joe *Complete Guide to Digital Infrared Photography* (Lark Books, 2006)

Frich, Arnaud *Panoramic Photography* (Focal Press, 2007)

Godwin, Fay *Our Forbidden Land* (Jonathan Cape Ltd, 1990)

Gombrich, E.H. *The Story of Art* (Phaidon, 1995)

McCullin, Don *Open Skies* (Jonathan Cape, 1989)

Newhall, Beaumont *The History of Photography* (Secker & Warburg, 1982)

Palmer, Frederick *Visual Awareness* (Transatlantic Arts, 1974)

Index